One

Hundred

Years

in the

Huntington's

Japanese

Garden

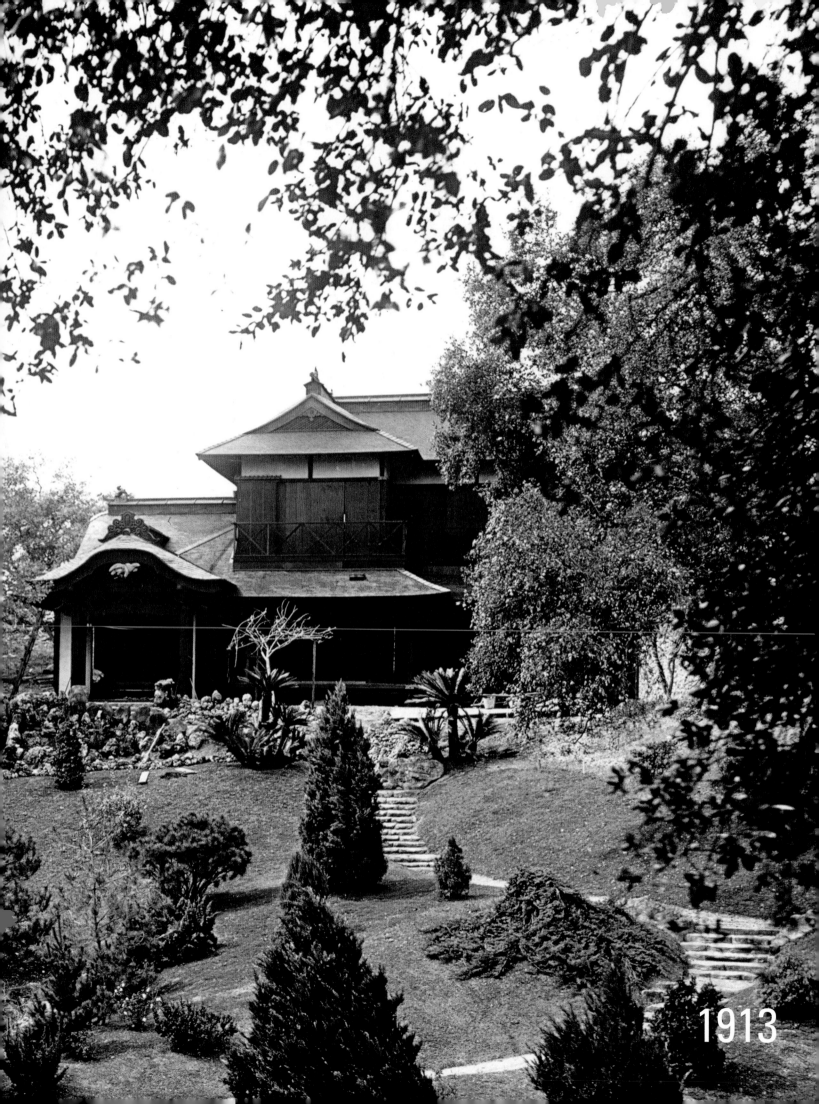

1913

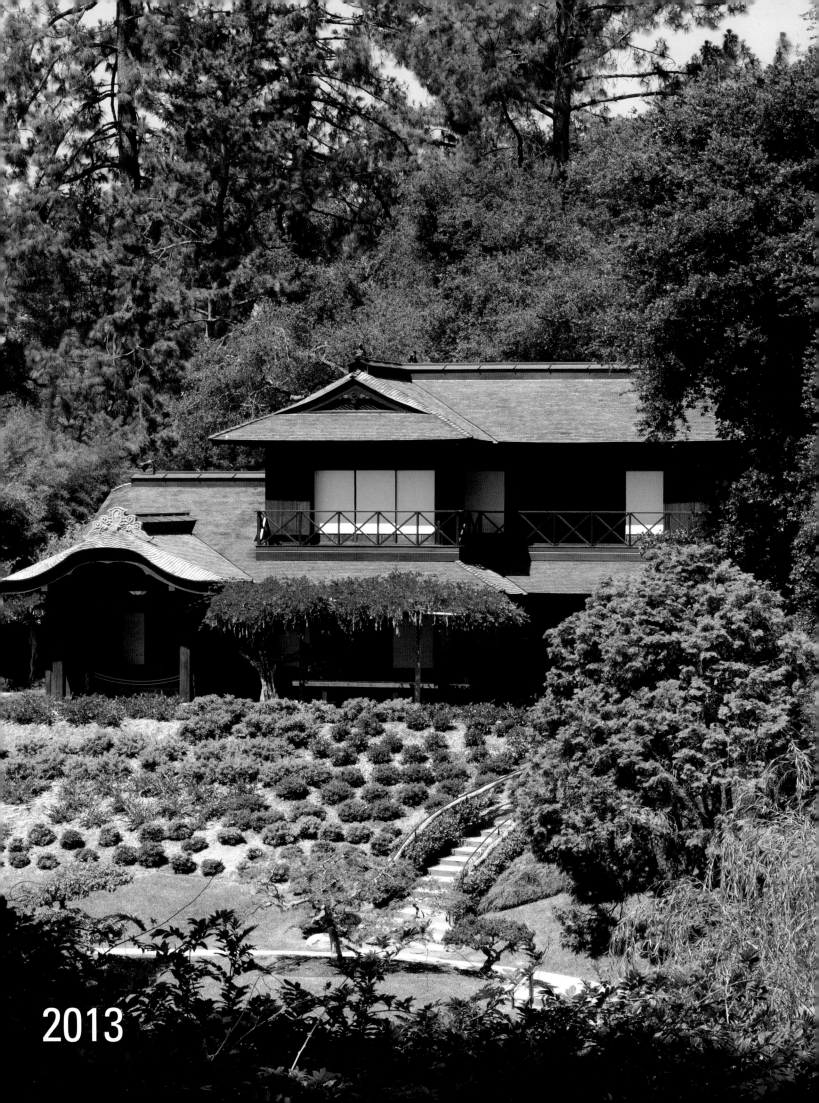

2013

One Hundred Years in the

Huntington's Japanese Garden

HARMONY WITH NATURE

EDITED BY T. JUNE LI

Huntington Library, Art Collections, and Botanical Gardens | San Marino, California

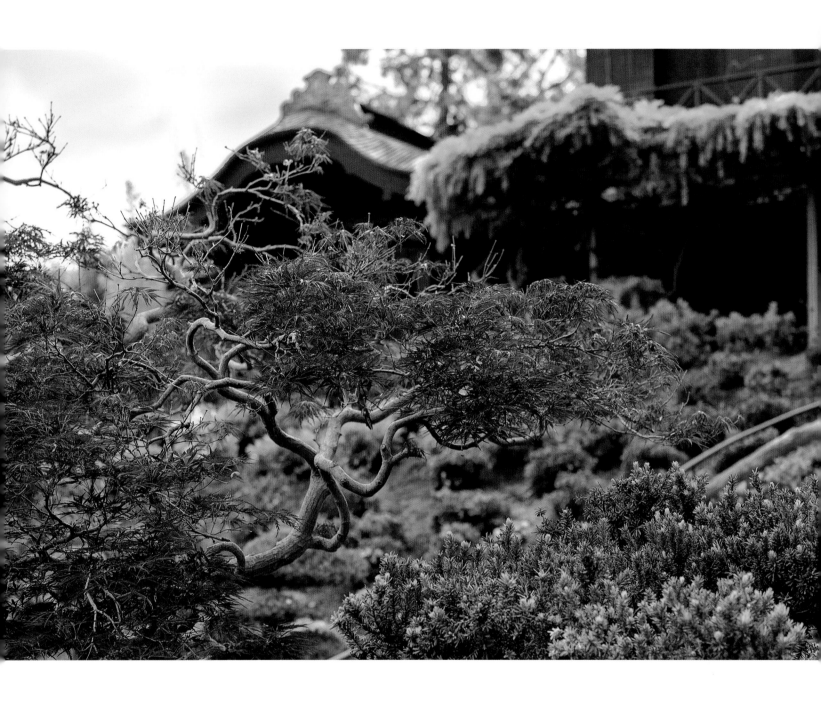

This book is dedicated to Mary B. Taylor Hunt, whose decades
of volunteer work and leadership, vision, and philanthropy
were fundamental to preserving the Japanese Garden.

Contents

Foreword

As the Huntington prepared to celebrate the 100th anniversary of the establishment of its Japanese Garden, it decided to mark the occasion with a group of essays about the garden, edited by T. June Li, Asian art scholar and curator of the Chinese garden. The volume that follows is the product of those efforts.

Henry Edwards Huntington, a native of New York, fell in love with Southern California while working there for his uncle Collis P. Huntington's transportation imperia. After Collis's death in 1900, Huntington moved from San Francisco to Los Angeles and began a second career as the major developer of the region. In 1903, he bought a 500-acre ranch, San Marino, where he built a Beaux-Arts mansion. As the residence took form between 1906 and 1910, his ranch foreman, William Hertrich, began to establish formal and informal gardens on the property. Huntington simultaneously was trying to persuade Collis's widow, Arabella, to be his wife.

The creation of the Japanese garden in 1912 actually was, in some sense, kismet, as well as a culmination of both gentlemen's activities. Arabella herself was a serious and engaged gardener. Huntington was a year away from convincing her to marry him. Hertrich wanted to convert a canyon with a small dam into a formal garden. And at the time, Americans in general were increasingly interested in Japanese art and culture. So a beautiful garden emerged in San Marino.

Hertrich remained in charge of the gardens until 1948, long after the deaths of Arabella and Henry E. Huntington in 1924 and 1927, respectively. The Japanese Garden became the pride of the Huntington Library, Art Collections, and Botanical Gardens once the institution opened to the public in 1928. Beginning with World War II, however, the garden fell into disrepair, was closed for periods of time, and was referred to as the "Oriental Garden" until the late 1950s.

A group of volunteers known as the San Marino League, led by Mary B. Hunt, then stepped forward to return the garden to its original splendor, restoring its name, providing annual funding, and training a cadre of docents to help interpret the garden for schoolchildren. The Japanese Garden blossomed again as one of the Huntington's great gardens, providing enjoyment and education for millions of visitors and a filming location for any number of motion pictures. This use led to wear and tear.

By 2008, the Telleen/Jorgensen Director of the Botanical Gardens, James Folsom, recognized that the garden needed renewal again, as its centennial approached. He and Laurie Sowd, the Huntington's vice president for operations, led a team effort to plan the renovation and expansion of the Japanese Garden. Many staff members and outside experts participated in the planning and execution of the project. A lead gift from Michael Monroe and Deane Weinberg provided the initiative to raise nearly $7 million to cover the cost.

In addition to this revitalization, the Pasadena Buddhist Temple's stunning gift of its ceremonial teahouse, Seifu-an, gave the Huntington the opportunity to create an entirely new formal element in the garden. On April 12, 2012, the Japanese Garden was honored with a visit from the current Grand Master of the Urasenke tea tradition, Sen Soshitsu XVI, whose grandfather had commissioned the teahouse to be built in Kyoto and then donated it to the Pasadena Buddhist Temple in 1964.

The refurbished Seifu-an teahouse, the remarkably restored Japanese House, and the renewed historic landscape —these iconic features join the new tea garden, the Zen Court, and the Bonsai Courts to create a Japanese Garden that will no doubt be the glory of the Huntington for a hundred years to come.

Steven S. Koblik
President of the Huntington Library, Art Galleries, and Botanical Gardens

no longer grow in their places of origin. An understanding of the commonalities of China and Japan elucidates the two nations' botanical and horticultural differences and the separate developments in their history and culture.

There are many people to thank for the making of this book. First and foremost, I am grateful to the authors for weaving together intricate and sometimes disparate information into coherent accounts. Many other experts and friends of the garden have contributed knowledge and informed observations: Shelley Bennett, former curator of European art and senior research associate at the Huntington, on the history of the Huntingtons in Southern California; Anita Brandow, former docent and friend to the Huntington, on many details of the garden and its craftsmen; David MacLaren, curator of the Asian gardens, on all aspects of care and landscaping; landscape architect Keiji Uesugi on the rehabilitation of the ponds; and Vergil Hettick, curator of the Earl Burns Miller Japanese Garden at California State University, Long Beach, on the emblematic koi in a Japanese garden.

The book's many images are indispensable to its stories. For unearthing archival photos at the Huntington, I thank Kendall H. Brown, Kuniko Brown, Jennifer Goldman, Jenny Watts, Erin Chase, Ann Scheid, and Danielle Rudeen. John Sullivan, senior photographer at the Huntington, Andrew Mitchell, and Martha Benedict photographed the garden onsite, recording the restoration work while in progress and after completion.

Amy McFarland's design for the book has been inspirational. And as always, Susan Green, director of the Huntington Library Press, and Jean Patterson, managing editor, worked tirelessly and cheerfully on smoothing out the text and design, allowing us to soar effortlessly above all complications. My colleague Michelle Bailey, curatorial assistant for the Chinese garden, accomplished the herculean task of organizing all the photographs and strands of details for an orderly production. And last but not least, my husband, Simon, served as a behind-the-scenes personal editor and coach.

Editor's Note about Japanese Names and Terms

Because the essays refer to historical and modern Japanese figures as well as Japanese Americans, this volume uses the traditional Japanese order for names—that is, with the surname followed by the given name—as well as the Western convention of placing the surname after the given name. The former system is used for Japanese historical figures and modern citizens, while the latter is reserved for Japanese Americans, starting from the first generation, or Issei, on. Likewise, diacritics are used for Japanese words and names in a Japanese context but not in an American one.

T. June Li
Curator of Liu Fang Yuan, the Chinese Garden at the Huntington

Editor's Preface and Acknowledgments

In the early twentieth century, Henry E. Huntington built a fashionable Japanese garden, complete with ponds, a house, and other structures, on his recently acquired ranch estate. That garden eventually became the southern neighbor of Liu Fang Yuan, the Garden of Flowing Fragrance, constructed a short distance up-canyon almost a hundred years later. Today, the two gardens form a cultural zone that integrates yet distinguishes the art, literature, and botanical traditions of Japan and China. This unique occurrence helps us appreciate two great civilizations that are keenly aware of nature's ways and equally adept at cultivating their artistic visions in gardens. Understanding their similarities clarifies their differences.

While preparing for the Japanese Garden's centennial, James Folsom encouraged the Huntington to publish a book that would serve as a companion to the one on the Chinese garden, *Another World Lies Beyond: Creating Liu Fang Yuan, the Huntington's Chinese Garden* (2009). As it turns out, the present volume has become the heftier of the two. It not only recounts more than a hundred years of history but also records significant milestones, including the restoration of the 110-year-old Japanese House, which sets a gold standard for the care of all crafted garden structures at the Huntington. Seifu-an, the ceremonial teahouse generously donated by the Pasadena Buddhist Temple, and its newly created garden provide a model for future expansions.

Five authors—Folsom, Kendall H. Brown, Robert Hori, Kelly Sutherlin McLeod, and Naomi Hirahara—have contributed to this volume, enlightening us with observations and information gathered from letters, newspapers, and discussions as well as from painstaking archaeological work on the house, landscape, and ponds during the restoration. The authors debunk myths and clarify misunderstandings, uncovering facts that have been unintentionally overlooked for many years.

The book is organized into two parts. The first, "History and Culture," provides a historical overview of the Japanese Garden from 1912 to 1927, the year of Henry E.

Huntington's death. Folsom, only the third person to serve as director of the Botanical Gardens, begins by recounting the decisions that affected the evolution of the Japanese Garden; he also highlights the practices of bonsai and ikebana and the embrace of cultural arts associated with gardens. Kendall H. Brown, whose academic research centers on Japanese gardens in America, provides a diverse history of gardens in Japan, setting the context for understanding the Japanese Garden. In his second essay, Brown describes the creation of the garden and its part in transforming an agricultural property into an elegant Gilded Age estate. Following this, Robert Hori, a dedicated practitioner of the tea ceremony, discusses the history and ritual of tea in Japan. He tells the story of the teahouse Seifu-an, and how it came to the Huntington as a means to share the ideals of tea in Japanese culture. Finally, in the last essay of the section, Naomi Hirahara, an author with great personal interest in the Japanese American community in Southern California, recounts the significant contributions of Japanese Americans to the building and care of the Huntingtons' Japanese Garden in the early twentieth century.

The second part of the book, "Living History," focuses on the garden from 1927 to the present. Folsom relates the history of the garden after Huntington's death and describes its near-disintegration after World War II. He tells how the Japanese Garden's timely rescue through community and volunteer efforts gave it a second lease on life, and how over the next half-century, it evolved into a beloved icon. In the next essay, noted preservation architect Kelly Sutherlin McLeod provides a thoughtful account of the preservation and restoration of the Japanese House. She describes the team's rumination on how to restore the house to the highest of standards, so that it would be true to the past, but functional for the future. Folsom concludes by highlighting particular plants in the Japanese Garden. He illustrates how Japan compares to the mainland—China and Inner Asia—in terms of geography and climate. He notes some of the many "refugee" plants from the continent that thrive in Japan but

The Gift of Seifu-an

It gives me immense pleasure to be connected, through a set of very amazing circumstances, with the Japanese Garden at the Huntington. The fact that those circumstances came together and took shape in the form of the newly installed Seifu-an teahouse and surrounding tea garden just in time for the grand 100th anniversary of the Japanese Garden also makes me feel fortunate indeed. This would never have come to pass, were it not for the decision of the Pasadena Buddhist Temple to part with its prized teahouse, Seifu-an, so that this fine example of an authentic teahouse could be ensured a bright future at the Huntington.

My connection with Seifu-an dates to the time of its conception, when the idea for a teahouse at the Pasadena Buddhist Temple was still an abstract vision. It was the early 1960s, and I was on another of my visits to America to encourage interest in the traditional cultural practice of Japan called *chado*, the "way of tea." My house and family, the Urasenke of Kyoto, had in Japan been responsible for passing forward this important, multifaceted tradition for three and a half centuries, and my dream was to have people worldwide learn of the beauty and peaceful spirit of *chado*.

From vision to clear design on the drafting board of my youngest brother, under my supervision, and then the actual preparing and test construction of the materials in the workshop of master teahouse architect Sotoji Nakamura, Seifu-an, or Arbor of the Pure Breeze—given this name by my father, the fourteenth Urasenke Grand Master—took concrete shape. The materials reached Pasadena, and the teahouse was raised. My father did not live to see it with his own eyes, but I, having become the fifteenth Urasenke Grand Master, was there for the official opening ceremony in 1965.

The amazing circumstances began in 2008, when I received a letter from Director James Folsom of the Huntington Botanical Gardens. Plans were being developed for the revitalization of the Japanese Garden, and the question was, how could a traditional tea garden and teahouse be incorporated?

I happily introduced Takuhiro Yamada, the top tea garden designer in Kyoto, and Yoshiaki Nakamura, the top teahouse architect. The two went to survey the site and found that there was a fine area for a tea garden and teahouse. They took a side trip to view Seifu-an, which was quietly tucked away in a little back tea garden space at the Pasadena Buddhist Temple. Though in need of some renovation, it was a gem of a teahouse, and indeed it was the work of Yoshiaki Nakamura's late father, the esteemed Sotoji Nakamura. It virtually begged to be included in the revitalization project at the Huntington. So, it did come to pass that Seifu-an has come to life again, this time as the centerpiece of the splendid new tea garden in the Huntington's Japanese Garden.

Together with the major restoration work on the Japanese Garden overall, the Huntington can be proud to have one of the best examples of an ideal *chado* setting to be found in the world. In putting pen to paper to convey my congratulations on the 100th anniversary of the Japanese Garden, and my congratulations on this wonderful new addition to it, I also wish to express my intense hope that Seifu-an will see many, many good years at its new home, giving many people the chance to experience, practice, and enjoy the "way of tea" in a beautiful, authentic setting.

Genshitsu Sen, Ph.D. (Soshitsu Sen XV)

Former Grand Master, Urasenke Chado Tradition

History and Culture

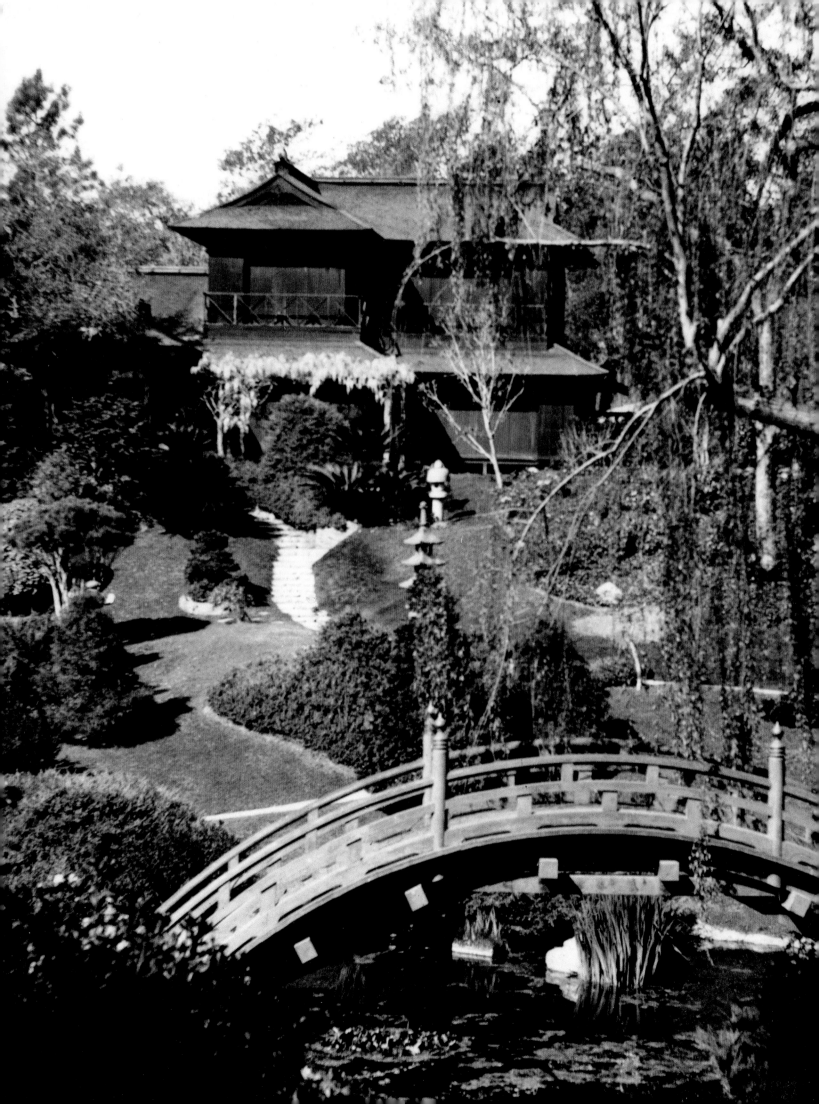

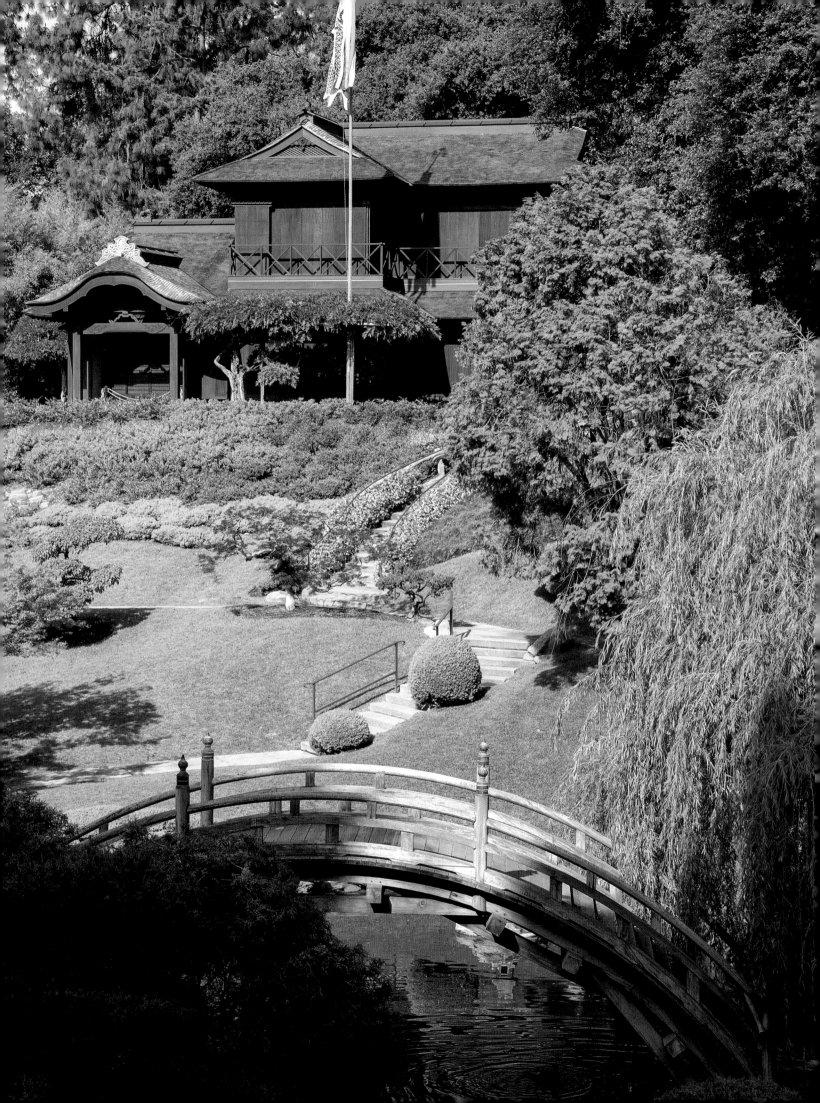

A Garden of Culture

JAMES FOLSOM

By any measure, the Japanese Garden is the most popular destination in the Huntington's Botanical Gardens, its iconic collection of plants and objects defining 9 acres deeply embedded in the 207-acre estate. The garden draws visitors past exhibition halls, galleries, and flowerbeds to the far reaches of the grounds, where entry to this alluring, exotic landscape is ample reward.

Its story begins before 1912, the year Henry E. Huntington and his ranch foreman, William Hertrich, decided when, where, and how to build the garden. It reaches into an unclaimed future, where possibilities abound. Though it is situated within the acreage of San Marino Ranch, its connections stretch across an ocean and throughout the United States.

The Huntington's Japanese Garden is one of the oldest public Japanese gardens in North America. Huntington relocated it from nearby Pasadena to his estate in a matter of months, complete with the Japanese House, the garden's plants and ornaments, and even its caretakers. Since then, it has been one of the most visited Japanese gardens on the continent, having received at least 12 million visitors through the years. But this landscape is something of a relic, considering the many other Japanese gardens that vanished long ago.

To account for the garden's perennial popularity, one might consider its charm, age, style, and culture. But the appeal is based on more than appearances; visitors understand this to be a garden of ongoing creative endeavor, layered and meaningful, reflecting several generations' worth of work and thought.

 Few North American Japanese gardens have involved the efforts of such a long chain of leadership. More than seven curators and thirty long-term gardeners have cared for it over its ten decades. Volunteers, too, have made vital contributions. In 1957, one of the Huntington's first volunteer groups, the San Marino League, led the drive to reopen the Japanese House, which had been closed to the public from World War II on. For more than fifty years, this self-sustaining

Bamboo walk in the Japanese Garden.

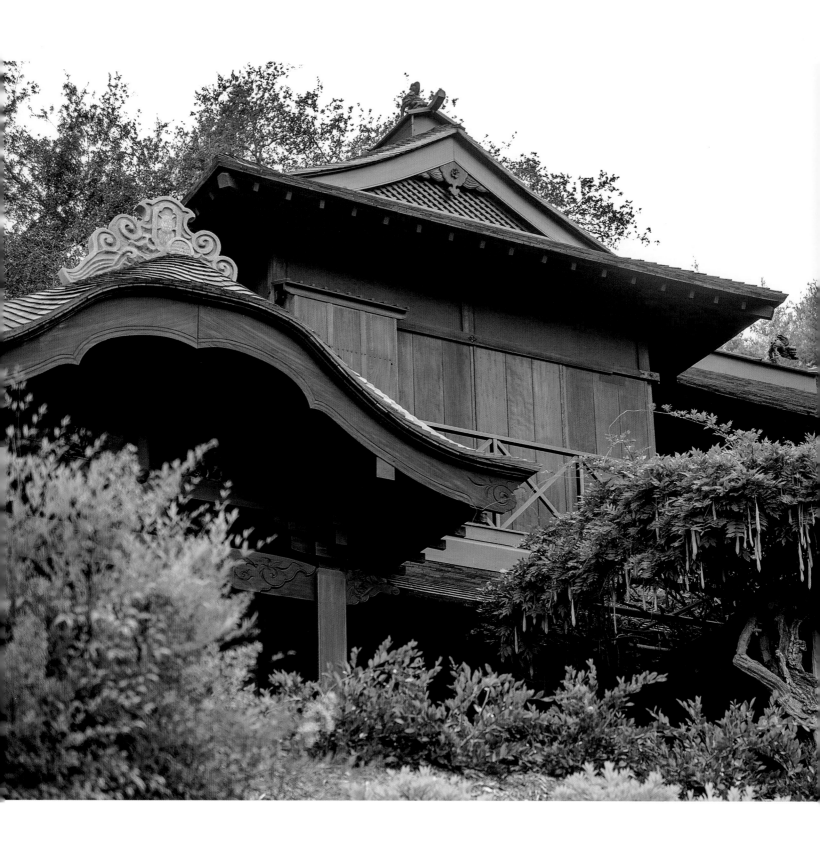

The Japanese House was relocated from Pasadena to the San Marino Ranch in a matter of months.

group has increased public involvement in the garden by giving tours to schoolchildren, teaching and exhibiting ikebana, and underwriting a variety of garden programs and improvements.

In 1993, California's Golden State Bonsai Federation adopted the Japanese Garden as the home for its GSBF Collection at the Huntington, bringing its clubs and volunteers together to expand the bonsai display begun there in 1968 and organizing annual events that attract and educate thousands of participants. Partnerships such as these maintain a strong base as other collaborations evolve, providing new potential for today's garden.

New developments are crucial because context and opportunity change constantly. The Southern California of today is very different from the region Huntington helped develop in the early years of the twentieth century. The population of California, which was 2.5 million in 1912, now stands at 37 million, with entirely different demographics. A fresh vision for the Japanese Garden is required.

Over the past few years, several teams of people who share a direct interest in the future of the Japanese Garden have met to solidify their appreciation of its historical nature and importance, and to envision how this garden and its many programs and elements can remain vital to Southern California audiences. The core garden is a time capsule connecting visitors directly to early Pasadena and to the Huntington estate. Astonishingly, even with thousands of changes in plants and structural detail over the past century, most of the garden's original "fabric" remains—the house, the stonework, even many of the mature plants that were present when the garden was first completed—making the central sector of the garden essentially the same landscape that was there during Huntington's lifetime.

The garden's history may be divided into three distinct eras: its creation for a private estate (1912–27), its opening to the public and then quiet deterioration (1928–56), and its flowering as a showcase of Japanese culture and arts (1957–present). After taking on a more active role in 1957, the garden experienced real growth with the addition of the Zen and Bonsai Courts in 1968, followed by the construction of the Ikebana House in 1973, all of which supported growth in programs related to Japanese garden arts. Ikebana was, very early on, a strong element through the work of San Marino League members, but emphasis on the art of bonsai developed only after the forging of a relationship with the local bonsai community in the early 1990s and the establishment of a formal relationship with the Golden State Bonsai Federation, mentioned above. Now, after a century of development, the garden has grown again, with the addition of a beautiful teahouse, Seifu-an, which was given to the Huntington by the Pasadena Buddhist Temple.

These developments that combine collaboration and core resources make the Huntington uniquely capable to introduce historically important Japanese garden arts—gardening and pruning, garden construction, bonsai, stone appreciation and placement, ikebana, and *chaji*, the formal tea ceremony—to the broader community of Southern California. In this way, the Japanese Garden not only reflects the historical significance of Japanese garden arts but also

promotes the skills and values relevant to practicing those arts today. This is timely recognition of a challenge that exists in Japan and elsewhere—addressing how a society preserves the most essential, useful, and meaningful aspects of its cultural arts and crafts.

In the context of the Japanese Garden, the process and outcomes are not as clear as the challenges. But the sense of precariousness is obvious and irrefutable: If this landscape is not used to help people learn and practice its inherent arts and crafts, then the garden cannot be preserved. Indeed, the Japanese Garden merits preservation and improvement, having served as the Huntington's most iconic and beloved landscape for a century, with no indication that that status will diminish. Building on its own success, and using the simple power of place and the magic of personal experience for visitors, the garden can create memories and inspire future generations of Southern Californians to learn more about Japanese history and culture, and, in a larger sense, nature and human industry. The Huntington's vision for this garden, therefore, calls for restoring and amplifying the site itself, while learning more fully and passing down more actively the crafts required for its perpetuation.

Physically, the core Huntington stroll garden has been restored to preserve as much of its original character as possible. At its heart is the Japanese House, showcasing ikebana and reflecting more than a century of America's fascination with the traditional Japanese lifestyle. The Zen and Bonsai Courts present the garden arts of pruning and stone appreciation and display, and they have become a workshop for promoting these arts. Seifu-an and its surrounding tea garden bring new opportunities and obligations to explain and advance the appreciation of tea culture and its influence on the evolution of Japanese life and arts.

Future additions to the Japanese Garden will align with these goals. To the west of the ceremonial tea garden will be a new stroll garden designed to reflect the finest and most traditional aspects of classical Japanese garden-building. Adjacent to that new area, an expansion of the Ikebana House will better support teaching and interpretation of the garden arts, as well as care of the Huntington's many related collections, such as tea implements, viewing stones, bonsai pots and tools, ikebana vases, and ceremonial objects. Finally, to the north, a beautiful passageway garden will connect the Japanese and Chinese gardens.

As the Japanese Garden enters a second century, the time is right to document and publish its story, and to explain how that story relates to broader issues in the region and in public institutions around the world. Actions of the past, present, and future embody the life of the garden, a life that responds to the place, the plants, the times, and the people who inhabit it. The sources and logic, the challenges and potential of those actions are recorded in this volume, not only in celebration of a centennial, but also in an audacious attempt to understand the value and meaning of this garden, now and in the future.

Color in the Japanese Garden.

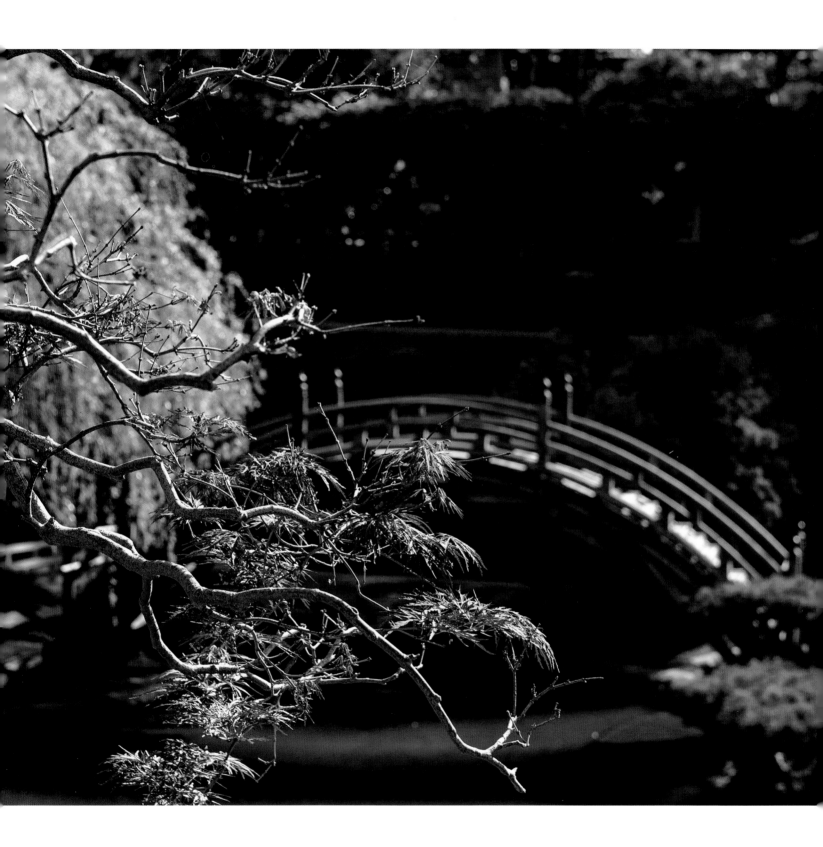

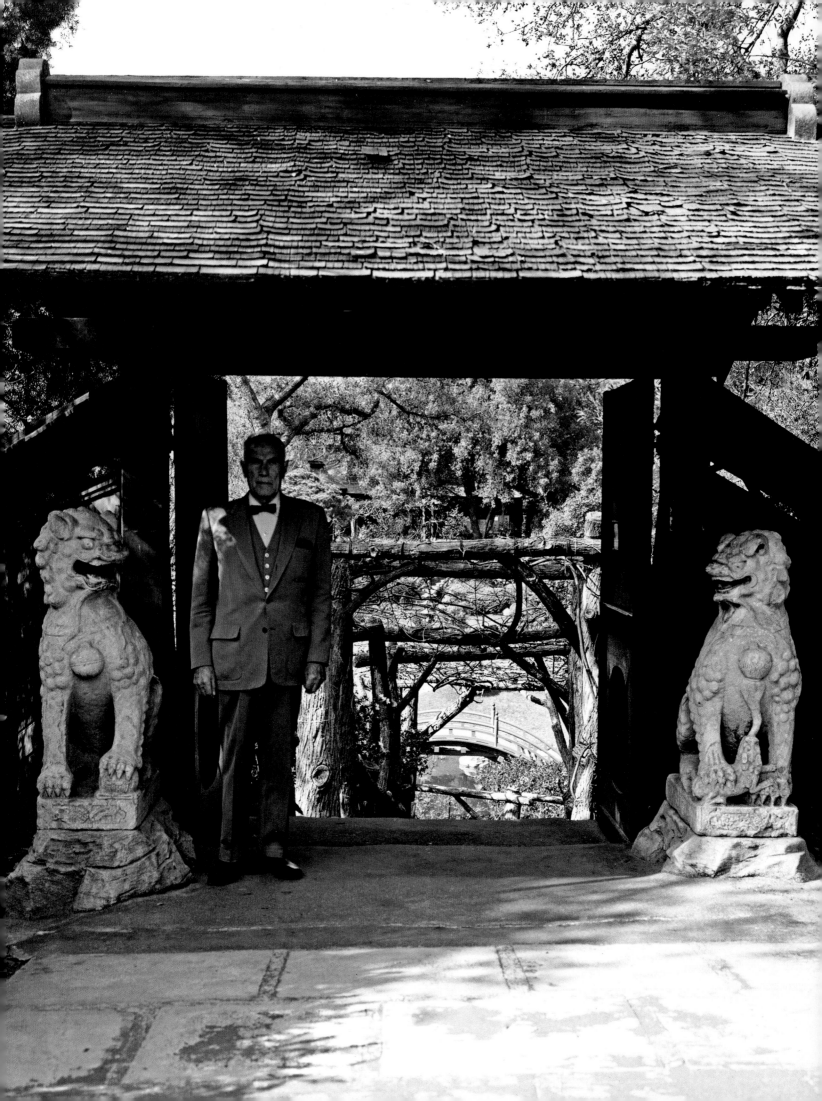

Traditions of Transformation:
Gardens in Japan before 1868

KENDALL H. BROWN

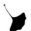

For most people, the term "Japanese garden" likely evokes the simple image of a natural-looking pond, flanked by stone lanterns and crossed via an arched bridge. Yet, the reality of Japanese gardens is far more complex. Common design types include the plant-free "dry landscape" as well as gardens built around rich collections of carefully pruned trees and water features. Japanese gardens are also complex conceptually; some carefully adapt to their natural topography, and others are artificially crafted to evoke distant places and eras. They are not only self-conscious displays of cultural refinement but also spaces where culture is actively practiced. Gardens are markers of social status and they are, potentially, places for personal transformation. Finally, many of the most famous gardens in Japan are not static monuments of the past but have evolved from intimate private spaces to popular tourist sites. This wide variety of functions and social implications of gardens in Japan roughly parallels those of the Japanese-style gardens created over the past century at the Huntington.

Despite this complex, three-dimensional view of gardens in Japan and Japanese-style gardens around the world—one that links horticulture, aesthetics, and social function—these gardens have sometimes been reduced to one-dimensional stereotypes. For Japanese gardens outside Japan, this essentializing impulse is expressed in terms of so-called authenticity. The goal is to find certain formal elements in these gardens that link directly to gardens in Japan, in order to establish obvious connections and a nonproblematic "Japanese" identity for the garden. The result can be a self-imposed blindness to the range of differences in gardens and their often-purposeful adaptations in form, as well as subtle but important incongruities in meaning and function. Likewise, there is a notion that the diverse history of gardens in Japan can be boiled down to a set of basic characteristics. This leads to broad exaggeration, intense reductionism, and imagined absolutes, while ignoring complex realities. Both of these approaches are shortcuts to understanding. They

Arched bridge in the
Japanese Garden.

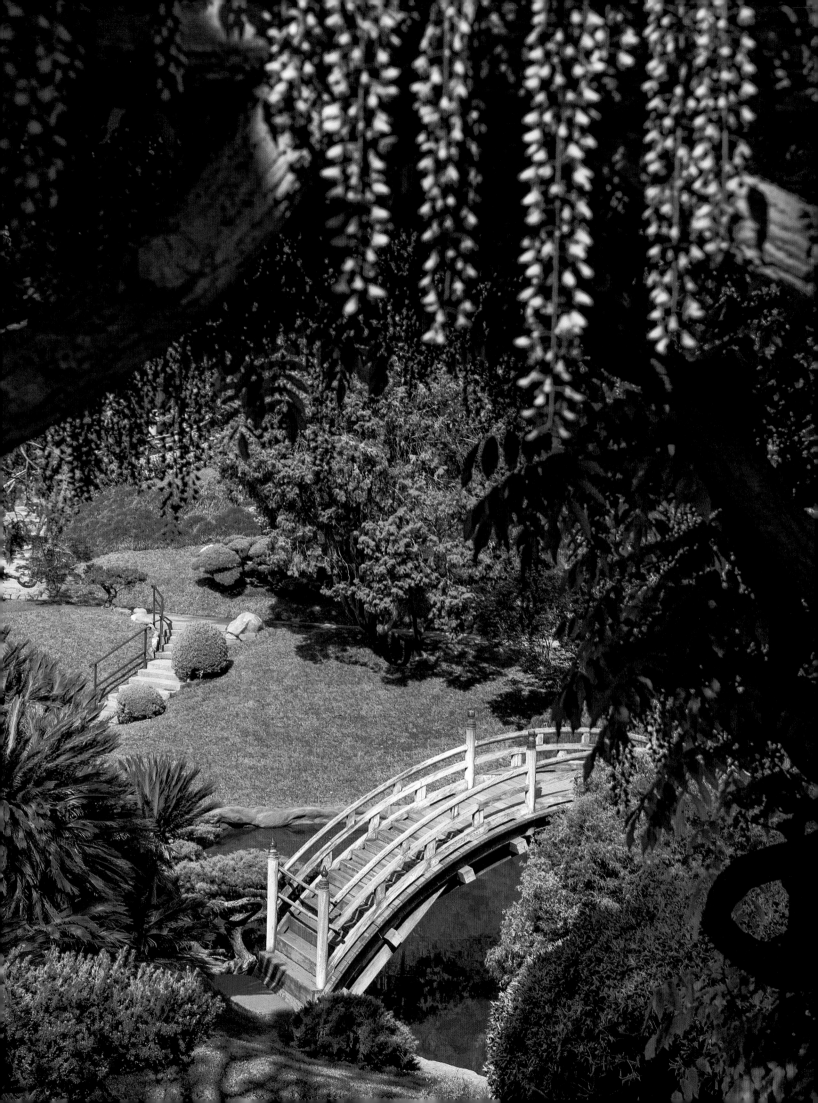

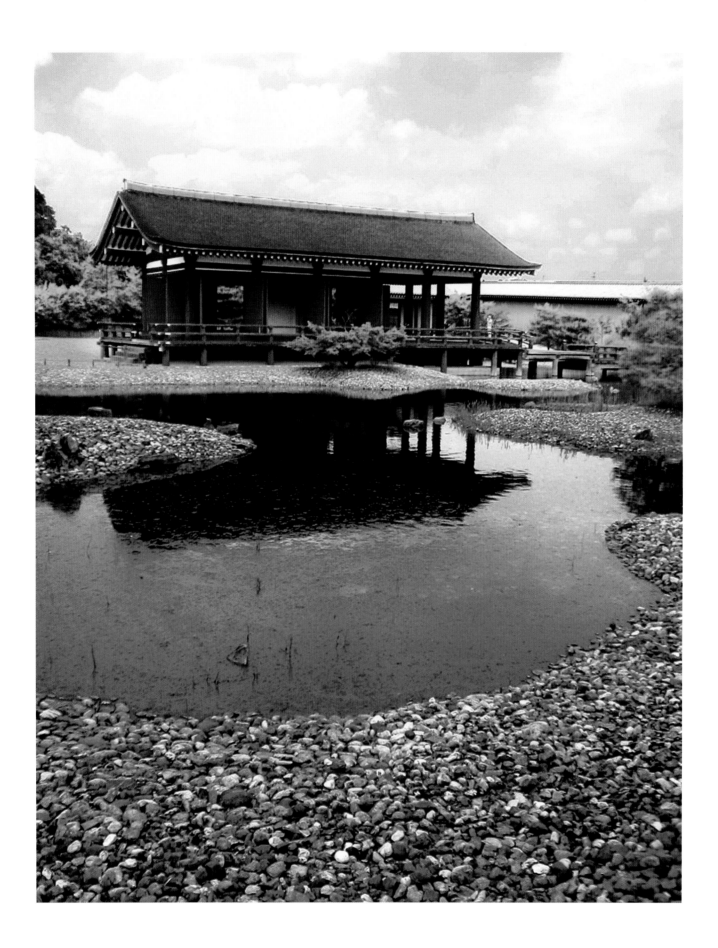

erase important differences in the styles and uses of actual gardens in pursuit of an ostensibly larger truth.

The suite of Japanese gardens at the Huntington—the stream-and-pond garden, the dry garden, and the tea garden—points to and borrows from the rich tapestry of gardens in Japan. Thus, it is useful to sketch a history of gardens in Japan that focuses on styles, uses, and concepts that correspond to the gardens at the Huntington. The following capsule account is by no means a substitute for the excellent chronicles that exist in English.[1] Rather, it is intended to demonstrate that ideas about "the essence of the Japanese garden" are products of modern minds rather than of gardens in the ground. Notions of authenticity have, at best, only very limited value as insight, however useful they may be as rhetorical strategies. Indeed, the history of gardens in Japan reveals a wealth of approaches to style and meaning, each calibrated to specific physical, social, and ideological functions. What has made gardens in Japan such compelling objects of enjoyment and adaptation around the world is not so much a unique core of values as a tradition of transformation.

Left: Eastern Pavilion Garden, Heijō Palace, Nara. Restoration and recreation of original from the mid-eighth century.

Below: Drawing of a Heian-period villa garden. Drawing by Marc P. Keane (from Keane, *Japanese Garden Design*, p. 33). Courtesy of Marc P. Keane.

Pond Gardens of the Nara (710–794) and Heian (794–1185) Periods

Though the earliest history of gardens in Japan still awaits archaeological research, recent excavations at the imperial capital at Nara show that by the eighth century, gardens created for aristocrats were already large in scale and sophisticated in form.[2] Built adjacent to pavilions (opposite), they featured meandering streams or substantial ponds, surrounded by stone beaches, and likely had a variety of plantings. As with so much else in Japanese court culture at the time, this basic form was surely derived from Chinese imperial models. Gardens evolved during the Heian period, adding features that may have evoked specific places made famous in Japanese poetry. A typical palace contained a spacious garden (left) with a pond large enough for pleasure boats. The pond was fed from the north by a stream and contained multiple islands reached by arched bridges painted vermillion. Long halls from the main residence culminated in a fishing pavilion and a pond pavilion overhanging the water.[3]

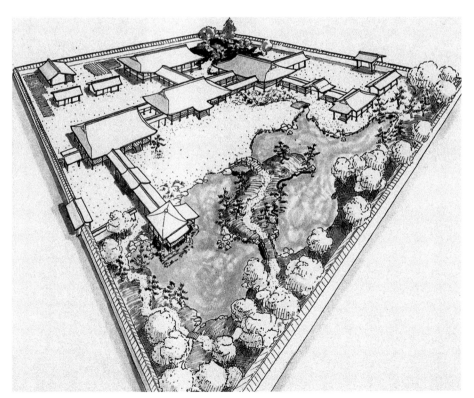

The palace gardens of the nobility also included areas of low hillocks and flat gravel court-yards, suitable for daily activities and annual rites or for such special observances as banquets, kickball matches, and archery contests, as well as New Year visits and poetry-writing events.

Gardens were sources of poetic and artistic inspiration. Their plants and other natural phenomena appear in literature and art as metaphors for emotions and, most basically, for the transience of all things. Garden-making was an appropriate pastime for the nobles, as shown in the text known popularly since the late seventeenth century as *Sakuteiki* (Notes on Making Gardens). It was called *Senzai hishō* (Secret Writing on Gardens) in the eleventh century, when it was written by Fujiwara Toshitsuna. The text considers garden creation as a specialized pursuit, requiring a proper theoretical understanding that includes sensitivity to the nuances of location, function, the appearances of nature, and even effects created in older gardens. From *Sakuteiki*, it is clear that by the eleventh century, various garden design modes—"The Ocean Style," "The Mountain Stream Style," "The Reed-Hand Style"—were available to the designer and his patron.[4]

As Heian estate gardens evolved from Nara garden forms, some were adaptively transformed from mere places of privilege to seats of the sacred. In some cases, when aristocratic villas were bequeathed to temples of the Buddhist Pure Land sect, these pleasure gardens were turned into "paradise gardens." Flowering plants and red-arched bridges were removed, and lotuses were added to the ponds, which were fronted by worship halls replete with Buddhist images. Whether at re-modeled villa gardens or newly built temple complexes, these pond gardens were manifestations of Amida Buddha's Western Paradise, where souls would be reborn in order to reach enlightenment.

Stroll Gardens of the Kamakura (1333–1392) and Muromachi (1392–1573) Periods

During the rise of the warrior class in the Kamakura and Muromachi periods, some older estates and even Pure Land gardens were retooled. Some became palaces of local feudal lords (*daimyō*) or retirement villas for military rulers (shoguns) in Kyoto. In other cases, most famously at Saihōji in Kyoto, Pure Land gardens were reworked as Buddhist Zen sect temples, with the old gardens rebuilt or re-imagined even as new gardens were added. These transformations included the creation of "scenic," or picture-like, features using dramatically placed stones in compositions based on Chinese landscape painting and gardens of the Song dynasty (960–1279).

A sterling example of physical and functional transformation is the garden at the Kitayama villa built by the powerful nobleman Saionji Kintsune (1171–1244) on the model of those of the exemplary statesman Fujiwara Michinaga (966–1027). The estate featured a vast lake fed by a magnificent forty-five-foot waterfall. There were groves of cherry trees and dramatic-looking stones, including a "spirit rock" (*reiseki*) brought to the site in 1229. The intent was to evoke the refined garden parties described by Lady Murasaki in the influential eleventh-century novel *Tale of Genji*. The grounds were used for courtly entertainment that included imperial visits with guests strolling the garden and playing music on nocturnal boat rides.

In 1394 the much-dilapidated property was purchased as a retirement villa by shogun Ashikaga Yoshimitsu (1358–1408), who spent lavishly, adapting the space to express his self-image as both military leader and ultimate aristocrat. In addition to decreasing the size of the lake, he altered many of its islands by adding new rock groups in the auspicious tortoise-crane rock formation associated with Chinese imperial gardens. Yoshimitsu also erected structures dedicated to divinities of the Pure Land and Zen sects. Accounts describe the garden as being like the land of the immortals, noting stones that represented such Chinese Daoist paradises as the Isle of Immortals and Penglai, or Hōrai in Japan. Parties in the garden featured cherry-blossom viewing, boat rides, and poetry recitations.[5] After Yoshimitsu's death, the estate was donated to the Rinzai Zen sect, becoming "Rokuonji," affecting another transformation in function, with attendant changes in the garden's appearance. In the Edo period, and even more dramatically in the twentieth century, this estate-turned-temple (below) became one of Kyoto's leading tourist attractions—the so-called Temple of the Golden Pavilion (Kinkakuji).

Rokuonji Garden, known popularly as Kinkakuji, Kyoto.

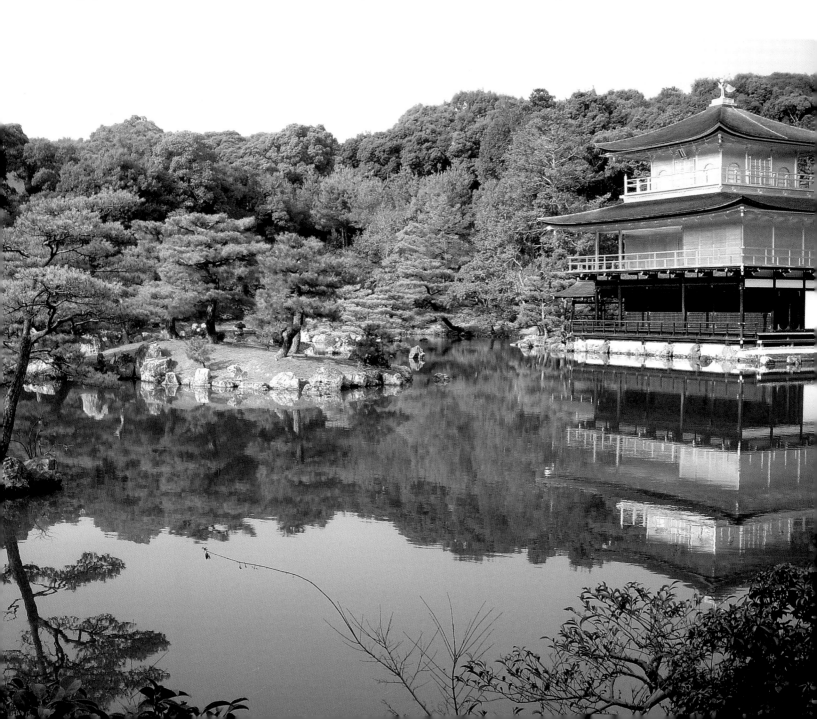

Stroll Gardens of the Edo Period (1600–1868)

In the first decades of the Edo period, competition among *daimyō*, as well as between the imperial family and the warrior class more broadly, led to the dramatic expansion of pond-style stroll gardens (*chisen kaiyūshiki*) in which views unfolded as one walked or boated through complexly layered spaces. Based on the concept of "hide and reveal," focal points were concealed, obliquely glimpsed, and then fully revealed, so that observation was always contingent on a changing point of view. Building on the complex cultural references in earlier gardens, these lavish gardens created miniature simulacra of places in China, such as Mt. Lu and West Lake (above), and in Japan, including Amanohashidate and even Mt. Fuji.[6] These places were dense with literary allusions, and recognizing these scenes and their poetic references became a requisite mark of erudition for warriors. These gardens also featured attractions that visualized poems and famous places in poetry. For instance, the almost-obligatory zigzag wooden bridge through an iris marsh (opposite) evoked Narihira, the exiled courtier, and his famous poem about longing for his beloved wife. This poem, found in the tenth-century *Tales of Ise*, plays on the word for *iris* and was written while the poet was gazing at an iris marsh with a rustic, eight-planked bridge (*yatsuhashi*).[7]

Above, left and right: Stroll gardens with literary references to Mt. Lu and West Lake.

Right: Eight-planked bridge, or *yatsuhashi*, at Koishikawa Kōrakuen, Tokyo.

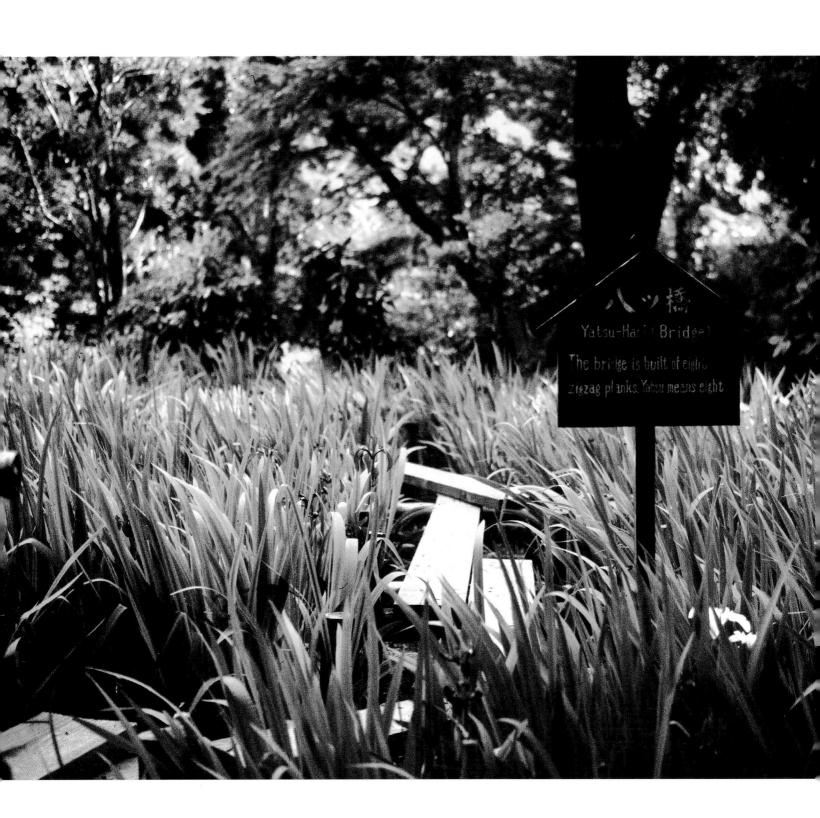

八ッ橋

Yatsu-Hasi (Bridge)

The bridge is built of eight
zigzag planks. Yatsu means eight

Elaborate stroll gardens were built by the *daimyō* in their local domains across Japan and at their estates in the capital of Edo. The size and complexity of these gardens reflected the depth of the patron's taste and his financial resources. *Daimyō* further deployed their gardens for social events, at which the patron could display, among other things, intimate knowledge of literature through the references that were built into the garden's design. For instance, Rikugien (Garden of Six [Poetic] Principles), built in the capital in 1702, includes eighty-eight poetic sites (below).[8] For all their conspicuous display, these gardens also evinced the moral propriety demanded by the Confucian values that were espoused by samurai codes. Thus, gardens had to display a devotion to agriculture, manifest in their rice paddies and plum groves. Moreover, gardens were given names, like Kōrakuen (the "Garden of Pleasure After [Duty]"), that proclaimed core Confucian values despite the overt display of wealth (opposite).

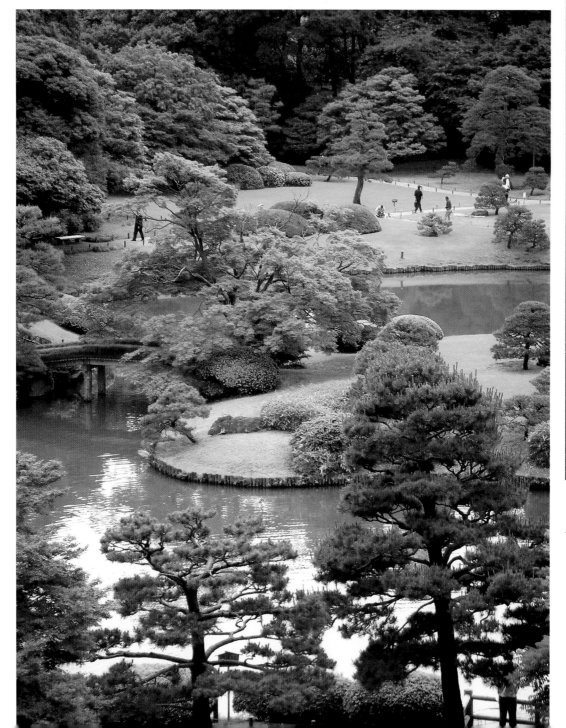

Stroll garden at Rikugien, Tokyo.

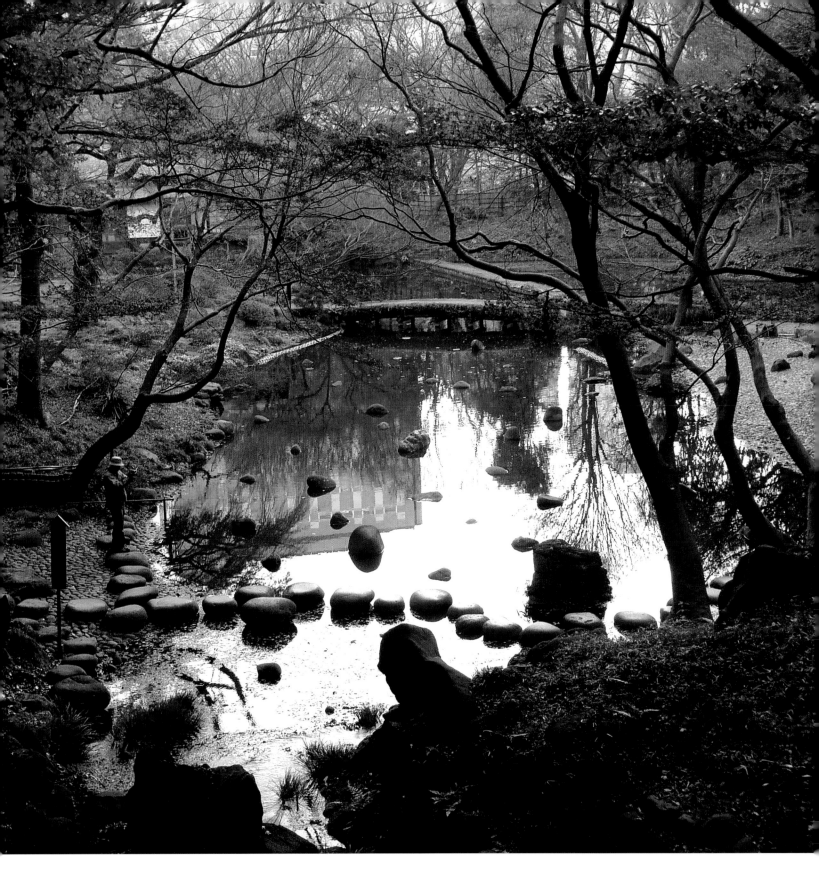

Stroll garden at Koishikawa Kōrakuen,
Tokyo.

Dry Landscape Gardens at Zen Temples

Whereas great estate gardens comprised worlds in themselves, a second lineage is the garden as microcosm, which developed from the Muromachi period. These gardens are not to be journeyed through bodily, but explored with the eyes and, perhaps in a few cases, with the mind or consciousness. Whereas estate stroll gardens sought to impress with displays of abundance, these gardens suggested their meanings through a reduction of elements. They were often overtly pictorial. With asymmetrical compositions and overlapping visual planes seen through the "frame" of architecture, these highly compressed gardens were three-dimensional adaptations of paintings. Typically they abjured real water, difficult to control in intimate spaces before the invention of hydraulic pumps, replacing it with raked gravel symbolic of water (below). In most cases, these "dry landscapes" (*kare sansui*) were created in the small courtyards of residential subtemples of the Zen sect, emphasizing the theme of escape into nature and a subdued visual or poetic style.

Within temple courtyard gardens, a second tradition, represented by the stone garden at the sixteenth-century Kyoto temple Ryōanji, denied the orthodox traditions of pictorial symbolism in favor of abstraction. This extreme approach seemed to contest the idea that a stone might represent a mountain, or raked gravel a stream. Like a visual *kōan*, or conundrum, it challenged the viewer's ability to understand it using the senses and the rational mind. Although this garden at Ryōanji and others like it were termed "Zen gardens" in the mid-twentieth century, there is little historical evidence to link them with Zen practices, other than perhaps the total concentration, or "mindfulness," required to rake them properly.[9]

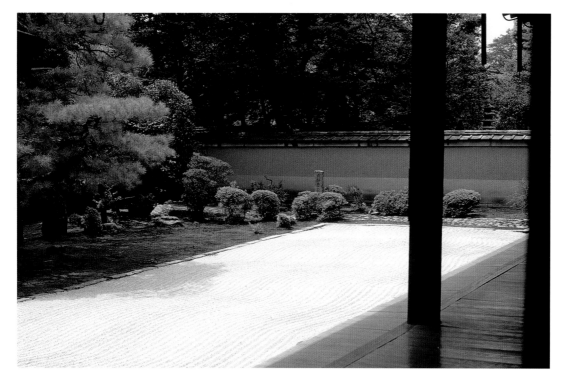

Daitokuji Hōjō Honbō, Kyoto.

Drawing of a tea garden. Drawing by Marc P. Keane (from Keane, *Japanese Garden Design*, p. 79). Courtesy of Marc P. Keane.

Tea Gardens, Residential Gardens, and the Expression of Taste

Garden-making increased dramatically during the Edo period. Political stability encouraged the rise of the merchant class and the cultural interests of warrior bureaucrats, bringing new patrons, fresh functions, and original ideas to landscape design. Most critical was the so-called tea ceremony (*chanoyu*) or tea gathering (*chakai*), which crystallized the ideal of the hermit—one devoted to the pure exploration of art and nature. These intimate tea gatherings were held in elegantly rustic environments. The tea garden, sometimes called *rōji* (dewy path), served as the literal preamble to, and mood-setter for, the tea gathering in the tearoom. The tea garden was intimate in scale, subdued in color, and full of elements that symbolized escape into the purifying embrace of nature. Temple lanterns and other stone sculptures added a Buddhist aura and patina of the past to tea gardens. Tea masters codified and commodified various styles of lanterns, water basins, fences, and even stepping-stone arrangements, in keeping with the artistic forms of various schools and masters. As a result, patrons of all types of gardens became increasingly conscious of the ways in which the style of a garden might signal a type of aesthetic refinement.[10]

This rich taxonomy of garden ornaments and styles, and levels of formality within tea gardens, spurred a proliferation of gardens in both sacred and secular environments, from temples to homes and restaurants. Often mixing elements from tea gardens, courtyard gardens, and stroll

MODERN GARDENS IN JAPAN

In the popular imagination, Japanese gardens are associated with ancient temples. In reality, gardens encompass a variety of forms, functions, and contexts. Over the past 120 years, Japanese gardens have accommodated aspects of Western landscape design and even incorporated ideas from foreign Japanese gardens. Modern gardens share a keen awareness of innovation within "tradition," and of "Japanese identity."

From the last decades of the nineteenth century, Japanese garden designers and patrons faced the choice between a Western-style garden and a Japanese garden (*Nihon teien*). For the latter, changes in taste and technology wrought dramatic growth. Hydraulic pumps meant that water gardens could be built anywhere, and this created a taste for dramatic waterfalls. Wealthy patrons favored massive rock arrangements and colossal lanterns. In Kyoto, the garden designer Ueji (Ogawa Jihei VII [1860–1933]) pioneered a style using ferns and azaleas around stones, and even turf. In addition, the first public "Japanese gardens" were built within Western-style parks, some of them adapting elements from Western parks.

The suite of gardens at Kyoto's commemorative Heian Shrine, built from 1896 by Ueji, began the creation of gardens in historical styles. Gardens and pavilions created by the government for world's fairs continued in this vein. This retrospective orientation affected gardens in Japan and abroad after World War II. From 1954 to 1960, Kinsaku Nakane (1917–1995) created Heian, medieval, and modern gardens at Jonangu in southern Kyoto. More recent civic gardens, exemplified by Momijiyama Garden in Shizuoka (below), are inspired by Japanese gardens in America. They include paths that accommodate wheelchairs, as well as ponds flanked by such stereotypical features as zigzag bridges, teahouses, and cherry tree groves.

From the 1960s, many Japanese garden designers have worked abroad, and foreign garden builders have studied in Japan. The result is a universal culture of modern Japanese gardens as a transnational phenomenon.

KENDALL H. BROWN

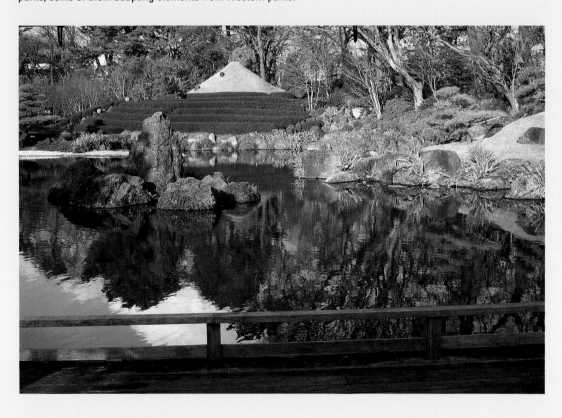

Momijiyama Garden, Sunpu Park, Shizuoka, Japan.

gardens, this array of new hybrid forms indicates the spread of garden-building and garden enjoyment among a far broader social spectrum. By the eighteenth century, a sizeable number of professional garden designers plied their trade, and illustrated books explained various types of gardens, presenting famous gardens and espousing garden theories new and old. *Tsukiyama teizōden* (1735), the most famous of these texts, forms the backbone of Josiah Conder's famous book, *Landscape Gardening in Japan* (1893), which served as the template for many Japanese gardens in America and England.[11]

Postscript

Today, while some gardens in Japan comprise little more than a few square feet, with a single plant and a water basin, others spread over many acres and contain priceless collections of architecture, stone ornaments, and plants. There are gardens devoted to a single plant—focusing on a plum grove or iris marsh—and others that feature only stones and gravel. Some garden designers seek to connect with the past, while others look to innovate. Styles of garden building—and of pruning—differ not just according to function and philosophy but also by region, with significant climatic variations that make the styles of Kyoto and Edo (Tokyo) impractical in the deep south or far north.

The diverse styles and meanings of gardens in Japan have continued to evolve from the Meiji period (1868–1912) to the present. As the Japanese adapted elements of Western culture at a frenetic pace, they also looked to their own past as a kind of storehouse—sometimes familiar, sometimes exotic—with elements to be used in time-honored fashion or imaginative ways. The resulting gardens often served not merely as artistic expression but also as part of the creation of modern identity, whether for domestic or foreign consumption, as "the Japanese garden" became an emblem of Japanese culture and a popular national export. The basic approach of most modern garden designers—the desire to innovate within "tradition"—may have stressed change to degrees unknown for most of Japan's history, but the basic creative ethos was not different in kind. Generations of garden builders sought to transform incrementally the accomplishments of those who had gone before. As even a cursory summary amply demonstrates, the heritage of Japanese gardens is one of dynamism, in which landscape design, like nature itself, always finds a way to adapt to changing circumstance.

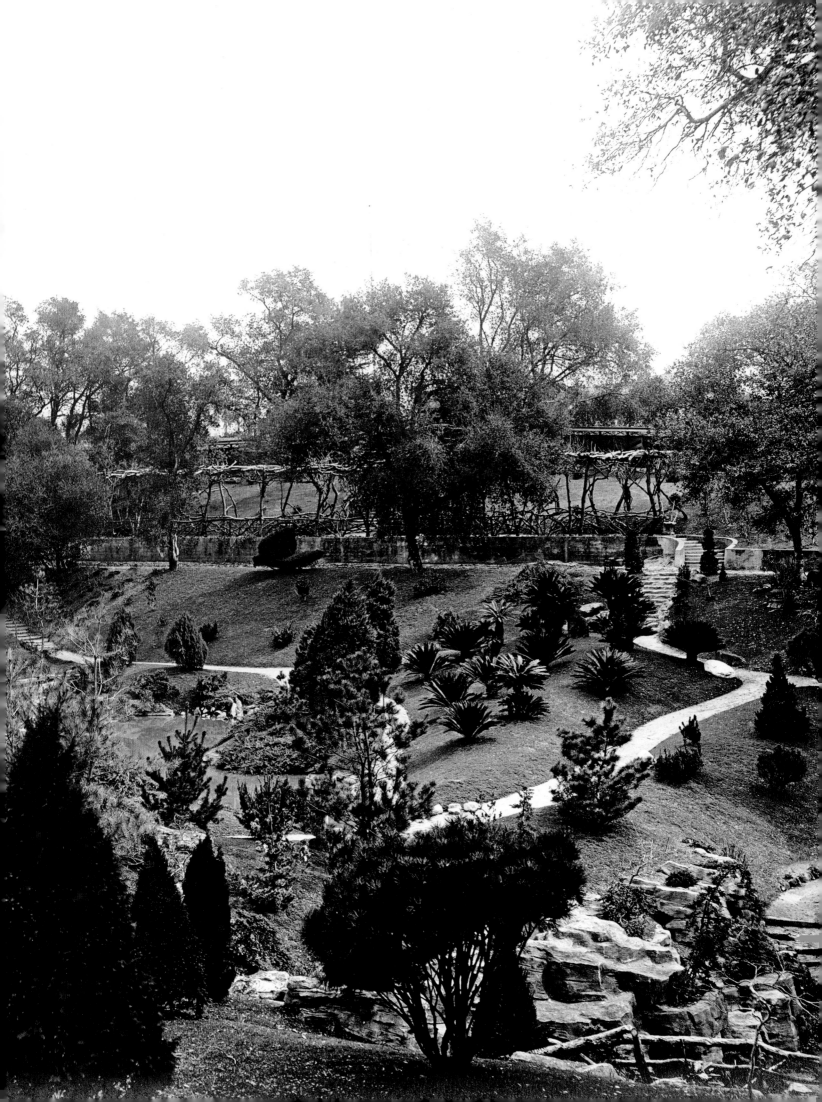

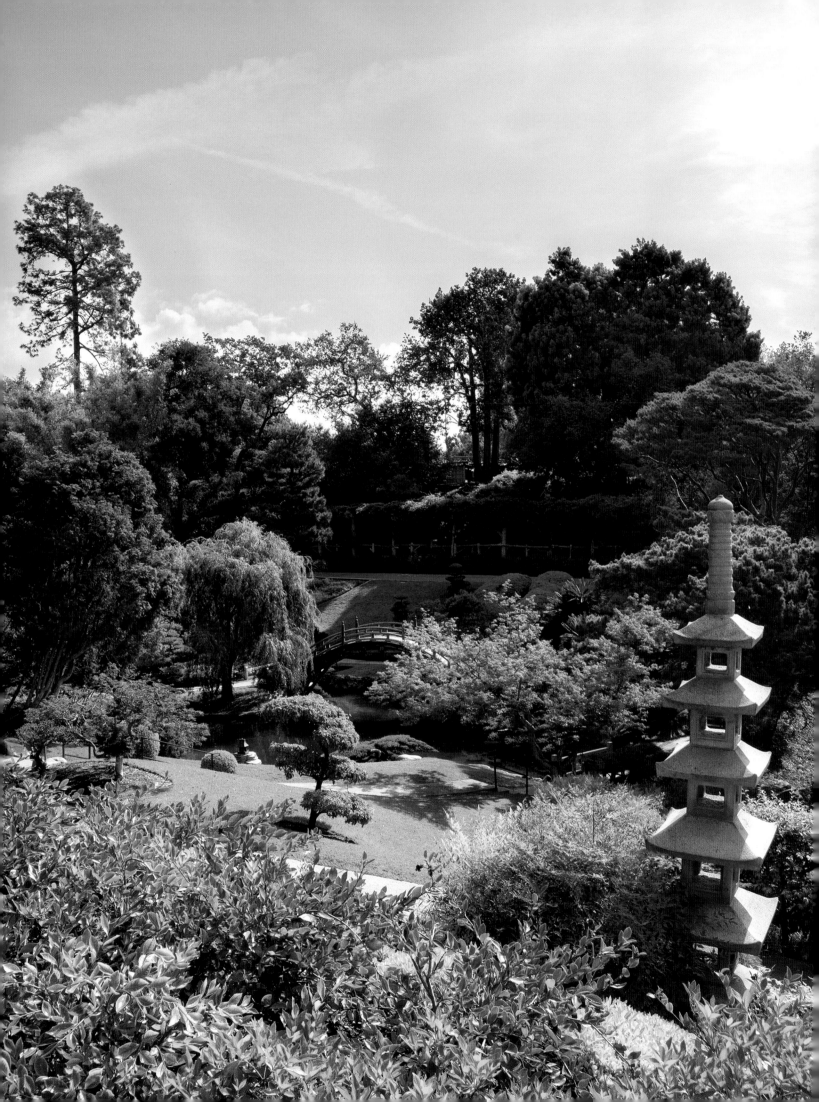

From Ranch to Estate:
A Japanese Garden Comes to San Marino

KENDALL H. BROWN

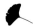

In terms of form and function, the Huntington's Japanese Garden embodies three basic Japanese garden types: the pond-and-stream garden (1912), the dry garden (1968), and the tea garden (2012). Taken as a whole, this triad reveals the ways in which the approach toward Japanese-style gardens in North America changed throughout the twentieth century. Pond gardens with multiple buildings were constructed in large numbers after 1900, during the first wave of enthusiasm for Japanese gardens. Reductive stone gardens appeared in the 1960s when Japanese garden aesthetics and styles were rediscovered to fit modern (and Modernist) values. Finally, over the past fifty years, teahouses (*chashitsu*) and tea gardens have been created largely through the international outreach of the Urasenke school of *chanoyu* (tea ceremony). The Huntington's Japanese Garden is unique in that it provides a living link to several formative stages of Japanese gardens in North America.

This essay details the first iteration of the Japanese Garden—the pond-and-stream garden and the Japanese House—at the Huntingtons' lavish private estate. The garden's "arrival" helped to transform the land from an agricultural property, known as the "Ranch," to an elegant "country place," where collections of art, books, and plants attested to the wealth and eminence of the patrons. In contrast to other horticultural displays at the estate, the Japanese Garden brought with it associations of cultural sophistication, fervently desired by those Americans whose social status was attained on the basis of wealth rather than birth or knowledge. In early twentieth-century America, broad awareness of—and fascination with—Japanese gardens initially stemmed from the gardens built by the Japanese government at world's fairs; it then took root in the national cultural landscape when the "Japanese tea garden" became a mark of refinement for many cities.

Not surprisingly, Japanese gardens became fashionable emblems for many American estates in this period, sometimes called the "country home" era. The initial Japanese Garden at the Huntington amply demonstrates this development and, presumably, function. It was in large part relocated from a nearby commercial Japanese garden, which was in turn created by an entrepreneur who had built a formative world's fair garden. The first Japanese garden at the Huntington thus points to the rich social history of Japanese landscape design in America and suggests another dimension to the "culture collecting" of the Huntingtons.

World's Fair Gardens and Japanese Tea Gardens

The first Japanese garden in America comprised a modest display of bonsai, other plants, and such ornaments as stone lanterns and bronze cranes, laid out by Chinsayemon Miyagi behind the Japanese Bazaar at the Centennial Exposition in Philadelphia in 1876.[1] More impressive Japanese gardens, constructed by the Japanese government as settings for buildings evoking historical styles, became a feature of world's fairs beginning in the 1890s. And with St. Louis's Louisiana Purchase Exposition of 1904 (below) and San Francisco's Panama–Pacific International Exposition of 1915, impressive multiacre Japanese gardens became among the most popular displays at most fairs.[2] In some cases, well-to-do fair goers were so impressed that they commissioned Japanese gardens for their estates. For instance, in 1904 Adelaide Tichenor insisted that Charles Greene, then at work with his brother Henry on designing her house in Long Beach, California, visit the "Imperial Japanese Garden" in St. Louis and incorporate features of the pavilions and surrounding landscape into her house and garden. The resulting Japanese elements appeared in much of the Greene brothers' work in Southern California. It is not known whether Arabella or Henry E. Huntington visited the Japanese gardens at any of these expositions, but they were both living in San Francisco at the time of the city's Midwinter Exposition of 1894. Surely they would have read the effusive reports of this and other exposition gardens in newspapers and magazines.

"The Sunken Garden" at St. Louis's Louisiana Purchase Exposition, 1904.

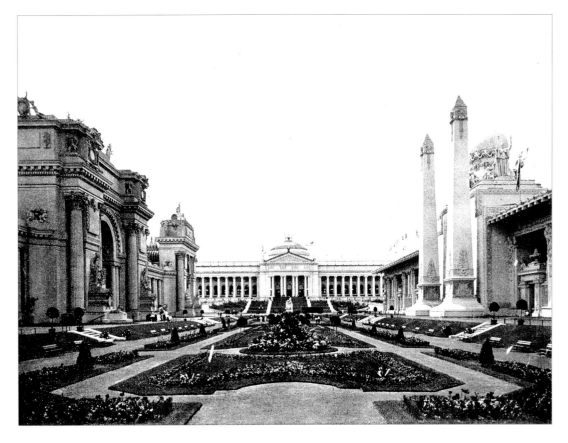

The large fair gardens introduced many features of Japanese gardens and architecture to the American public. As a result, one no longer had to journey to Japan to marvel at the intricacies of Japanese craftsmanship or be astounded at "miniature landscapes" that captured the power of nature. Moreover, the world's fair gardens distilled the most congenial features of Japanese culture—gaily clad "geisha girls," tempting foods and drinks, arts and crafts, and even spiritual exotica—into a single space that provided visual complexity within an order seemingly sanctioned by both nature and history. As part of a greater vogue for Japan in the late nineteenth and early twentieth centuries, these gardens demonstrated how Japanese things could be successfully transplanted to the United States. Most basically, the gardens were responsible for bringing Japanese buildings, horticultural specimens, garden ornaments, and even artisans to America in large numbers.

With the end of each fair, the Japanese garden's constituent parts—structures, lanterns, and plants—would be relocated to other public or private gardens. As a result, the fair gardens did not merely stimulate a desire for Japanese gardens; they literally furnished many of them. For instance, after the St. Louis exposition, the Nio Gate from the commercial "Fair Japan" concession in the carnival zone known as the Pike was moved to Philadelphia's Fairmount Park, and the so-called Commissioner's Office and other structures from the Japanese government's "Imperial Japanese Garden" were remade into a country lodge in the Catskills.[3]

The best-known fair garden with a second life was in San Francisco: the Japanese Tea Garden in Golden Gate Park, which grew out of the Japanese Village designed for the Midwinter Fair of 1894. The central figure in both configurations of this space was Oriental art dealer George Turner Marsh (1857–1932).[4] Marsh was responsible not only for building several commercial tea gardens in California but also for creating the first and most influential exposition Japanese garden—one that, in its physical form and degree of success, was the model for all subsequent gardens.

Encouraged by the World's Columbian Exposition in Chicago in 1893, newspaper publisher and real estate baron Michael de Young planned the Midwinter International Exposition for San Francisco in 1894. Though the Japanese government was invited to participate, it declined, citing its vast expenditures in Chicago and its escalating war with China. This led de Young to offer the Japanese concession to his friend Marsh, despite protests from local Japanese citizens and eventually the Japanese government. Marsh's plan featured more than a single building with an attached garden, as had been the case in Chicago and earlier European fairs. Instead, within a fenced compound, entered through an impressive two-story gate, was a "Japanese Village" with small thatched-roof pavilions for tea and food concessions, an indoor theater, and a large house on the hill at the rear. In between these structures, Japanese plants and garden ornaments decorated a hillside riven by a waterfall that fed a series of pools (opposite). On the north side of the complex, a large torii gate led to the Japanese bazaar. Japanese women, and a few men, staffed the village.[5] This exotically landscaped and populated environment would be re-created over the next forty years in various sizes across America, including at the San Marino Ranch.

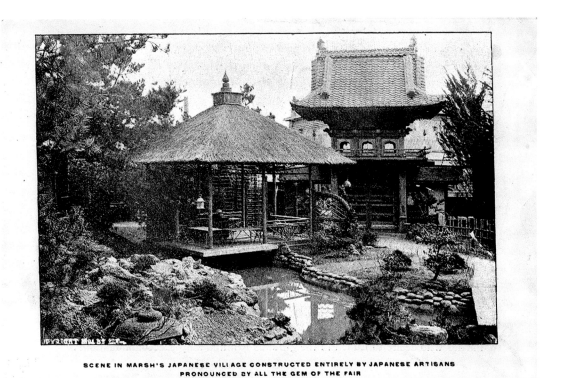

SCENE IN MARSH'S JAPANESE VILLAGE CONSTRUCTED ENTIRELY BY JAPANESE ARTISANS
PRONOUNCED BY ALL THE GEM OF THE FAIR

Postcard of scene in Marsh's Japanese Village, San Francisco, 1894. Collection of Kendall H. Brown.

After the fair, Marsh donated most of the village's plants and buildings to the city of San Francisco. The city turned the site into a commercial Japanese tea garden, hiring entrepreneur Makoto Hagiwara to run it. Marsh, flush with his triumph, built a series of commercial Japanese tea gardens. After constructing a hillside Japanese retreat on his own property on the side of Mt. Tamalpais in Mill Valley, in 1903, Marsh teamed with John D. Spreckels, a sugar and shipping magnate turned real estate tycoon (and an in-law of Henry E. Huntington), to create a Japanese garden on the Silver Strand on Coronado Island in San Diego.[6] When the garden was destroyed in a storm, Marsh built a far larger pond-and-stream garden, called "Marsh's Japanese Tea Garden." It was located on the property surrounding Spreckels's own mansion but was open to the public and aimed at guests staying at the Hotel del Coronado, owned by Spreckels. Eventually, Marsh would add Japanese or Chinese gardens to the antiquities shops in Santa Barbara and Monterey that were managed by his children.

Marsh's commercial tea gardens in California were part of a phenomenon that saw such gardens take form in large cities and small towns across America. Many were not only short lived but also of slight consequence. They were essentially glorified restaurants found in entertainment venues from Coney Island in New York to Santa Monica in California.[7] Others were proper gardens filled with Japanese pavilions for viewing the scenery as well as structures for shopping and eating.

The king of entertainment-zone Japanese gardens at world's fairs and of Japanese tea gardens independent of fairs was Japanese entrepreneur Yumindo Kushibiki (1865–1924). Kushibiki ran Japanese concessions at numerous fairs throughout the nation, held nearly every year from

1893 to 1915.[8] He also briefly operated Japanese exhibits at Niagara Falls and Venice Beach, California (1906). In addition, Kushibiki administered a four-acre Japanese garden in Atlantic City from 1895 to 1900 (destroyed in 1904), then another of comparable size in South Orange, New Jersey, from 1901. Both sold Japanese plants as well as bonsai, initiating a vogue in New York for these miniature specimens. Kushibiki's most notorious "garden," called "Japan by Night," sat atop the original Madison Square Garden in New York City. A popular spot with New York's élite, it was also the place where architect Stanford White was shot to death in 1906. In 1903 Kushibiki built a Japanese house and garden for Frederick W. Vanderbilt at his summer residence on St. Regis Lake in the Adirondacks.[9] Whereas Vanderbilt commissioned Kushibiki to create a new garden, Huntington took the far bolder step of buying one of Marsh's commercial gardens outright.

The Marsh Japanese Tea Garden in Pasadena

In the summer of 1903, G. T. Marsh began construction of a Japanese garden on a 250- by 300-foot lot at the northwest corner of California Street and Fair Oaks Avenue in Pasadena. The focus of the garden was a Japanese house used to sell Japanese art.[10] Since 1895, Marsh's brother Victor had operated Marsh's Corner Store, an Oriental art emporium across the street from the Hotel Green on the northeast corner of what is now the intersection of Raymond Avenue and Green Street in Pasadena. An ad in a pamphlet for the 1897 Rose Parade states that the store included an interior "Japanese tea house garden." When Victor expanded his store in 1903, George created a far more lavish environment to sell Japanese art only four blocks away (right). An ad for "G. T. Marsh & Co.'s Japanese Tea Garden" in the *Pasadena Evening Star* reads: "One of the greatest landscape gardeners in America said, 'The Japanese Garden is the most worth while of all the places I have been in years.'" Yet another ad boasted, "If you buy before you see us, you'll regret it."[11]

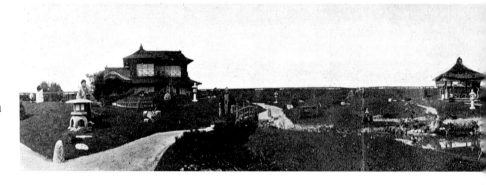

Marsh Japanese Tea Garden, Pasadena, ca. 1903. Photo from untitled pamphlet, published by G. T. Marsh and Co.

The impressive Marsh Japanese Tea Garden was surrounded by a six-foot wooden fence stained black and red in an "arrow pattern." It was entered through a small A-frame gate, and visitors struck a "gong" to summon the caretakers. Although created on a flat parcel of land, the garden featured a large pond ("the lake") in the front area and undulating hillocks leading to a "miniature mountain" in the rear. The lotus- and goldfish-filled pond was fed by a waterfall and stream, with the water presumably recirculated by means of a hydraulic pump. The hill by the waterfall held "a collection of idols" from old Tokyo temples, although the garden's official pamphlet warned that these were not for sale. Alongside the pond was a "look out house," or viewing arbor, open on all sides and surmounted by a roof thatched of bamboo with a woven bark ceiling. There, visitors could buy Japanese tea and *senbei* "cakes" from a kimono-clad Japanese woman while gazing out at the garden.

The pond was traversed at one end by a low, gently arched bridge, and its earthen banks were heavily planted. Evergreen trees, including several varieties of pine and cypress, appeared in an irregular arrangement along the hill. Flowering trees—plum, peach, and cherry—added color in the spring, as did many Japanese maples in the fall. Japanese azalea, chrysanthemum, peony, and camellia were planted throughout the garden. There was also a smaller pond, planted with iris (*shobu*) in a variety of colors, crossed by a "crooked bridge." The bridge led to a tiny red shrine dedicated to the agriculture god Inari, containing two fox statues. Earthen paths wound through the garden, climbing the turf-covered hills dotted with stones and lanterns in a half-dozen styles.

Marsh Japanese Tea Garden, Pasadena.

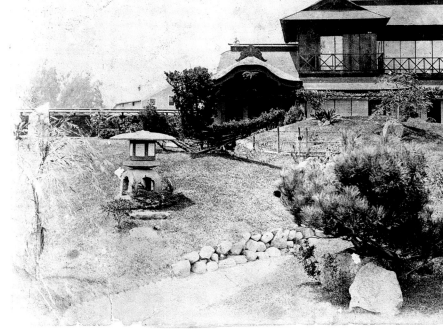

A smaller open pavilion, with a thatched, hipped roof surmounted by a figurine of a rooster, occupied a small hillock in the northern part of the garden. A rare postcard reveals that the garden also boasted a wisteria arbor alongside the smaller pond.

The garden's main focus was the hilltop "house." According to newspaper articles from 1903, it was created in Japan and then shipped to California and reassembled. A few exterior details, notably the raised-leaf patterns on the protruding crossbeams at the main entrance, reveal the slightly ornate taste of the late Meiji period (1868–1912). Although the garden's pamphlet claims that it "has been built in exactly the same way as a house of the better class in Japan," it functioned as a display house meant to show off paintings and other objects for sale (above). Interior photos correspond with the description in the pamphlet, showing an elegantly designed

space in the florid style of the era. There are carved transoms (*ranma*) in such patterns as bamboo and waves, as well as several kinds of woven wood ceilings. The sliding room dividers (*fusuma*) include one between rooms with a modern "window panel," and another, at the back of the main room, with pictures of pine and maple. In that formal room (*shoin*), the primary wall features a *tokonoma* alcove, filled with a hanging scroll, figurine, and paper lantern, while the adjacent staggered shelves (*chigaidana*) hold a cloisonné vase and several bamboo baskets (below). In Japanese fashion, the rooms on the bottom floor are minimally furnished. Photos show a dresser (*tansu*) as well as a wooden standing screen of the so-called Shibayama type, decorated in ivory and metal with a scene of fighting samurai. Presumably these items were for sale, and the "stock" displayed in the house changed periodically. In keeping with the colorful items in the house, "fancy chickens" and elaborately plumed roosters were kept in a yard behind it.[12]

The garden's six-page souvenir pamphlet proclaims the "true art" of Japanese "miniature gardens," describing "the particular significance" of things in a Japanese garden. It does not, however, say anything about the Japanese artisans who constructed the garden and its architecture. The early newspaper articles only speak generally about Japanese workers. However, an ad in the *Pasadena Star* for the first week of February 1904, placed by A. Y. Okita, "contractor and builder of Japanese Tea Houses and Gardens," includes the claim, "We built Mr. Marsh's Tea House and Garden."[13]

Marsh Japanese Tea Garden, interior of house, Pasadena, ca. 1905. Photo by Will A. Benshoff. Courtesy of the Archives, Pasadena Museum of History.

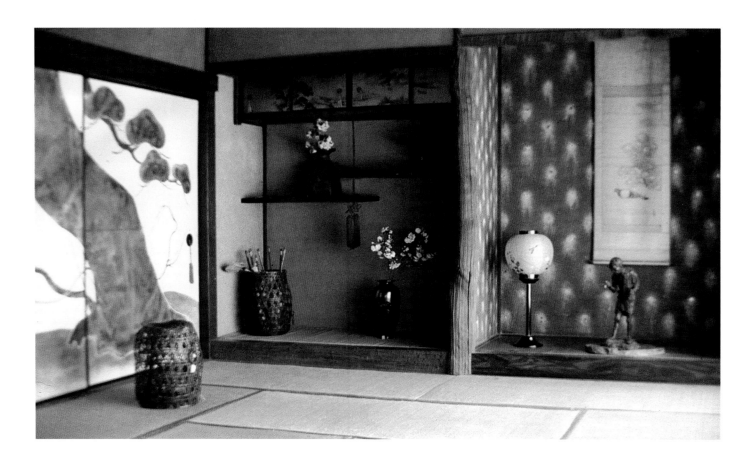

The Japanese Tea Garden was in economic trouble by 1911, and newspaper accounts tell of an auction of "Oriental curios" and then of plans to subdivide the property.[14] By early August of that year, a buyer had been found. On August 19, the front-page headline of the *Pasadena Star* announced, "Huntington is Buyer of Garden: Will Remove Treasure of Japanese Tea Garden to His Home." The total selling price was not announced, but the value of the land alone was listed at $12,000.[15]

A Japanese Garden for San Marino

Although Huntington's purchase of an entire garden was unusual, garden plants, ornaments, and structures were frequently relocated from exposition and commercial gardens to private residences. For example, when Kushibiki's tea garden in Atlantic City closed in 1901, much of it was sold to private gardens in the Philadelphia area. Indeed, historically in Japan, stones, lanterns, and buildings were transferred from defunct gardens to new ones. In America in the 1910s and 1920s, businesses like S. S. Vantine and Yamanaka & Co. that sold garden plants and ornaments likely acquired some of them "secondhand" in Japan or the United States. These items filled the lavish Japanese gardens of such patrons as Isabella Stewart Gardner in Boston, Abby Aldrich and J. D. Rockefeller Jr. in New York, and Gertrude and Frank Seiberling (the Goodyear Tire founder) in Akron, Ohio.

At the beginning of the twentieth century, Japanese gardens were found at many of the country retreats of wealthy Americans and Europeans. Even in the relative hinterlands of Los Angeles County, by 1911 there were substantial Japanese gardens on the properties of Capt. Randolph Miner in the West Adams district and Dr. Rudolph Schiffmann in Pasadena.[16] The addition of a Japanese garden to horticultural displays on the Huntington property may have been motivated by a desire to keep up with the likes of the Spreckels locally, the Rockefellers nationally, and the Rothschilds internationally. Yet, even as Japanese gardens were fast becoming a requisite part of an up-to-date American or European estate, the appearance of one on Huntington's San Marino Ranch is important because it signals a critical shift in the conception and function of that property from agricultural ranch to cultured manor. It also comes at precisely the time that Henry E. Huntington and his future wife, Arabella, were teaming up to become multidisciplinary patrons of culture and shifting their locus of display from New York and San Francisco to Southern California. Because no primary documents record Huntington's reason for building a Japanese garden, it is worth exploring the personalities around its creation.

Henry Edwards Huntington (1850–1927) was the nephew and close business associate of Collis P. Huntington (1821–1900), founder of the Southern Pacific and Central Pacific railroads.[17] From 1898 Henry E. Huntington turned his attention to Southern California, becoming a major landowner and then president of the Pacific Electric Railway, among other enterprises. In 1903, at age fifty-three, with his children grown and his estranged wife, Mary Alice, living in San Francisco, he purchased the dilapidated San Marino Ranch (pp. 49–51) from J. De Barth Shorb. While living at the Jonathan Club in Los Angeles, from 1904, Huntington, together with

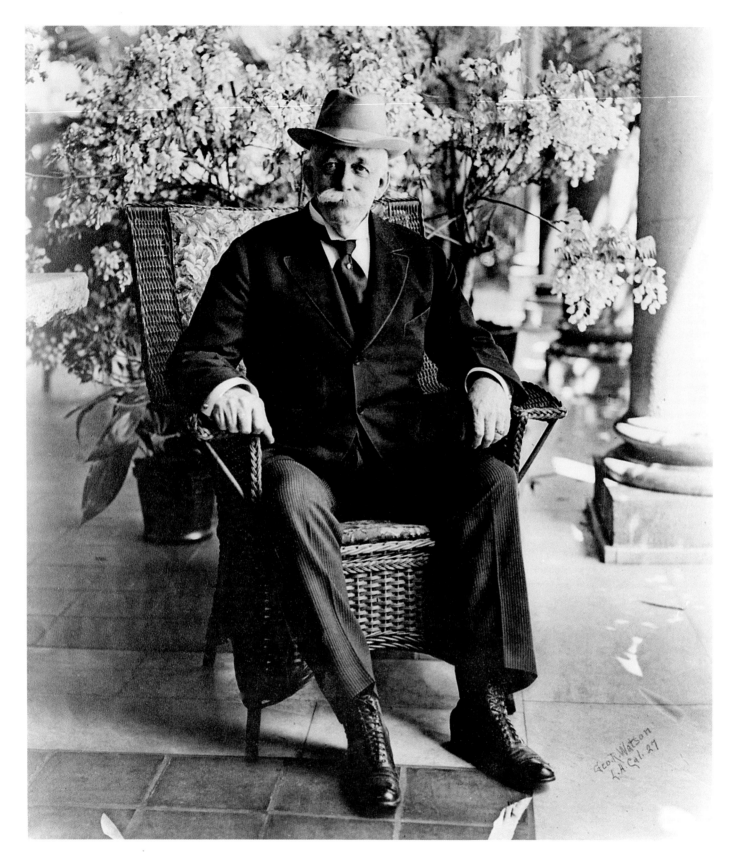

Henry Edwards Huntington, 1927.

his young ranch foreman, William Hertrich (1878–1966), developed the ranch to include citrus orchards, peach and avocado groves, and a vineyard, as well as wheat and alfalfa fields. Hertrich's curiosity about plant specimens and Huntington's hope to make money out of those interests led the two men to "experimental horticulture." Some of these projects resulted in the addition of the lily ponds (1904), the palm garden (1905), the desert garden (1907), and the rose garden (1908). Prior to the creation of the Japanese Garden, neither Huntington nor Hertrich demonstrated significant interest in "aesthetic" or cultural gardens. In fact, Huntington rejected architect Myron Hunt's plan for an Italian garden near the mansion that Hunt and Elmer Grey started designing for the property in 1907.[18]

Yet, the plans for that grand house itself (made in consultation with Arabella in New York) demonstrate that from around 1908, two years after he divorced his wife, Huntington began to imagine his property as much more than a ranch. The reason for this change was his relationship with Arabella. After the death of Collis in 1900, Huntington, the heir to a third of his uncle's fortune, separated from Mary Alice to split his time between Los Angeles, the center of his business

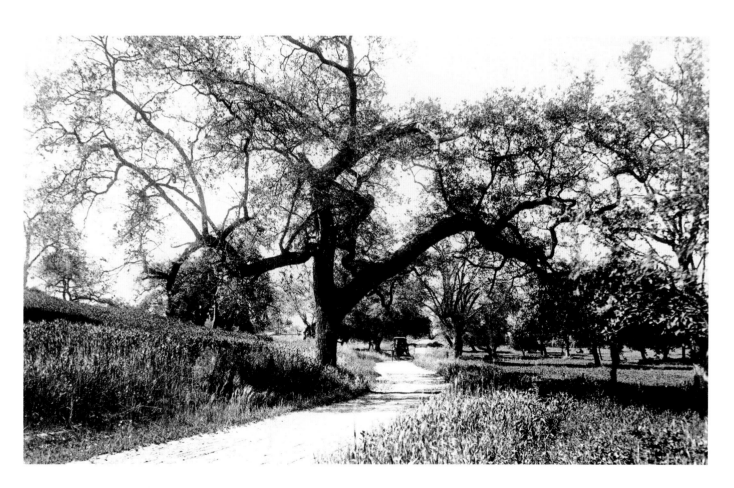

J. De Barth Shorb's San Marino Ranch.

Olive orchard on J. De Barth Shorb's
San Marino Ranch, ca. 1890.

Upper reservoir on J. De Barth Shorb's
San Marino Ranch.

empire, and New York, the place where his aunt lived. Reportedly, he proposed to Arabella in 1906, and again in 1908, but she deferred the marriage—and, with it, part-time residence in Southern California—for another five years. During this time, Arabella, called "the richest woman in the world" in the newspapers, was dramatically asserting her identity as a woman of culture. Living in New York and Paris, where she had purchased a "palace" on the Rue de l'Élysée, Arabella was rapidly putting together sterling collections of European Old Master paintings and French decorative art.[19] Beginning around 1908, she and Huntington began to coordinate their cultural interests, concentrating their collecting in a new area—English art of the Georgian period. This focus may well have been aimed at filling the palatial home planned for San Marino. Correspondingly, Huntington's avid collecting of books and manuscripts grew in scale and scope as he contemplated creating a library that eventually would be open to scholars and the public.[20]

Although Arabella has been linked to the collecting of art (and to sumptuous residences), just as Huntington has been connected with books and manuscripts, Arabella also had a fondness for gardens and plants that has been little noted. When Arabella married Collis Huntington in July 1884, after the death of his wife Elizabeth in October 1883, she purchased from Frederick C.

Original entrance drive to
J. De Barth Shorb's San Marino Ranch,
ca. 1905.

Havemeyer the 113-acre "Homestead" estate in Throggs Neck, New York. There, according to a *Los Angeles Times* article, Arabella personally supervised the work in the huge greenhouses dedicated to ferns and palms, and roses and violets. The article continued, "She has a large library of botanical books, and spends many hours, microscope in hand, analyzing flowers, and studying new and improved methods of horticulture."[21] Even if this effusive account is taken with several grains of salt, Arabella's interest in plants and landscapes must be considered. Although the "Homestead" contained a formal European garden rather than a Japanese one, Arabella would certainly have been familiar with the Japanese-style gardens being created in large numbers by her social peers on both coasts.[22]

In this context, at San Marino the addition of a Japanese garden in concert with a massive Beaux Arts–style house marked a critical tipping point in the transformation of the property from a working ranch into a country estate. This radical makeover meshed perfectly with Huntington's relationship with Arabella, an imperious woman who did not hide her disdain for uncouth Southern California. Moreover, she was ever eager to remodel her public persona from that of the calculating companion, then wife, of two enormously wealthy men named

Huntington to a *grande dame* of the highest or at least most conservative cultural realm. Oral tradition holds that the garden was added to make the ranch attractive to Arabella, and a related version claims that it was a wedding gift to Arabella.[23] In light of Arabella's cultural and horticultural interests, Huntington's frequent attempts to woo her to San Marino, and the social cachet as well as aesthetic status attendant on Japanese gardens, these claims seem to be more than gossip.

In his memoirs, written thirty-five years after the fact, Hertrich offers a different account of the origin of the Japanese Garden—one that highlights his own role. In his personal recollections, the former ranch foreman states:

During the summer of 1912 [*sic*] Mr. Huntington suggested that I prepare a plan to improve the small canyon to the west of the rose garden. Mr. Shorb, the former owner, had installed a dam across the south end and had used it as a reservoir. It appeared that the dam could be leveled and thus an unsightly spot could be transformed into an attractive garden, possibly a Japanese garden. I made this suggestion to Mr. Huntington. The idea was acceptable, but Mr. Huntington's chief concern was the time element. I estimated that it would take six months to complete the project properly but he wanted it ready sooner, so that it would all be in perfect order that following winter, when his family [Arabella] planned to occupy the new home.[24]

Lower reservoir at J. De Barth Shorb's San Marino Ranch, now the location of the Japanese Garden.

Hertrich then briefly recounts his building the concrete rockery, waterfall, ponds, bridges, walks, and steps. The last phase, planting, led him to search nurseries in California for plants. Finding nothing, he "approached the owner of a commercial Japanese tea garden" in Pasadena as a last resort. Learning that the garden was for sale, Hertrich wrote to Huntington, who ordered that it be bought immediately. Crews of men brought the plants and buildings to the ranch, where they were installed in "record time" and finished by the time the Huntingtons moved in.[25]

Hertrich's own letters to Huntington from 1911 to 1912 contradict this account, however. They reveal that the Huntington Japanese Garden was begun in September 1911, immediately after the purchase of the Marsh Japanese Tea Garden—not, as Hertrich later maintained, nearly finished before that garden was acquired. This correction to the chronology also challenges Hertrich's claim that he came up with the idea for a Japanese garden. Hertrich's reminiscences, however, do buttress the interpretation that Huntington was very concerned that the Japanese Garden be finished by the time he and Arabella resided on the property. Hertrich's weekly letters to Huntington (who was in New York or Europe during this period) describe in detail the construction of the Japanese Garden and reveal that Hertrich was entirely in charge of the construction, working with a crew of seventy men. The return letters from Huntington show him to be a passive, though enthusiastic, supporter of the project.

Construction of the Japanese Garden started in September with rough grading of the site. In October the pond was excavated and its concrete bottom poured, the waterfall and rockery built, and molded concrete retaining walls constructed. At the same time, boulders were gathered from the San Gabriel River, and the boxing of trees at the Marsh garden commenced. In November, as more plants were boxed at the Marsh garden, transported by wagon, then planted, the pond edges were detailed and the ponds were filled with water. During the fall, Hertrich had looked for a carpenter to disassemble the structures at the Marsh garden then reassemble them. After he found his man, the entrance gate was moved in November. December saw the moving of the remaining plants, the disassembly of the two teahouses and fence, their transportation to San Marino, and their reassembly. The stone lanterns were also transported and placed. Most vexing for Hertrich was the soliciting of bids for moving and plastering the house, with Japanese contractors offering very high figures because—as Hertrich speculated—they "had found out it was for Mr. Huntington and had made the price accordingly." By early December Hertrich secured a bid of $1,200 to move the house, reconstruct it, and plaster it. In January the house was taken down, moved, and reconstructed. Its roofing was finished in February. Four coats of plaster were applied during that month and in early March.[26]

With the Marsh garden relocated to the Huntington property and looking "like new," Hertrich began to add several elements in the spring of 1912. Although Hertrich's letters do not name the carpenter, Toichiro Kawai was hired late in 1911 to relocate the structures and then create several architectural features.[27] First, for the south entrance to the garden, spanning the access road, he built a shrine-style torii gate (opposite) using yellow cedar brought from the

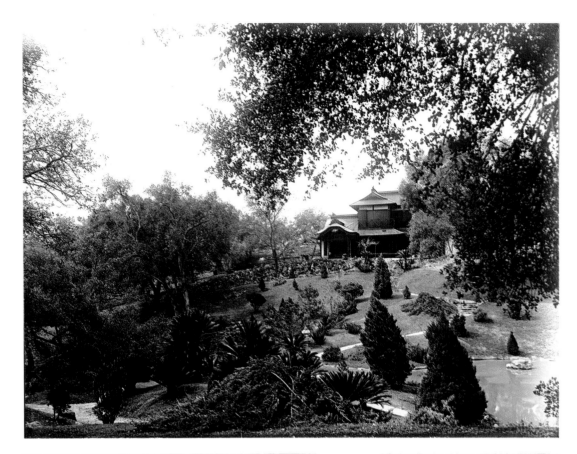

View to the Japanese House,
ca. 1913.

Torii gate, autochrome photograph,
ca. 1924.

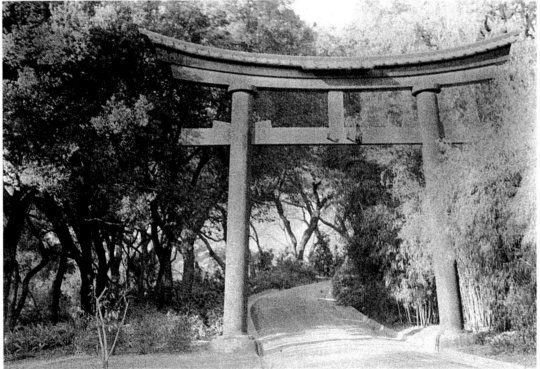

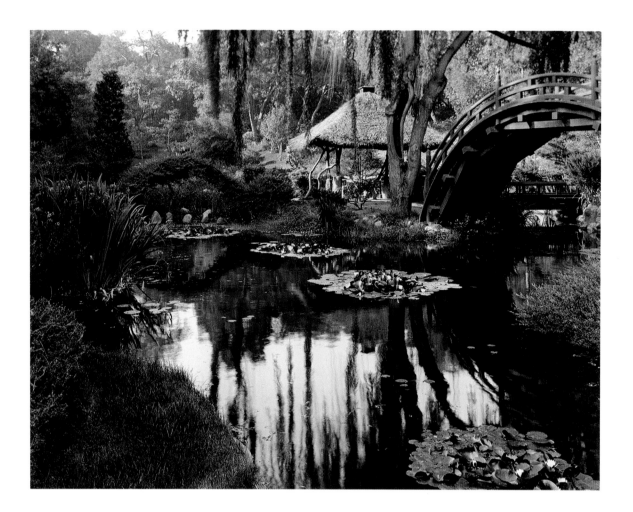

"Indian Village" in Lincoln Park just east of downtown Los Angeles;[28] at the north entrance, he created a gate made of eucalyptus. In October 1912, a work order for a "Full Moon Bridge" was issued, and on the east side of the larger pond, Kawai constructed this typical feature of Japanese gardens in America. On the pond's north side, the pyramidal "tea house" brought from the Marsh garden was reached by the arching moon bridge and a flat bridge that was likely also created by Kawai (above). While Kawai was adding these architectural features, Hertrich created an ornamental waterfall that descended from a well perched on the hill northeast of the Japanese House.

With the garden effectively finished at the end of 1912, minor additions were made over the next two years to increase its beauty and functionality. In May 1913 Hertrich ordered the construction of a three-room cottage behind the Japanese House so that the Goto family caretakers could have a functional kitchen and bathroom, which were absent from the display-oriented house. In June 1914, a work order was issued to construct a "Japanese Bell House" near the entrance by the rose garden.[29]

When newly created, the garden appeared substantially different from its form today. The two ponds have been altered in size and configuration, with some of the edging materials changed as well. More dramatically, the *original* combination of structures—three entry gates, two thatched *azumaya* (viewing pavilions called "tea houses" at the time), bell tower, A-frame roofed well, vermillion full moon bridge and flat bridge, and newly plastered and stained house—created the kind

Moon bridge and thatched pavilion, ca. 1918.

Wisteria pergola, ca. 1913.

of Japanese village atmosphere made familiar by world's fairs and commercial tea gardens.[30] In addition to the numerous stone and iron lanterns and such stone ornaments as the pagoda and fu dogs, the garden featured a collection of three dozen stone-carved votive figures. Presumably these tombstones, showing the Buddhist divinities Jizō and Kannon, were the "idols" from old Tokyo temples described in the pamphlet for the Marsh Japanese Tea Garden.[31]

Though the garden has acquired a natural patina of age over the past century, it was created with new techniques and styles. Hertrich's letters (and careful examination of the garden) reveal the skillful use of poured and molded concrete for the pond bottoms and edges, streams, craggy arched "bridge" across the north pond, "rustic steps" throughout the garden, retaining walls and handrails, and wisteria pergola (above). Several of the "stones" placed on the hill below the house are also poured and textured concrete. The most dramatic use of poured concrete was for the rockery, or grotto, and waterfall located just downstream from the site of the original dam near the main pond's south edge. This feature, long overgrown and closed to the public today, was accessed by a path that led down some steep steps to a cavern large enough to hold several men. The path then terminated at the base of a ten-foot waterfall that cascaded over the poured concrete "rockery." Hertrich wrote, "It certainly will be a fine feature when all planted."[32] Although a grotto of poured concrete seems anathema to Japanese gardens, the technique and form enjoyed a brief vogue in the early twentieth century.[33]

BUDDHIST SCULPTURE

The Huntington's collection of three dozen Buddhist stele, a unique feature of the original Japanese Garden of 1912, was acquired from G. T. Marsh, who had purchased the sculptures from temples in Tokyo. Made as gravestones for temples, these stele were sold when the temples closed or gave up their land after the persecution of the 1870s. Most of them bear dates between 1650 and 1750. Although a few Japanese gardens in the United States have one or two such sculptures, the Huntington's collection is unparalleled in terms of its size.

In the Edo period (1600–1868), government regulations requiring commoners to register with local temples coincided with a resurgence of devotion and economic prosperity. The result was the creation of tombstones featuring divinities of salvation. Many tombstones are dedicated to Jizō ("Ksitigarbha" in Sanskrit, "Dizang" in Chinese), protector of souls, guardian and savior of children. Jizō is represented as a priest, with simple robes and a shaved head, his hands in prayer or holding a staff. This image usually appears on the tombstones of men or children. More popular is the bodhisattva Shō Kannon ("Avalokitesvara" in Sanskrit, "Guanyin" in Chinese)—shown standing, with a lotus bud in the left hand—or the wish-granting bodhisattva Nyoirin Kannon ("Ruyiluun Guanyin" in Chinese). Nyoirin Kannon is represented with one leg folded and the other bent, either with the hands folded in contemplation or with one hand touching the right cheek. Because Kannon protects mothers, children, and aborted fetuses, this image typically appears on women's tombstones.

These boat-shaped tombstones are characteristic of the Tokyo region. Written on each is a Sanskrit "seed syllable" (denoting the divinity), the deceased's death date, and the posthumous "dharma name" of one to three persons, presumably from one family. An example depicting Shō Kannon features the syllable *sa* and the names of two men and one woman: "*Kantaku ryōton shinji* [layman Kantaku Ryōton], tenth day, seventh month of the dog year, Kyōhō 15 [1730]; *tame Kankō baiten shinnyo bodai nari* [for the salvation of laywoman Kankō Baiten], twelfth day, twelfth month of the dragon year, Shōtoku 2 [1712]; *tame Kōgaku rinō shinji bodai nari* [for the salvation of layman Kōgaku Rinō], fifth day, fourth month of the horse year, Shōtoku 4 [1714]."

KENDALL H. BROWN

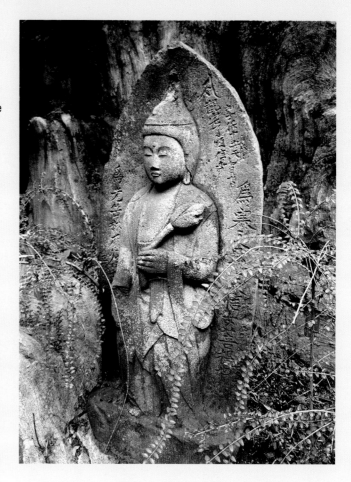

Stone stele of Shō Kannon, inscribed for Layman Kantaku, 1730, Laywoman Kankō, 1712, and Layman Kōgaku, 1714.

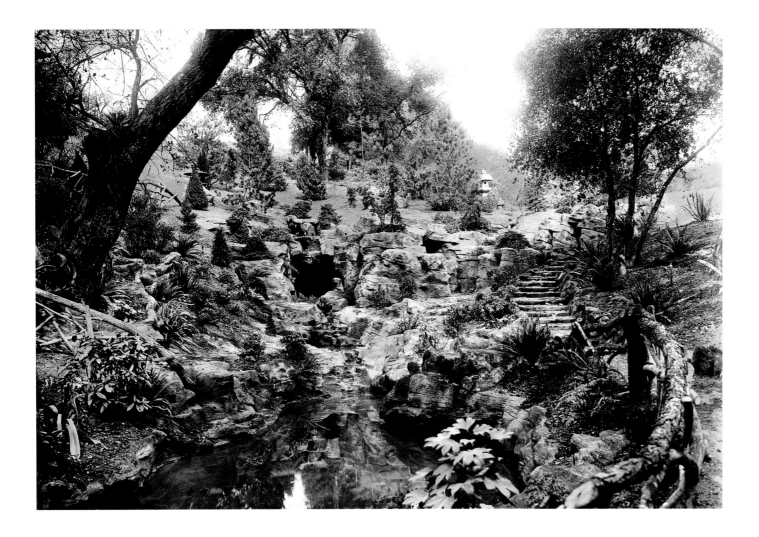

Lower grotto, ca. 1913.

Upon its completion, the Japanese Garden received limited but largely positive press coverage and thus likely fulfilled part of Huntington's aspirations for it. In an article for *Gardener's Chronicle of America*, P. D. Barnhart described the Japanese Garden as the estate's "crowning glory," praising the thatched teahouse and the natural appearance of Hertrich's grotto.[34] In his book *Stately Homes of California*, Porter Garnett concluded, "It is difficult to imagine a sharper contrast than that which exists between the architecture of this Japanese house, . . . and that of the residence itself. Both are charming in their way as representing a high development of highly divergent standards and ideals."[35]

Allies who championed Huntington as a titan of American business interpreted his Japanese Garden as an emblem of American power. An unsigned article in the *Los Angeles Times* praised Huntington's newly created estate as well as his many businesses. The article, which concluded by calling Huntington "a man of genial disposition, . . . liberality, independence, justice and patriotism," expanded on the glories of his newest garden:

The Japanese garden, wrought from naked ground within the year, is a story in itself. It is quaint, with its Nipponese herbage, its pond with sacred rocks, its family of idols coaxed by American yen and sen [that is, currency] from their Oriental temples; its native house and native tenants, its tea-houses, its rustic grottoes fashioned of cement in the likeness of real stone—replicas of contours chiseled by Nature in her elemental workshop.[36]

Those less sanguine about Huntington's financial accomplishments used aspects of the garden to lampoon his attempt to acquire social status through the acquisition of art. For instance, a short article published by newspapers across the country read in part:

H. E. Huntington of Pasadena, Cal., has done a foolish reactionary thing. He has bought 57 idols, brought them from their original Japanese temple, and installed them in his grounds so that he can worship Buddha in seclusion. How much better it would have been if he had got statues of some of the American idols and put them up so that the populace might worship. He could have several political favorites, Mammon, two or three baseball heroes, [and] several moving picture cowboys.[37]

Despite this skewering of Huntington's cultural pretensions, the Japanese Garden was only the means of criticism, not the object.

Once the garden was constructed, there arose the need to maintain it. Hertrich ends his reminiscence on the garden by mentioning that, although a Japanese family was hired to live in the house and care for the garden, producing "an Oriental atmosphere" that was "enhanced on occasion by the family's custom of dressing up in Japanese costume for special holidays," after a few years this situation could not be maintained. Thus, the garden quickly became overgrown "due to restricted budgets and the inability to procure suitable personnel."[38] Photos confirm that the garden had become overgrown by the 1920s.

At the Marsh Japanese Tea Garden, the Goto family had lived in a small residence behind the Japanese house, with Chiyozo doing maintenance and his wife, Tsune, serving in the "tea house" (opposite, bottom). Reportedly, Chiyozo and Tsune had previously worked as cook and maid, respectively, for Marsh in San Francisco.[39] After the creation of the Pasadena garden, when the gardener Mr. Fujio and his wife (opposite, top) wished to return to Japan, the Gotos were sent there to replace them. When Huntington purchased the Marsh garden, he invited the Gotos to move along with it. The Goto family lived in the three-room dwelling built behind the Japanese House. Reportedly, Chiyozo was in poor health and returned to Japan in 1917, but was back in Pasadena about a year later. Chiyozo and Tsune returned to Japan for good in 1923.[40]

The spotty Huntington estate payroll records include a "Y. Gotto" receiving $60 in July 1912. In December 1919, "T. Goto" was paid $70 for "general work," and in December 1920, T. Goto was paid $85 as "Japanese Gardener" and Kame Goto was paid $19.80 as "Laborer." In the same records, for several years beginning in November 1914, S. Oshita received $65 each month, with the title "Japanese Gardener" appended to his name in December 1915.[41]

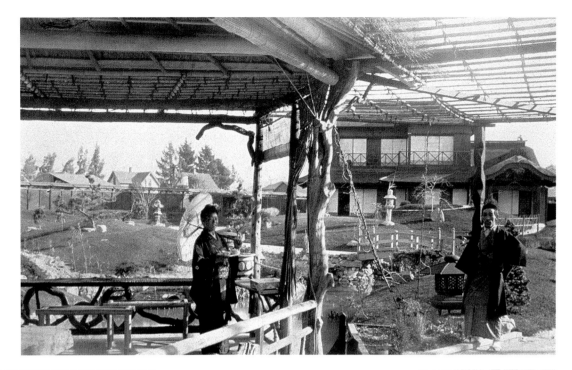

Mr. and Mrs. Fujio in the Marsh
Japanese Tea Garden, Pasadena,
ca. 1903.

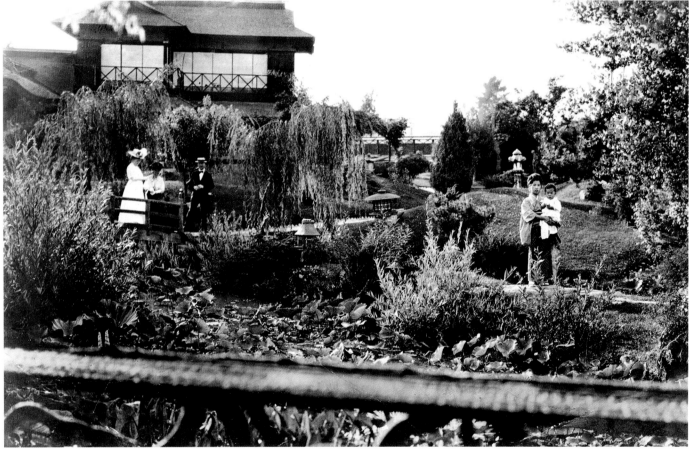

Tsune Goto in the Marsh Japanese
Tea Garden, Pasadena, ca. 1910.

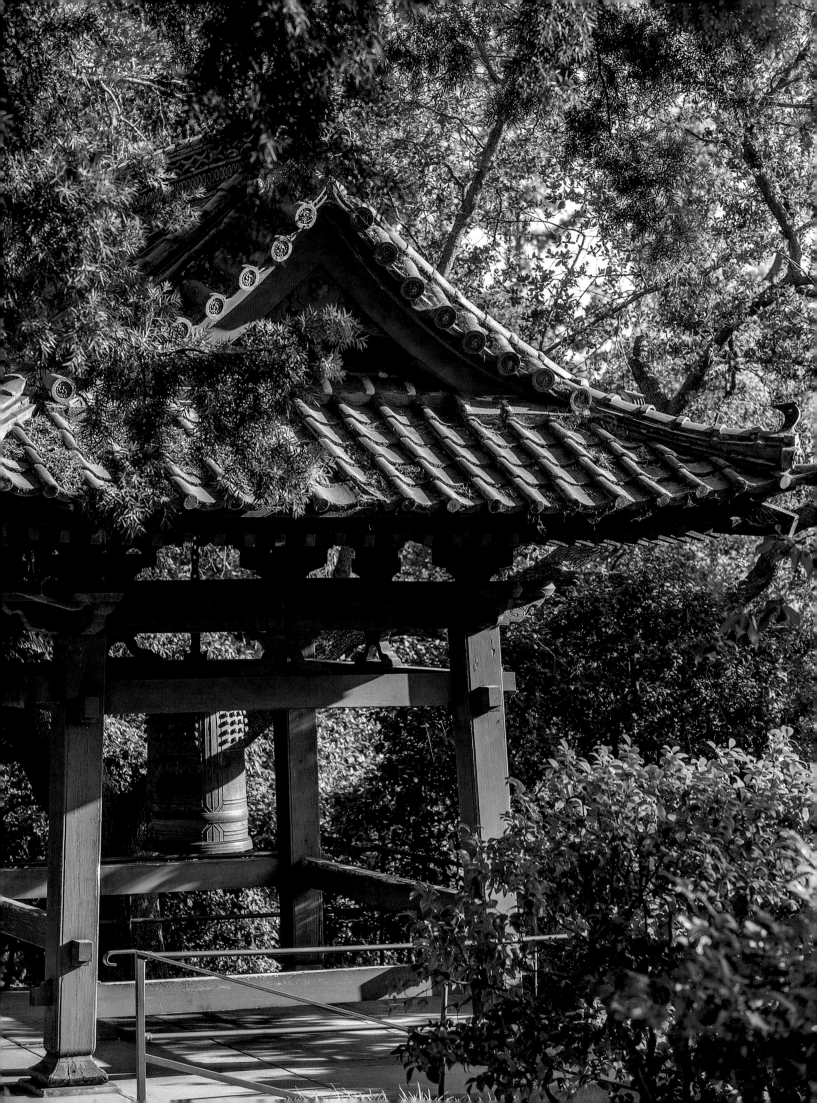

Postscript

There is little evidence to explain how the Huntingtons physically used the Japanese Garden, if they did at all during the three months they spent on the property each year. Arabella's failing eyesight would have made strolling and viewing very difficult. Oral tradition suggests that at times, they showed the garden to visitors, preferring the Goto family to dress in Japanese clothes for these occasions. The Huntingtons may also have hosted occasional social events there, although it should be noted that the only evidence from the society pages to be uncovered thus far is a meeting of the Los Angeles Horticultural Society, with luncheon served in the thatched "tea house," from June 1912—more than a year before the Huntingtons first resided on the property.[42]

One consequence of the garden was that it provided another opportunity for Hertrich to build a Japanese garden. After Huntington purchased the struggling Wentworth Hotel in 1912, he hired Hunt and Grey to refurbish the structure and Hertrich to landscape the grounds. Many features of the Huntington estate were echoed at the hotel, including a Japanese streamside garden in the area below the "bridge" on the hotel's south side. The garden was to be used, in part, for amateur theatricals that would be staged there and filmed, then screened the following day. Newspaper accounts point out that the ground floor of the renamed Huntington Hotel was to be as grand as Huntington's own estate, and that its grounds would likely "eclipse the world-famed sunken Busch gardens in magnificence." The main difference was that, unlike the Huntington estate, the hotel would allow the public to see Huntington's display of cultivated taste.[43]

Huntington's aspirations to surpass the thirty-acre semi-public garden on the Pasadena estate of brewery magnate Adolphus Busch, and to bring to people the kind of opulence seen in his own home, were more than just marketing ploys for the hotel. They suggest Huntington's desire to share his vision with the public. This wish began to be formalized in 1919 when he drafted a document establishing a trust "to promote and advance learning, the arts and sciences, and to promote the public welfare by founding, endowing, and having maintained a library, art gallery, museum and park."[44] By 1922, the *New York Times* was reporting that Mr. and Mrs. Huntington had signed a first deed transferring "the library and a part of the grounds, including the Japanese gardens. . .into the hands of the trustees," with the intention "to throw open the library and grounds to the general public."[45]

When the Huntington estate was opened to the public after 1927, interest in the famous gardens as well as the library and art gallery led to the opening of the desert and Japanese gardens. These two gardens remain among the most popular features. For the Japanese Garden, various vicissitudes would almost spell its demise after World War II. Yet, thanks to generous and wise benefactors, the garden created by Hertrich, Kawai, and many others was not merely preserved but would serve as the dynamic heart of what would become a series of Asian gardens. The Japanese Garden would be actively "performed" through docent tours and such annual cultural festivals as Tanabata, even as it would play the role of Japan in such movies as *Midway* (1976) and *Memoirs of a Geisha* (2005). More importantly, its beauty and popular appeal would help launch the creation of the dry garden in the 1960s, the tea garden in 2012, and even Liu Fang Yuan, the Huntington's Chinese garden.

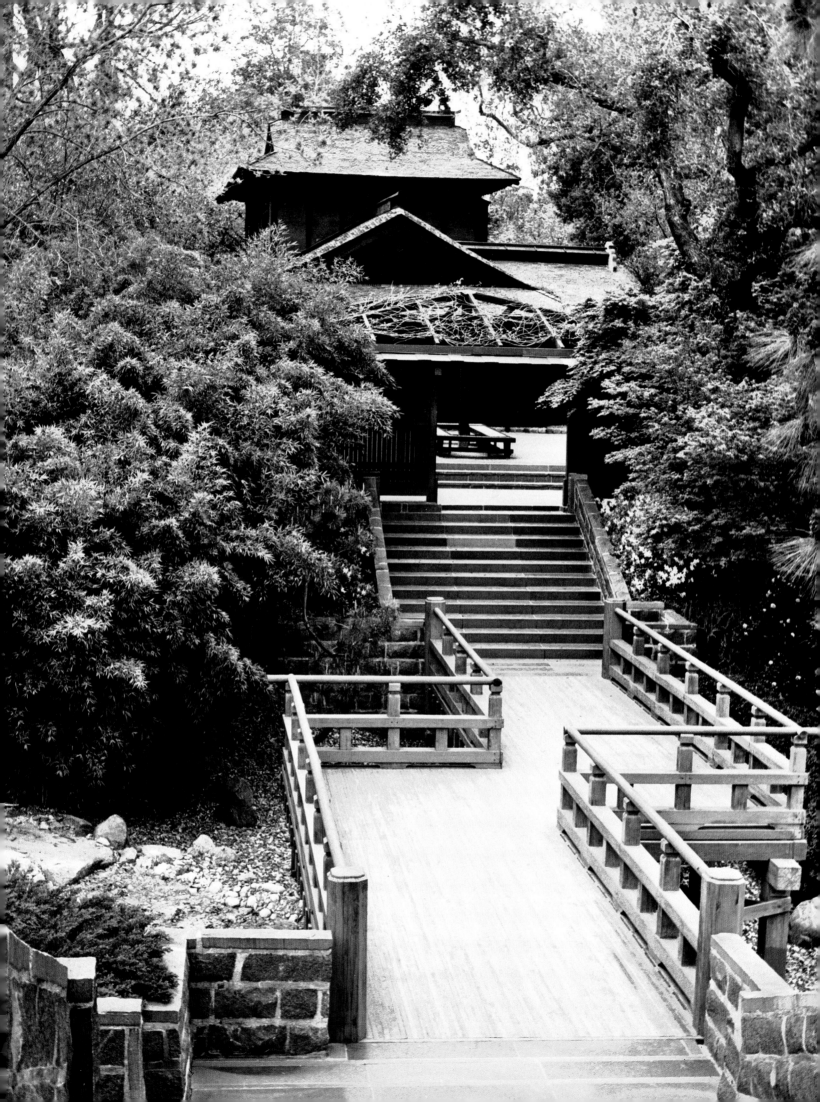

This teahouse is a handcrafted wooden structure commissioned by Dr. Sen Sōshitsu (1923–), who was then the Grand Master designate of the Urasenke Tradition of Tea, one of the three major tea schools dating to the sixteenth century.[4] On a visit to Los Angeles in 1963, Dr. Sen promised to build a teahouse equal to the best found in Japan for practitioners in the area. He had made similar donations to branches in Honolulu and São Paulo and had just arranged for a teahouse to be part of the Japan Pavilion at the 1964 New York World's Fair. He oversaw all aspects of the teahouse's design, which was executed by his youngest brother, Sen Otani Mitsuhiko (1929–1966), who headed the architectural and design division associated with the school.[5] The distinguished Kyoto firm of Nakamura Sotoji Kōmuten, long famous for its refined, traditional *sukiya* style of Japanese architecture, undertook its fabrication. In 1964, the house was shipped in pieces to the United States, where a crew of Japanese American carpenters reassembled it on the grounds of the Pasadena Buddhist Temple.

The teahouse was named "Seifu-an,"[6] or Arbor of the Pure Breeze, by Dr. Sen's father, Tantansai (1893–1964), the fourteenth-generation Urasenke Grand Master. His untimely demise, however, postponed its formal opening until the following year. On July 10, 1965, Dr. Sen, with his new title as fifteenth-generation Urasenke Grand Master, presided over the teahouse's dedication. A wooden plaque, or *hengaku*, brushed with his calligraphy hangs under the eaves of the teahouse. According to tea tradition, the bestowing of a name is a way for a grand master to demonstrate his approval and certify that the object is in accordance with his taste.

Seifu-an stood in the temple's courtyard in Pasadena for forty-five years until 2010, when the temple's leadership decided it would serve a broader public if it were given to the Huntington. It was then disassembled and shipped back to Japan for restoration at the Nakamura workshop before returning to the United States in June 2011. A team of carpenters and specialists from Kyoto, including traditional plasterers, papering specialists, and roofers, traveled to the Huntington to reconstruct the fifty-year-old structure. Landscape designers from both sides of the Pacific— Uesugi Takeo, based in Los Angeles, and Yamada Takuhiro of Kyoto—collaborated to create a traditional setting for the wooden structure.

According to Nakamura Yoshiaki, son of the original builder and current head of the Nakamura firm, Seifu-an is "one of the first teahouses built in the United States after World War II, and possibly the oldest remaining from the period."[7] He explained that teahouses are traditionally made only of natural materials, such as wood, paper, and mud plaster, so they become part of the natural landscape. With proper maintenance they can last several hundred years. But if left unattended, they will return to nature. Nakamura also sees the teahouse as representing a unique moment in the relations between Japan and the United States.

Seifu-an, Arbor of the Pure Breeze, the teahouse at the Huntington.

The Teahouse Seifu-an, Arbor of the Pure Breeze

ROBERT HORI

Camellia sinensis—better known by its common name, tea—is a plant cultivated throughout Asia. It was once considered an elixir of life. It drove a global trade that linked East and West and helped spark the American Revolution. In Japan, tea inspired the development of an artistic and spiritual discipline known as *chado*, the "way of tea," whose tenets have permeated all facets of Japanese life, including popular speech. A person who behaves recklessly is said to be *mucha*, or "lacking in tea."

When the preeminent scholar and art historian Okakura Tenshin, also known as Okakura Kakuzō (1862–1913), sought to introduce the arts of Japan to Americans, he chose tea as his vehicle. In *The Book of Tea*, published in New York in 1906, he characterized the tea ceremony as the very essence of Japanese culture. This comprehensive cultural form embodies the study of architecture, garden design, ceramics, flower-arranging, calligraphy, and cuisine, as well as the ethics and spiritual disciplines that help form one's character.[1]

Tea also presents a unique philosophical perspective on life that is captured in the phrase *ichigo ichie* (one moment, one meeting).[2] When host and guest come together, it is an encounter never to be repeated. This forces the host to put every effort into making the tea ceremony a memorable occasion and reminds the guest to savor the moment. Okakura referred to tea as the "religion of aestheticism"; it provides a means to discover beauty in everyday life.

A tea master once said that the spirit of tea is something that cannot be learned from books but needs to be experienced firsthand and transmitted from heart to heart. The newest addition to the Huntington's historic Japanese Garden is a Japanese teahouse built using traditional materials and techniques. It provides a unique opportunity to be immersed in the world of tea and to drink from Okakura's "Cup of Humanity."[3]

Camellia sinensis, the tea plant, labeled *Thea viridis* in this 1812 illustration from *Curtis's Botanical Magazine*.

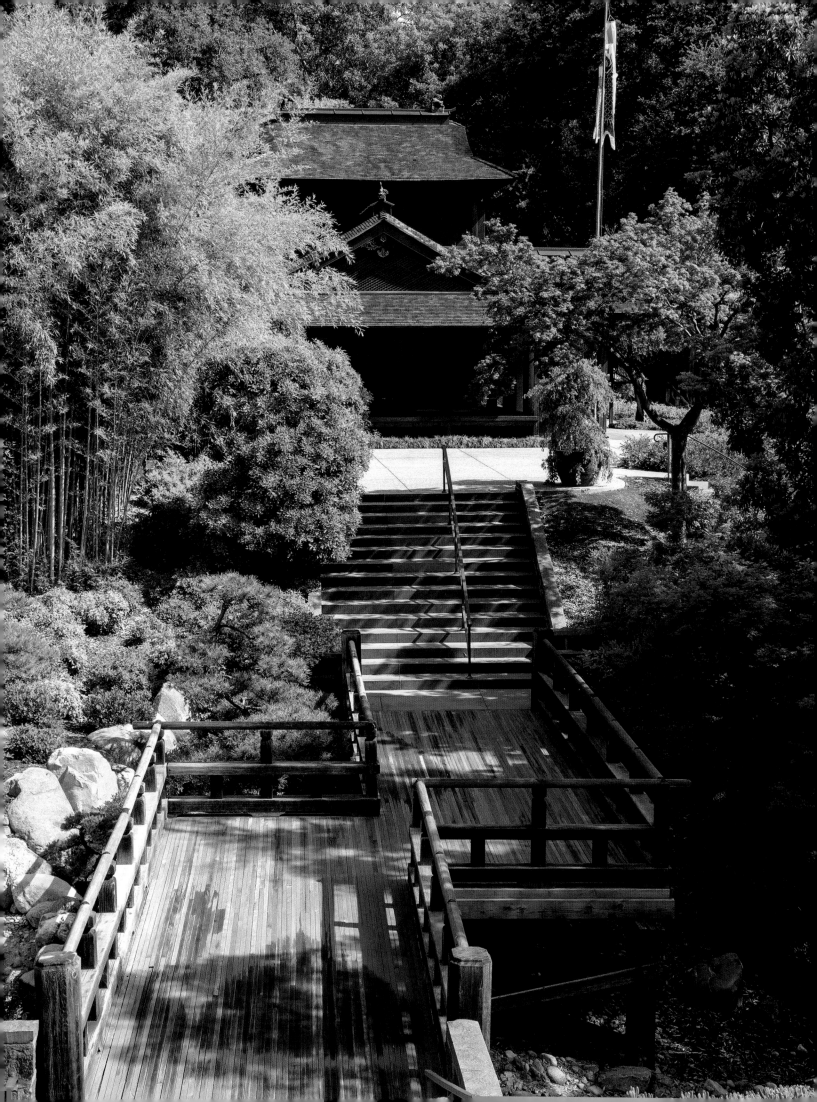

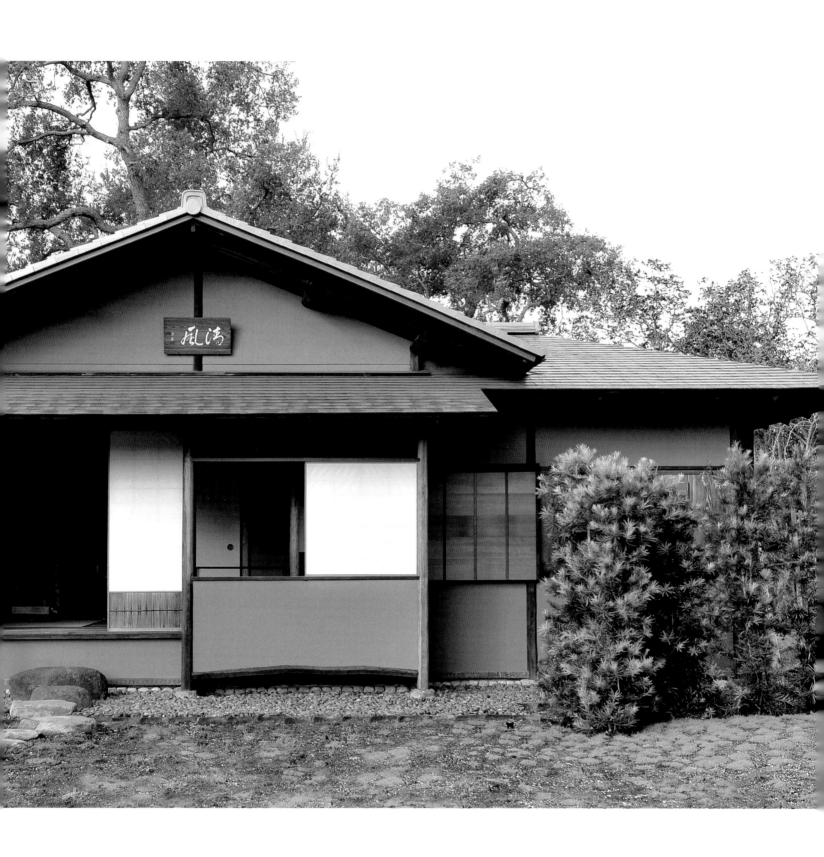

In 1964, Japan was re-entering the world stage by hosting the Summer Olympics in Tokyo. Many Japanese companies were making their first ventures into the American market. On the cultural front, government-sponsored exhibitions and performances of traditional arts were being organized for national tours.

It was also during this time that Dr. Sen, as the fifteenth-generation Urasenke Grand Master, began actively promoting an understanding of tea outside of Japan as a form of cultural diplomacy. Dr. Sen commented, "Not only does this provide an opportunity for tea to become international and worthy to be propagated the world over, but it provides the means by which Japan can become once again an equal member of nations through Sen Rikyū's (1522–1591) philosophy of 'Harmony, Respect, Purity, and Tranquility.'"[8]

Both Dr. Sen and his youngest brother, Sen Mitsuhiko (right), spent time in the United States during the 1950s. Dr. Sen made his first visit to Hawaii, Los Angeles, San Francisco, and New York in 1951, and then traveled as a cultural delegate to official ceremonies held in San Francisco in March 1952 to mark the end of the American occupation of Japan. Since then, he has traveled abroad on more than three hundred occasions to spread the ideals of tea. In 2012, Dr. Sen was named a UNESCO Goodwill Ambassador.

Millard Sheets (left) and Sen Mitsuhiko (middle) discussing construction of a Japanese model house at the 1955 Los Angeles County Fair. Photograph from the *Pomona Progress Bulletin*, August 13, 1955.

Sen Mitsuhiko first visited Los Angeles in 1952 to attend the Chouinard Art Institute, where he studied interior design and color theory. One of his objectives in coming to the United States was to develop a modern Japanese style that would incorporate, not reject, tradition.[9] In Los Angeles, he met the Japanese American sculptor Isamu Noguchi (1904–1988), who was striving to create works that not only reflected his bicultural heritage but also were international. Mitsuhiko developed an acquaintance with designers Charles Eames (1907–1978) and Ray Eames (1912–1988), and the influence of midcentury Modernism can be seen in his work.[10]

The design for Seifu-an reflected a desire to create a traditional structure that both embraced the past and appealed to a contemporary and foreign audience. But the challenges were great. As a teahouse sponsored by the grand master, it would be judged in the context of a four-hundred-year-old tradition that traced its origins to Sen Rikyū, the first great tea master. Moreover, the teahouse needed to function on a variety of levels, and therefore show Japanese creativity and inventiveness at work.

The true spirit of tea is found in the formal tea ceremony, the *chaji*, which lasts approximately four hours and involves a host entertaining a small number of guests. The ritual incorporates laying a charcoal fire, serving a meal, and preparing two bowls of tea, one thick in consistency, and the other a lighter, thinner mixture.[11] This full-length tea gathering typically takes place in a traditional Japanese-style room with tatami, or rice straw mats, covering the floor. A

four-and-a-half-mat room, a space of approximately nine by nine feet, is considered the ideal size to host a *chaji*. The first design requirement therefore was to create a small room appropriate for an intimate gathering (below).

Seifu-an was also to be used as a classroom or instructional space for students to learn the intricacies of the various *temae*, or tea procedures. One *temae* can take up to an hour to perform, and the classroom needed to accommodate several *temae* occurring simultaneously. Each student would require a dedicated preparation mat to lay out utensils and prepare the hearth for heating the water. A classroom space also entailed a separate area for observers and students waiting their turns. In addition, the teahouse needed to be large enough for fifteen to eighteen guests. In recent years, the full-length *chaji* has been replaced by the *chakai*, the more popular large public tea gathering in which several hundred guests are invited, and each is served a bowl of tea in shifts through the course of the day.

Finally, the teahouse had to function as an outdoor pavilion, open on the sides so that the public could watch and participate as guests without actually entering the room. In other words, Seifu-an needed to be designed as a small, intimate room that could also be transformed into a large, public stage to introduce a centuries-old tradition to new audiences.

Interior of the Huntington teahouse showing the sunken hearth and four-and-a-half-tatami-mat layout.

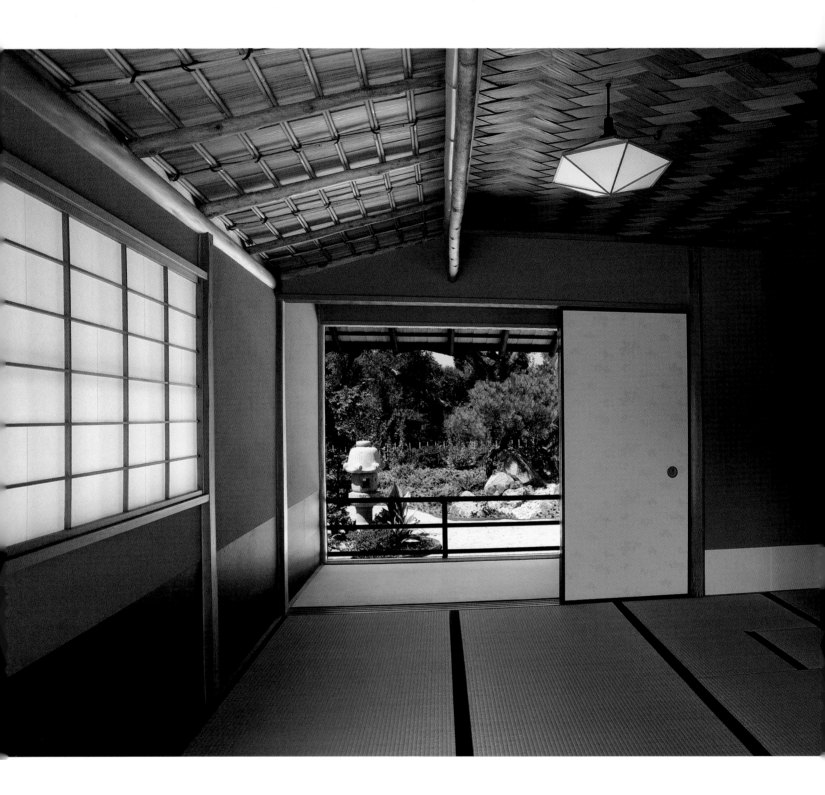

Architectural Styles of Teahouses

Interior of the teahouse showing the open *fusuma* and *shoji*, designed for public viewing.

There are two opposing styles of teahouses, and they emerge from separate lineages. One style is the *shoin*, or formal reception room, which was developed by the aristocracy and is considered appropriate for the design of large tearooms. The second style is the *sōan*, or thatched hut, used for small teahouses. Just as in Western architecture, established conventions dictate which elements can be used and how they should be combined.

To appreciate the challenges the designer faced in creating Seifu-an, it is helpful to have some background knowledge about the history and traditions of tea—the *shoin* and *wabi* styles. The *shoin* style of tea developed during the fifteenth century among aristocratic circles.[12] Tea had been introduced to Japan several centuries earlier by the Zen monk Eisai (1141–1215) on his return from studies in Song dynasty China, where he gained insight into its virtues and health benefits. In his treatise *Kissa Yōjōki* (Record of Tea Drinking and Cultivation), completed in 1211, he extolled the restorative properties of this wondrous plant. Tea kept the mind alert, alleviated fatigue, and served as a cure for sickness caused by tainted water. He recommended its use in monasteries to help monks stay awake during their long hours of meditation.[13] From his years in China, Eisai had learned how to cultivate tea, and he had developed an appreciation for the sophisticated culture of tea first expounded by Lu Yü (733–804) in the *Chajing* (The Classic of Tea) centuries earlier.

Under the patronage of shogun Ashikaga Yoshimasa (1435–1490), tea was transformed from a medicine into an aesthetic pursuit. On the grounds of the Silver Pavilion, located in the eastern hills of Kyoto, is the first tearoom constructed in Japan, the Dōjinsai (Study Chamber of All-Embracing Benevolence). The room has a subdued elegance and refinement suitable for a life of quiet contemplation. Its design stresses geometry and balance. Constructed as Ashikaga's private study and reception room, one of its special features is a small built-in writing desk, or *shoin*, with a window at its back looking out into the garden, giving this style of architecture its name.[14] The Portuguese Jesuit missionary João Rodrigues (1561–1633), in his *Historia da Igreja do Japão* (History of the Church of Japan), provides a description of the room:

He [Ashikaga] built there a small house [that] was used exclusively for gatherings to drink tea. He assembled all the utensils needed for such meetings—a copper stove, a cast-iron kettle, a tea caddy, a cane brush [tea whisk], a small spoon, and porcelain cups from which to drink the tea. The house was only four-and-a-half mats in size and was constructed of drab materials; to compensate for this plainness, he chose the utensils carefully, insisting on special proportions, sizes, and shapes, and hung monochrome ink paintings in the alcove.[15]

Prior to the construction of Dōjinsai, tea was prepared in a separate room or behind a screen by an attendant. Displaying the utensils prominently in the room made this impossible, necessitating the development of a formalized procedure to prepare tea in front of the guest. Nōami (1397–1471), the shogun's *dōbōshū*, or arbiter of taste, is credited with developing the *shoin* style of tea using rare Chinese utensils displayed on a black-lacquered ritual stand.

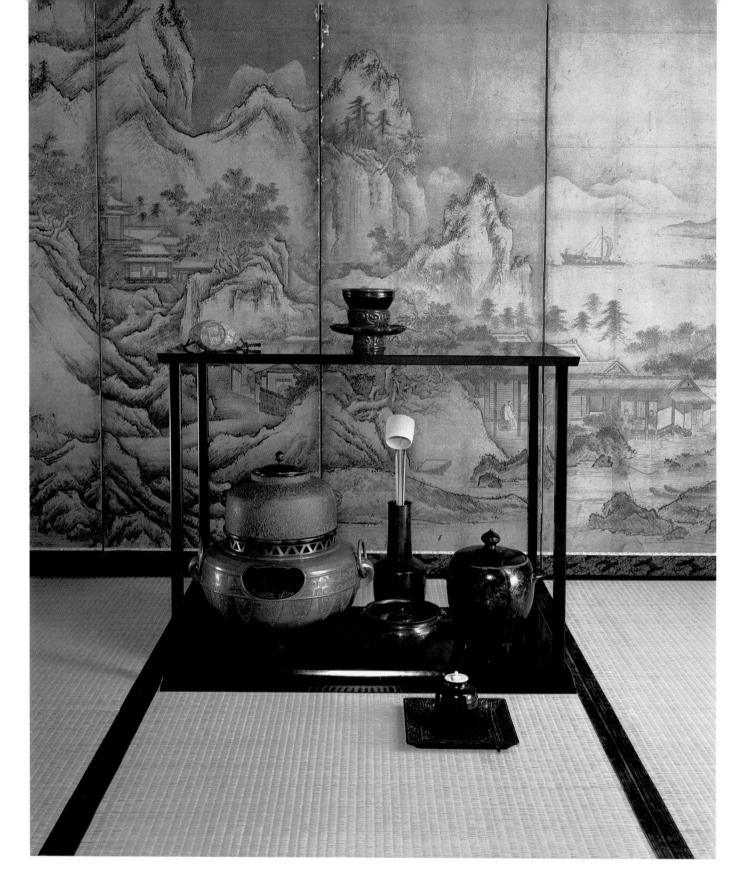

Formal display of Chinese objects on
a *daisu* stand. Photo courtesy of the
Tokugawa Art Museum, © Tokugawa
Art Museum Image Archive, DNPartcom.

Right: Details of ceiling.

Below: Nagahara Takasada (active mid-seventeenth century), *Portrait of Sen Rikyu*, calligraphy by Senso Soshitsu (1622–1697), ink and color on paper, Edo period, seventeenth century. 42.3 x 35.2 cm. Photo courtesy of Urasenke, Kyoto.

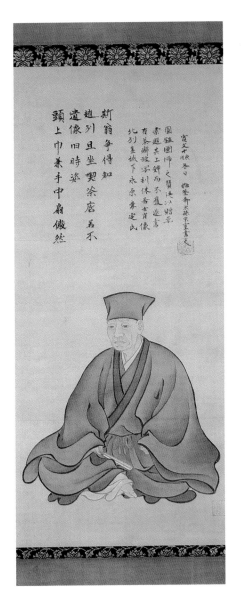

At about the same time, Murata Shukō (1423–1502), a pupil of Nōami, is credited with developing the *wabi* style of tea and popularizing it among the merchant class outside of the capital.[16] This style eschewed the refined beauty of Chinese objects of the *shoin* approach and called for a reappraisal of native Japanese wares. The *wabi* aesthetic discovered the beauty inherent in such natural materials as wood, bamboo, straw, clay, and stone. It rejected the gorgeous and perfect in favor of the humble and imperfect. Rodrigues writes:

Certain Sakai men versed in *cha-no-yu* built the *cha* house in another way. It was smaller and set among some small trees planted for the purpose, and it presented, as far as the small site allowed, the style of lonely houses which are found in the countryside, or like the cells of solitaries who dwell in hermitages far removed from people and give themselves over to the contemplation of the things of nature and its First Cause.[17]

The tea master Sen Rikyū, who lived during one of the most turbulent periods of social and political upheaval in the country's history—the Warring States period, which lasted more than a century until Japan was unified under the Tokugawa shoguns (1603–1868)—is regarded as the individual who had the most profound influence on transforming tea from an aesthetic pastime into a spiritual discipline called *chado*, or the "way of tea." For the samurai who risked his life on the battlefield, Rikyū's philosophy of *ichigo ichie*, each meeting being a unique moment never to be repeated, had real and special significance.

Rikyū was born into an affluent merchant family in the port city of Sakai; he began his study of tea while in his teens under the tea master Takeno Jōō (1502–1555). He underwent Zen training and assumed the Buddhist name "Sōeki" when he was twenty-three years old. From his mid-thirties to his mid-forties, his name appeared in numerous records of tea gatherings, but little more is known about the first half of his life.

Tai-an (Waiting Hut), the only surviving teahouse built by Rikyū. A simple flower arrangement in a bamboo container is featured in the *tokonoma*. Photo courtesy of Myoki-an, Kyoto. © Benrido Photo Archives.

Rikyū's life changed dramatically in 1568, when the warlord Oda Nobunaga entered Kyoto with the intention of unifying a nation that had fallen into civil war. As a provincial parvenu, Nobunaga developed a strong interest in tea, amassing a large collection of tea utensils, which he used as rewards for service in battle. Nobunaga's second-in-command, Toyotomi Hideyoshi, also became an avid tea enthusiast, fostering a close relationship with Rikyū. By 1574, Rikyū was regarded as one of the greatest tea masters of Japan. When Hideyoshi became the de facto ruler of Japan upon Nobunaga's assassination, Rikyū became his tea master and confidant.[18]

Rikyū is the tea master who turned the tea ceremony into an art form, redefining all aspects of it, from teahouse architecture to garden design and ceramic production. He rejected the gorgeous and the perfect, as upheld by the *shoin* tradition, advocating a return to an impoverished simplicity. On the grounds of Hideyoshi's Osaka Castle, which towered eight stories high, Rikyū built a small teahouse with an area of only two tatami mats, naming it "Yamazato" (Mountain Hamlet). In this diminutive space, Hideyoshi received guests, prepared tea himself, and discussed politics. This teahouse does not survive, but a similar structure also built by Rikyū does—the "Tai-an" (Waiting Hut)—which has been designated a national treasure. Built in a rusticated style, it features exposed ceiling beams reminiscent of a farmhouse, walls covered with thick mud plaster, and a small doorway, roughly three feet by three feet, called a *nijiriguchi*, or low entrance. This teahouse epitomizes the *sōan*, or grass-hut, style of teahouse.[19]

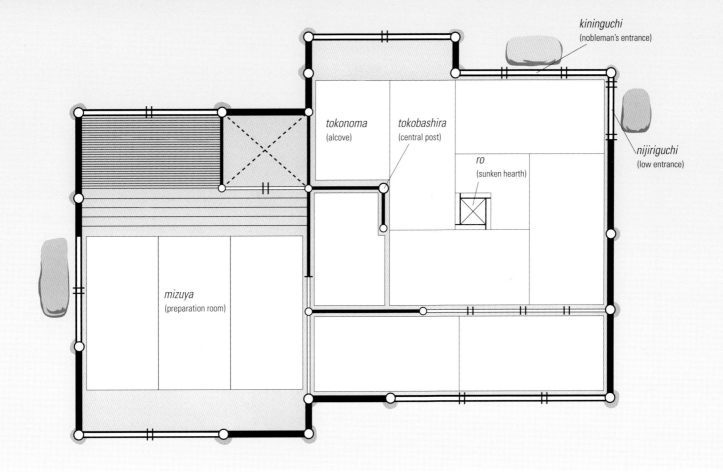

kininguchi
(nobleman's entrance)

tokonoma
(alcove)

tokobashira
(central post)

ro
(sunken hearth)

nijiriguchi
(low entrance)

mizuya
(preparation room)

The Design of Seifu-an

Floor plan of Seifu-an. Illustration by Doug Davis.

Seifu-an brings together in one room the *shoin* and *sōan* traditions of architecture. As we have seen, one style embraced refinement and display, whereas the other rejected it, stressing simplicity and the natural. What emerged is an ingenious study in harmony and balance, combining the function of both a large and a small room. In keeping with long-established conventions, the room's layout reflects a keen sensitivity to its surroundings and to the forces of nature (above). During Rikyū's time, each tatami in a four-and-a-half-mat room was associated with a cardinal direction, season, and element, based on Chinese Daoist beliefs and theories of geomancy.[20] North represented the cold, winter, and water. South embodied heat, summer, and fire. East, where the sun rises, symbolized spring and the element wood. West, the direction of the setting sun, controlled autumn and the element metal. The center half-mat represented the period before the onset of each season and symbolized earth.

Traditionally, the north wall of a house was left solid to keep out the cold north wind. This practice was maintained in the design of Seifu-an. The north wall of the tearoom has been divided into exact halves by a central post, the *tokobashira*, which was left in its natural form to preserve its textured grain. To one side of the *tokobashira* is a raised alcove, the *tokonoma*, where a scroll and flower arrangement is displayed. On the other side is the *daime*, a three-quarter-size mat used by the host for the preparation of tea when the room is expanded for large gatherings.

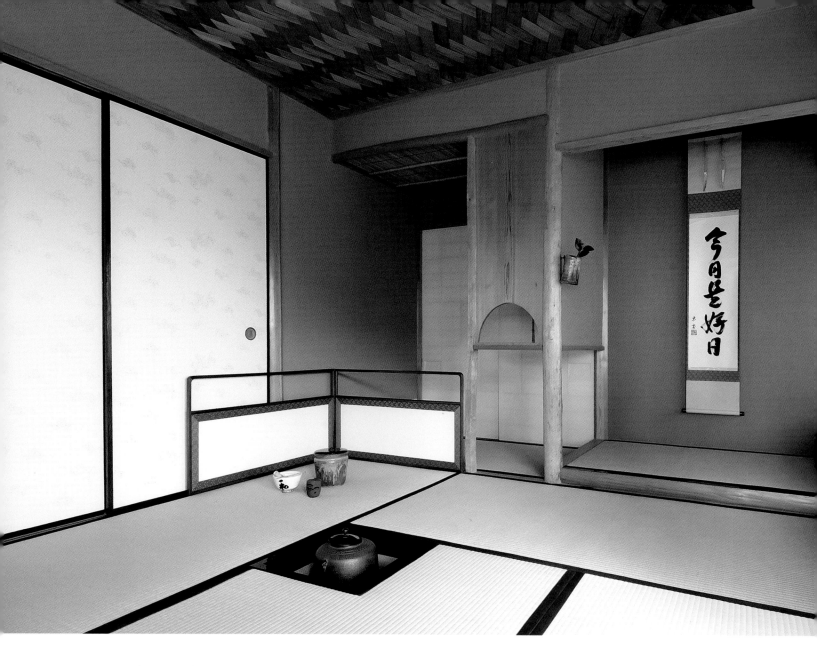

The east wall has a *shoin* desk alcove projecting outside of the room. A *shōji*-screened window above provides the *tokonoma* with natural light. Since east represents the beginning and positive elements of *yang* in Chinese geomancy, it is appropriate for the nobleman's entrance. The *kininguchi* are a set of *shōji* doors that allow the guest to step directly into the room. Both of these features derive from the *shoin*-style building, and they are devices that were consciously incorporated into the design to provide the public a full view into the room. However, at the east corner of the south wall is a feature unique to the *sōan* style of architecture, the *nijiriguchi*.

The west wall of the tearoom is made up of *fusuma*, sliding panels covered with thick paper, which serve as both doors and walls, helping to redefine the space. Outside the *fusuma* panels is a hallway that connects the tearoom to the *mizuya*, or preparation room. When the *fusuma* are removed, the tearoom can be expanded to a six-mat area. And when the outer *shoji* doors that flank the hallway are opened, the teahouse becomes a stage for public demonstrations.

Interior of the teahouse showing the north and west walls, four-and-a-half-tatami-mat layout, *tokonoma*, *fusuma*, and *shoji*.

Top: Detail of ceiling rafters made of branches and bamboo stalks.

Above, right: Detail of ceiling woven with cypress bark.

Overleaf: The *mizuya*, or preparation room.

A sunken hearth, *ro*, used for building a charcoal fire and heating water for tea, is installed in the center of the room. It is a feature that distinguishes a tearoom from an ordinary Japanese-style room, and it is the pivotal point around which the tea gathering unfolds. In the preparation of tea, the host symbolically brings together the five elements: fire, metal, water, wood, and earth—representing the entire universe—to prepare a bowl of tea for the guest. The tearoom becomes a microcosm of the universe, and through the tea ritual, host and guest are reminded of their interconnectedness with the cosmos. In the central mat, the cycle of creation and destruction according to Daoist tenets is re-enacted: wood feeds fire; fire creates earth (ash); earth bears metal (the kettle); metal carries water; and water nourishes wood (tea).

Connecting the four sides of the room is the ceiling, which is of particular interest. It is an expression of the craftsman's respect for nature and the desire to fully use his materials. Incorporated in the ceiling are the remaining parts of the tree not used in the main construction of the house, including the bark, upper limbs, and branches. The ceiling above the south and west sides of the house has been left unfinished, revealing the undersides of the sloping roof, with rafters made of branches and bamboo stalks bound together with wisteria vines (top). Above the main section of the tearoom is a woven ceiling made of cypress bark plaited diagonally to form a diamond pattern (above). A drop ceiling fabricated from reeds and grasses has been installed over the *daime* preparation mat as an expression of the host's humility.

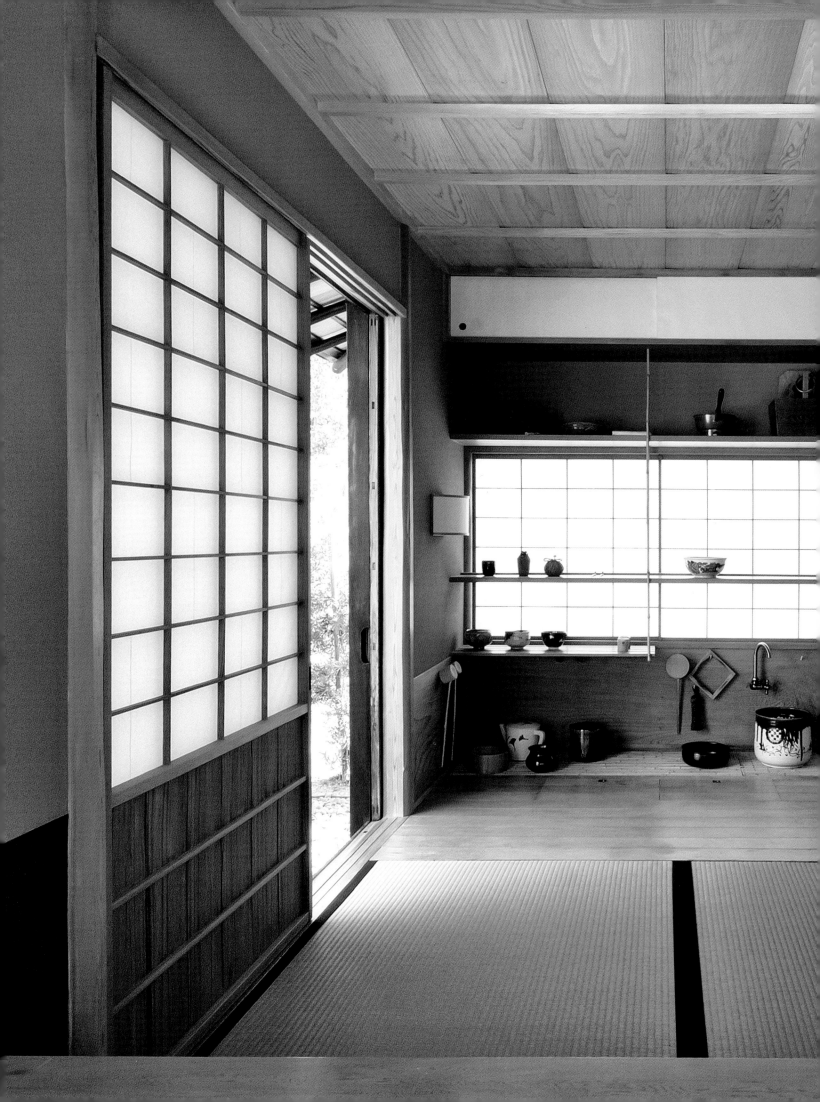

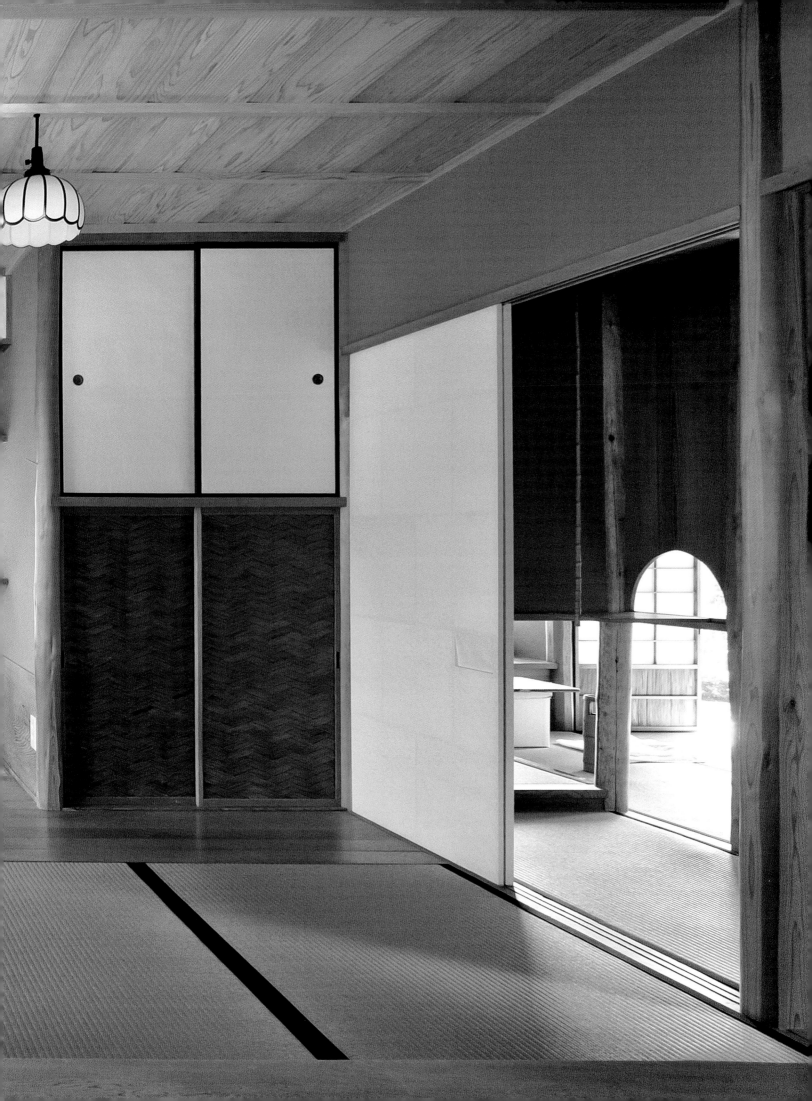

Symbolic Significance of the Tea Ceremony

In its development, the tea ceremony was influenced by Daoist, Shinto, and Buddhist thought.[21] Daoism stresses that humankind should strive to live in harmony with nature and the universe. Shinto teaches that everything in the universe, including inanimate objects, has a living spirit that deserves respect. The goal of life is to provide each with an opportunity to fulfill its useful purpose. Zen Buddhism concentrates on direct experience and focusing the mind to live in the moment, and the same can be said about tea. Sen Sōtan (1578–1658), Rikyū's grandson, said that the taste of tea and Zen are of one flavor.

Tea is not a religious practice, but it has deep spiritual and philosophic values. It is about making the ordinary into the special—taking the daily activities of eating and drinking and transforming them into something extraordinary. Through tea, the commonplace acquires a wholeness and significance it does not ordinarily possess. Rikyū achieved this by establishing a philosophical basis for tea in the four basic principles of harmony, respect, purity, and tranquility.[22]

Harmony defines humankind's relationship with nature and with society. The teahouse is built so that it becomes one with nature. The balance between materials, textures, and shapes in the well-crafted tearoom expresses harmony and balance. The utensils selected for use at a tea gathering should be in harmony with the season and appropriate for the occasion; and most importantly, host and guest should come together in a spirit of harmony.

Respect defines the relationship between host and guest, guest and guest, humankind and nature. It emerges from a spirit of gratitude and extends, not only to people and utensils, but also to all things animate and inanimate. By respecting the inherent beauty of nature, one is able to live in harmony with nature. The care and concern the host takes in preparing to receive a guest is a demonstration of respect.

Purity refers to both physical and spiritual attributes. Sweeping, cleaning, and washing create order and purity. In tea, the physical and symbolic act of purification simultaneously acts to purify the spirit and mind. Purity also implies simplification and elimination of unnecessary things. Purity is determining what is important and essential, and shedding the rest.

Tranquility can only be manifested when the three other principles are achieved. It is a dynamic state in which the body, mind, and environment are in accord. Tranquility is the goal of tea.

Grand Master Hounsai prepares tea at Seifu-an teahouse in Pasadena, 1965. Collection of Sosei Matsumoto.

The *Chaji*

The true spirit of tea is embodied in the *chaji*,[23] the full-length tea gathering that unfolds over a period of four hours. Approaching the teahouse at the appointed time, guests first pass through a wooden gate, humble in nature, that stands at the entrance of the tea garden. As they cross its threshold, they enter a sacred space. The gate is a symbolic barrier reminding guests to leave their troubles and thoughts from the everyday world behind and to savor the moment. The tea garden is a symbolic bridge leading guests on a journey from the mundane world to the inner world of tea.

The tea garden's outer gate.

When extending the invitation to tea, the host will leave the gate slightly ajar to signal to the guests that all is in readiness for tea. Passing through the garden gate, the guests enter the *roji*, or dewy ground, in single file. The path has been sprinkled with water to create a cool, refreshing feeling and to show that the garden has been thoroughly cleaned. The term *roji* derives from a passage in the Lotus Sutra.[24] According to the text, one lives in a burning house and is consumed

Left: The *nijiriguchi,* or low entrance.

Right: *Koshikake machiai,* or waiting arbor.

by desires. The tranquility of the dewy ground is what awaits when one chooses to abandon the life of endless passions. Roji can also mean a narrow road. Low shrubs, compact bushes, and ferns have been arranged around the path to suggest a mountain trail. Stepping stones are carefully and deliberately placed to slow the guests' pace and to focus their attention on the natural beauty around them. If there is more than one possible path of travel, the host will have placed at the fork a *sekimori ishi,* a stone tied with a length of cord, signaling the guests not to enter.

In a tea garden, the planting of colorful plants and flowering trees is avoided. Tea masters have often conveyed their teachings through poetry. One master selected this classic poem to describe the spirit of tea:

> As I look about
> I see neither cherry blossoms nor maples
> Only a grass-thatched hut
> Dusk in autumn[25]

At one corner of the roji is the *koshikake machiai,* a small covered arbor where guests congregate and wait for the host's invitation to enter the tearoom (right). A large garden normally is divided into an outer and inner *roji,* with the waiting arbor placed in the outer section. A small middle gate separates the two parts of the garden. The path leading to the teahouse is illuminated at night with stone lanterns.

After being greeted by the host, the guests make their way to the inner garden, where there is a *tsukubai,* a low stone basin where guests rinse their hands and mouths in a symbolic act of purification (overleaf). On both sides of the *tsukubai* are large, flat boulders with a candlestand for night gatherings and a pail of warm water for guests to use in the purification ritual during the

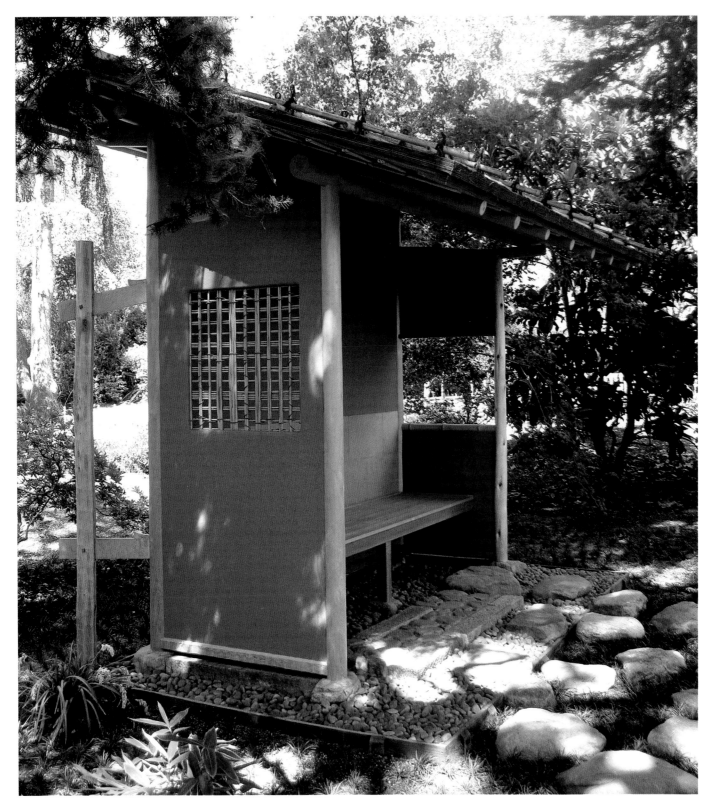

Page 86: Pathway and inner gate.

Page 87: The *tsukubai*, or water basin, in the inner garden.

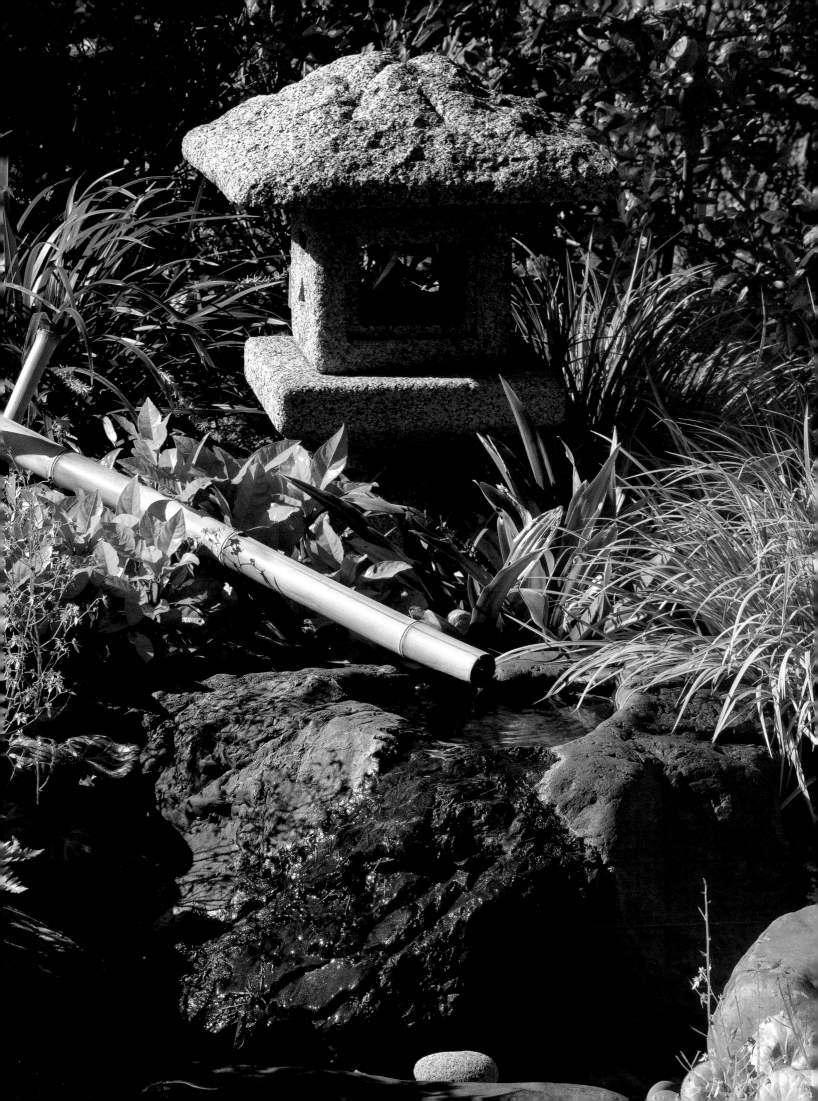

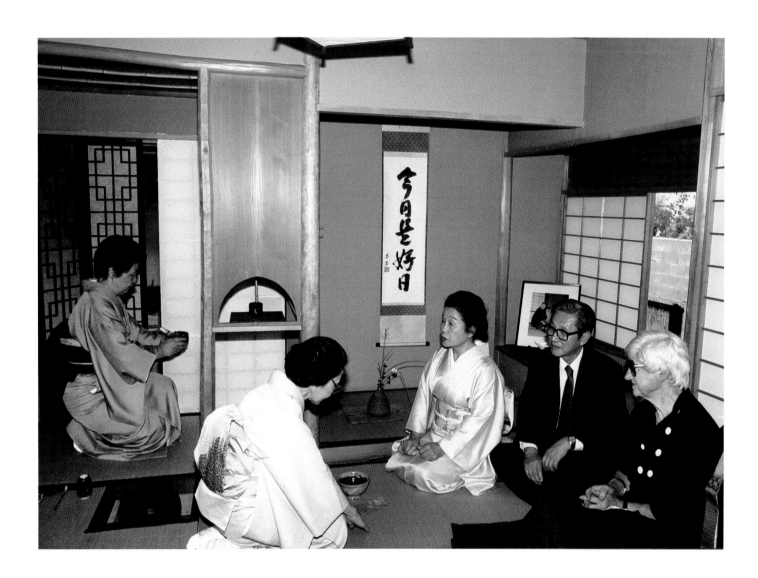

HORI

Mary B. Hunt (far right) and Sosei
Matsumoto (third from right) at
Seifu-an, ca. 1985. Photo courtesy
of Yaeko Sakahara.

cold winter months. The tea garden is said to embody the principles of purity and tranquility, and the tearoom, harmony and respect.

Making their way to the teahouse, the guests enter through the small, narrow doorway, the *nijiriguchi*. Standing at the entrance, all guests must lower their heads and look at their feet planted on the ground, a reminder of where they come from and where they will return.

Rikyū saw the tearoom as a place of perfect equality embodying the principles of harmony and respect. The *nijiriguchi* forces all to suppress their egos, bow, and enter with humility. During Rikyū's time, a sword rack was placed at the tearoom entrance. Even a samurai was not permitted to enter the tearoom armed. Today, symbols of wealth, power, or status, including jewelry, watches, and phones, are left behind when participating in a tea gathering.

As guests enter the room, they see a scroll with calligraphy or painting hung in the alcove, or *tokonoma*. Rikyū considered the scroll to be the most valuable of all utensils found in the tearoom. The written word, particularly calligraphy by learned monks, embodied and transmitted wisdom, and its meaning was unchanging. The host is not present when the guests enter the

room, and it is through this device that the host sets the tone and mood for the gathering. Once the guests have settled in the room, with the main guest sitting in front of the *tokonoma*, the host enters the room, greets each guest, and then returns to the preparation area, re-entering with a basket of charcoal to build a fire before the guests.

In a freshly prepared bed of ashes, the host lays a set number of charcoal pieces, burns incense to purify the air, and places a fresh kettle of cold water on the fire. While the water comes to a boil, the guests are served a light meal known as *kaiseki*. The word *kaiseki* refers to warm stones that monks would place in the folds of their robes to help stave off hunger pains. In tea culture, it refers to a small meal that is just enough to satisfy the appetite. In spite of its humble origins, *kaiseki* is now considered the epitome of Japanese cuisine. The choicest ingredients, delicacies from the mountain and the sea, are assembled to create a meal that represents the best of the season. The *kaiseki* should be beautiful to the eyes, pleasing to the tongue, and satisfying for the heart. The *kaiseki* meal is limited to one soup and three side dishes or courses, each featuring a different preparation method: the first one raw, the next one simmered or boiled, and the final one grilled. An exchange of sake cups takes place, with the host offering his guests tiny morsels representing earth's bounty. At the conclusion of the meal, a moist sweet is served. The guests are then invited to step back into the garden to stretch their legs while the host refreshes the room and arranges the utensils in preparation of serving tea.

When they return to the tearoom, they see that the scroll has been replaced with a simple flower arrangement. One of the rules of Rikyū is to "arrange flowers as they are in the field."[26] Unlike ikebana, which uses a variety of materials and set forms, tea flower arrangements may be as simple as a single blossom. Flowers symbolize the beauty of nature and the fragility of life. Blossoms that open in the morning and close at night are favored as an important reminder of *ichigo ichie*. In winter, the camellia is a favorite flower because the entire blossom drops when it reaches its prime. Rikyū is said to have invited Hideyoshi to a tea to see the morning glories blooming in his garden. Before his distinguished guest's arrival, he removed all the blossoms growing outside so as to feature in the *tokonoma* a single, perfect, white morning glory covered with dew, whose beauty would fade by midday.

The preparation of *koicha*, or thick tea, is the highlight of an invitation to tea. The water that has been heating on the hearth for an hour has just come to a boil, with gentle wisps of steam rising from the kettle. The sound of the water simmering at the perfect temperature is described as the wind whispering through the pines.

The tea procedure can be divided into three parts. The first is the symbolic purification of the utensils. All of them have been cleaned and prepared beforehand, but as a way for the host to assure the guest that every step is being taken to make a good bowl of tea, the utensils are again cleaned, warmed, and inspected in front of the guest.

Next in the preparation of thick tea, a measured portion of powdered tea is whisked with hot water to make a thick consistency. Each guest shares the same bowl, taking three and a half sips

and then wiping the rim with a linen cloth before passing the bowl to the next guest. *Koicha* underlies the harmony and bonds of friendship between the guests. Some scholars speculate that Rikyū saw Jesuit missionaries conducting mass and developed the thick tea ceremony as a secular form of Communion. Six of Rikyū's seven disciples were Christian, including Takayama Ukon, or Dom Justo Takayama, who fled to the Philippines when Christianity was outlawed in Japan in 1614.[27]

Following the service of thick tea is the final step, in which the host again cleans the utensils and presents them to the guests for viewing. After *koicha*, the host replenishes the fire with a second laying of the charcoal and then begins the preparation of thin tea, making an individual serving of frothy green *matcha* for each guest. Once all the guests have been served, the utensils used for the preparation of thin tea are presented to the guests for their inspection. Guests inquire about the maker of the objects, the circumstances of their creation, their history, and their provenance. The tea scoop, for example, is a simple object made from a single piece of bamboo that has been steamed, bent, and carved. Tea scoops are often made by the tea master, given poetic names, and presented as gifts. The full-length tea gathering, which began with a more somber mood, ends with a more buoyant atmosphere, accompanied by ongoing conversation concerning the selection of utensils and the circumstances of the gathering. Tea utensils form the vocabulary of a poetic language, and it is often only at the conclusion of the gathering that the guests are able to grasp the host's full intentions. Before leaving, they will again approach the *tokonoma*, taking a last look at the flowers arranged specially for the occasion.

After the guests leave the tearoom, they wait in the garden for one final farewell. The host opens the tiny *nijiriguchi*, bowing to the guests, and watches them as they leave the garden. To the casual observer, nothing remarkable has happened. But when approached with sincerity in accordance with the principles of harmony, respect, purity, and tranquility, a simple bowl of tea will satisfy the body and nourish the spirit.

Perhaps the true spirit of a tea gathering is best captured in the words of the Urasenke Grand Master Sen Sōshitsu XV, who has spent the last sixty years sharing the ideals of tea with the people of the world:

In my own hands I hold a bowl of tea; I see all of nature represented in its green color. Closing my eyes I find green mountains and pure water within my own heart. Silently, sitting alone, drinking tea, I feel these become part of me. Sharing this bowl of tea with others, they, too, become one with it and nature. That we can find a lasting tranquility in our own selves in company with each other is the paradox that is the Way of Tea.[28]

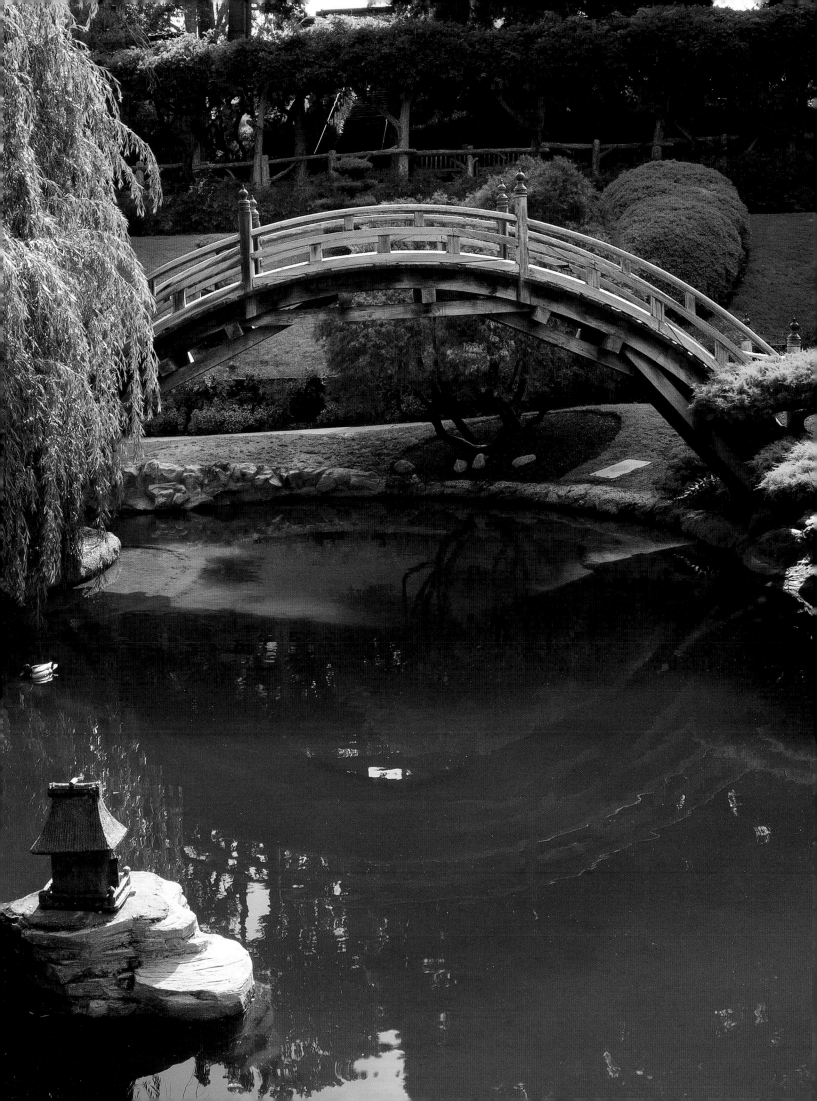

From Japan to America:
The Garden and the Japanese American Community

NAOMI HIRAHARA

On August 26, 1902, he arrived in San Francisco on the *Gaelic* after traveling across the Pacific Ocean from Japan. He was not a young man, but already forty years of age, with a wife and infant daughter back in Yokohama. Ship records state that he was a "servant" of a Mr. "Victor March," who paid for his passage. His destination: Pasadena, California.[1]

The traveler here was Toichiro Kawai. He had been in the United States months earlier, and his benefactor was not Mr. March, as was incorrectly listed on the passage records, but Victor Marsh, an antiques dealer. Kawai's move to Pasadena eventually led him to create one-of-a-kind structures for the Huntington's Japanese Garden.

Kawai and his Japanese peers were more than artisans desired for their ability to create things Japanese or promote exotica. While absorbing Japanese garden elements in their own homes and encouraging the continuation of Japanese language and culture, they also attempted to find a place in America for themselves, their children, and their community.

From the time he was a boy, Kawai had wanderlust and a passion for boats and the sea. Born in the rural town of Enshu in Shizuoka Prefecture on October 1, 1861, Kawai trained in woodworking and landscaping at a temple.[2] Later, he traveled northeast to the cosmopolitan port city of Yokohama. He stayed at a rooming house operated by the Ishiwatari family. The family's patriarch, a civil engineer, was responsible for the construction of a major bridge in Yokohama. In time, Kawai would marry Ishiwatari's daughter, Hama.

Yokohama, with its international flavor, gave Kawai the opportunity to serve as part of a crew on various foreign ships. His son Nobu wrote, "On British ships, he learned to eat beef,

Toichiro Kawai (center) with his wife, Hama, and their eldest daughter, Kimi, second from left, and the rest of their children, ca. 1918.

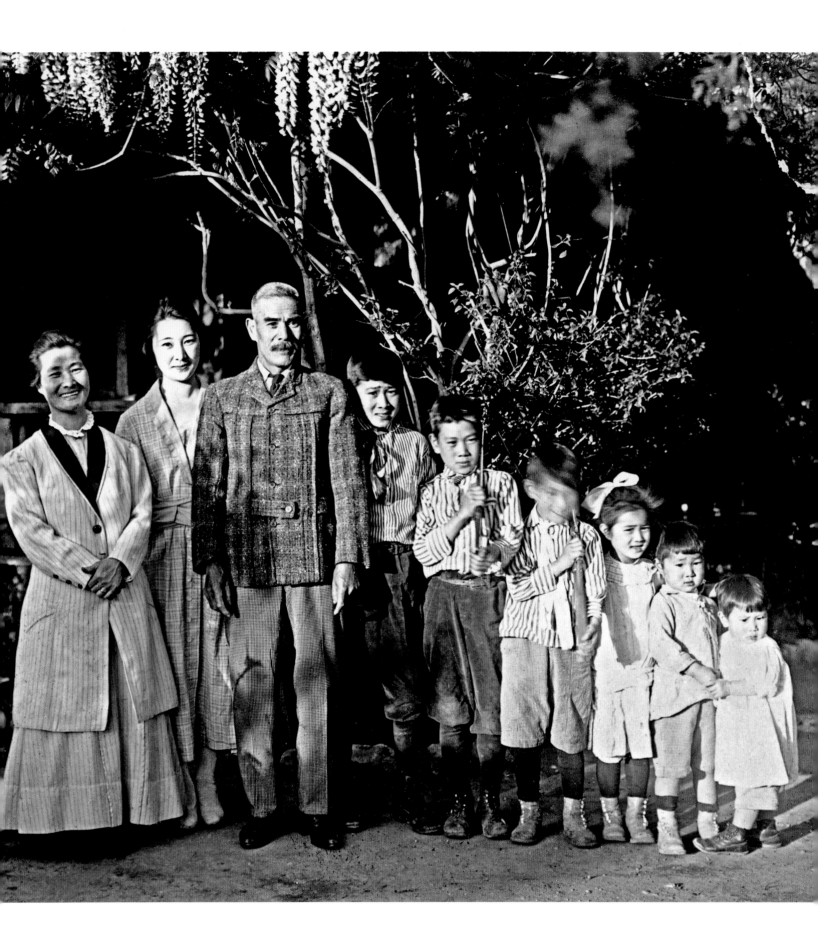

biscuits, and coffee and picked up a smattering of English, with a British accent."[3] Yokohama was also the stomping ground for art traders interested in antiquities. Victor Marsh happened to be on a buying trip when he met Kawai. Impressed with Kawai's bilingual ability, Marsh hired him to serve as an interpreter on trips to Kyoto and Nara. Thus started a strong relationship between the two men. Victor, the brother of George Turner Marsh, had opened an Asian art emporium on the northeast corner of what is now Raymond Avenue and Green Street in 1895.[4] He later expanded his operation with much fanfare. The *Pasadena Evening Star* reported on May 7, 1902, that a brick building was to be constructed in the central business district, with John Parkinson as architect. The building was to have two stories and a rounded corner; the first floor would be for Marsh's "Japanese goods business," while the second floor was reserved for rental office space for such institutions as the Hotel Green, located across the street.[5]

Kawai reportedly worked at the emporium as a restorer of art objects and a wood-carver. His tie to his employer was close. When Marsh was planning another buying trip to Japan in 1904, Kawai asked him to bring back his wife and toddler daughter. Sure enough, when the *Gaelic* arrived in San Francisco on September 23, 1904, it brought Marsh as well as Hama, twenty-seven, and Kimi, three.[6] Marsh did not stay in Pasadena long, however. In 1910 he announced that he would auction off much of his Japanese art collection and turn his attention to real estate holdings and ranching interests in Mexico.[7]

One of the torii gates in the Japanese Garden, built by Toichiro Kawai.

Kawai and the Huntington

The extent to which Victor Marsh was involved in the G. T. Marsh Company's Japanese Tea Garden on the corner of California Street and Fair Oaks Avenue is not known at this time. But Kawai's expertise as a master carpenter had reached the ears of William Hertrich, Henry E. Huntington's ranch foreman. Kawai was part of the crew who moved the Japanese House from the Marsh Japanese Tea Garden to Huntington's San Marino property in early 1912.[8] According to his son Nobu, Kawai marked each piece of the house as he dismantled it so that he could properly reassemble it in its new location.

More work followed at the Huntington estate for Kawai: torii gates, one of which was constructed of cedar logs (above), as well as new architectural structures. As reported by Hertrich, "[W]e secured the services of a Japanese craftsman who designed and constructed

By 1915, more than forty households of Japanese ancestry, or Nikkei, were in Pasadena, according to the *Rafu Shimpo* newspaper directory. By 1920, the city found that sixty Nikkei households had participated in that year's census.[15] A majority of householders were involved with floriculture, predominantly as gardeners, but also as owners of nurseries and flower shops. As their families grew, there arose a need for a Japanese-language school as well as other community gathering places. The Pasadena Union Church, a combined effort of the First Congregational Church and First Friends Church missions, was established for Japanese American parishioners in 1913. At first it was located in the central business district at 139 Mary Street, where the Japanese school had originally met. Later, it moved to its own building a few blocks west at 301 Kensington Place.[16]

In 1920, community members raised $5,000 for a down payment on three and a half lots at 56 Elevado Drive for a Pasadena Japanese Community Center.[17] On January 28, 1923, hundreds in their Sunday best met in the newly constructed building for a special celebration (below). Included in the crowd was Toichiro Kawai. This community did not remain insular, however.

The celebration of the new building of the Pasadena Japanese Community Center, January 1923, at 56 Elevado Drive (now Del Mar Boulevard) in Pasadena. Photo courtesy of Pasadena Japanese Cultural Institute.

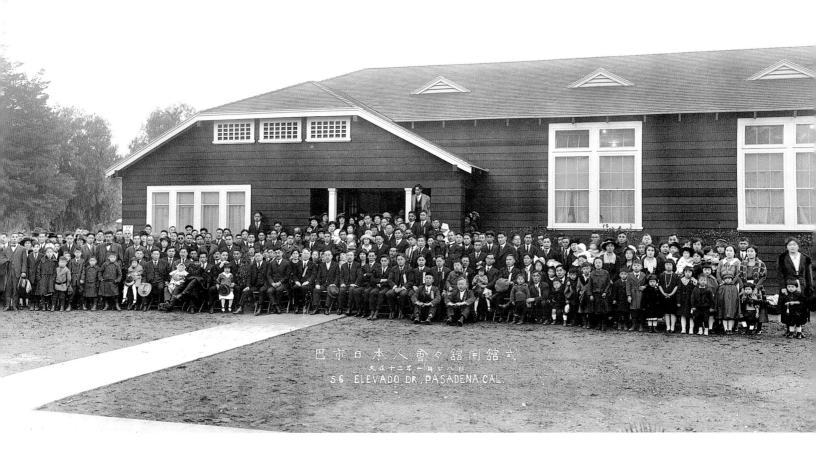

巴市日本人会々館開館式
大正十二年一月廿八日
56 ELEVADO DR. PASADENA CAL.

Kawai, who socialized with Wakiji, built his own home less than a mile away from Nippon Nursery at 84 Harkness Street—a 1910 building, according to Pasadena city documents. Because the two men had established themselves in the city before the passage of the California Alien Land

Toichiro Kawai and his wife, Hama.

Law of 1913, which barred foreign-born Asians from purchasing land, Kawai and Wakiji were among the very few Japanese who resided on the east side of Pasadena, not far from orange groves, packing sheds, and farmland, as well as the Huntington estate. According to Nobu Kawai's biography of his father, "Mom couldn't understand why dad bought property 'so far in the country.'" Seven of the Kawais' eight children were born in the United States.

Kawai, handsome and striking, with an imposing moustache and tall in stature, was photographed several times with Pasadena's other Japanese founding fathers. Most of the men had jet-black hair, but Kawai's was graying, as befit his senior and pioneering status.

Though there would be at least one other Japanese carpenter to hang his shingle in Pasadena, Kawai undoubtedly was the go-to man when it came to anything artistic in the local Japanese community. He designed at least three community floats for Pasadena's annual Tournament of Roses Parade, beginning in 1910. One was shaped like a huge flower basket, created with figleaf palm leaves and "heaped high with thousands of pink carnations."[12] Three girls in kimono, sitting in front of the basket, were the daughters of pioneering first-generation Japanese Americans, or Issei, including Kimi Kawai, seven, and Toshi Watanabe, four, the daughter of G. S. Watanabe, proprietor of the Manako Restaurant. Located at 30 N. Fair Oaks Avenue in the central business district, the restaurant was one of the first businesses operated by Issei that served Western-style food. The float reportedly was entered by Manako Restaurant and "the Japanese colony." According to the 1910 census, ninety-three Japanese were concentrated in two districts around downtown Pasadena.[13] The second float Kawai designed for the Japanese Association won first prize in the Historical Characters category. His third float, built in 1913, featured two figures from the official seal of the state of California—a grizzly bear, made out of pine branches, and his daughter Kimi as the Roman goddess Minerva.[14]

THE JAPANESE BELL AND BELL TOWER

In 1914 carpenter Toichiro Kawai erected a "bell house" (*shōrō*) on the Japanese Garden's east hill in order to shelter a temple bell (*tsurigane*) acquired from Asian art dealer Nathan J. Sargent in Pasadena. Though common at Buddhist temples, bell towers are not a standard feature of Japanese gardens. When the Japanese government taxed Buddhist temples in the early 1870s, some of them closed, while others sold their land and treasures to raise funds. Statues, ritual objects, tombstones, and bells were bought by collectors as "art" objects.

An inscription on the Huntington's bell indicates that it was "cast for Chōfuku temple, Yoshida, Kitauwa-gun, Iyo [Ehime Prefecture] affiliated temple of Koyasan." The central vertical inscription reads, "Namu Daishi henjō kongō" (Hail, great teacher, universal adamantine illuminator)—a formulaic prayer offered to Kūkai (774–835), founder of the esoteric Shingon sect. Smaller inscriptions list the bell's sponsors and donors and their addresses.

The bell is dated, "auspicious day, third month, third year Meiwa era [1776]." However, two particulars suggest that the bell was cast much later. First, the town of Kitauwa-gun was not formed until 1878. Second, according to Dr. Takanori Kimura and Takanori Matsuura, who have studied the bell and the Yoshida region, some of the named subscribers lived in the late nineteenth century. Thus, those who made the bell likely recast it after 1878, modifying the original but preserving its date of creation.

KENDALL H. BROWN

Bell installed in the Japanese Garden in 1914, originally from Chōfukuji, Yoshida, Ehime Prefecture, Japan.

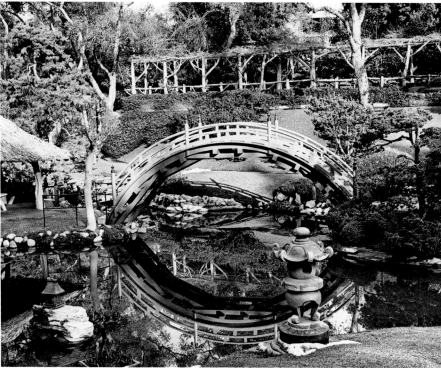

Above: The bell tower and moon bridge in the Japanese Garden, built by Toichiro Kawai.

the Full-Moon bridge, and at a later date, the ornate enclosure for the temple bell, a late acquisition. The bell tower was erected by this workman without the use of nails."[9] According to Hertrich's records, a "T. Kawai" was paid $96 for labor in November 14, 1914, with a work order of $230.52 for the "Japanese Bell House." At least two other payments followed for the bell tower work: $17.48 in December 1914 and $46.35 in January 1915.[10] Although the moon bridge eventually had to be reconstructed, the bell tower has remained intact ever since Kawai built it almost a century ago (above).

Kawai and the Japanese Community in Pasadena

Another early immigrant in Pasadena was Hanhichi Wakiji of Wakayama, Japan. Wakiji cofounded what is believed to be the first Japanese-owned nursery in Pasadena, Nippon Nursery, around 1903. Referred to by some customers as "Mr. Nippon," Wakiji established his business with two other partners at 1501 E. Orange Grove Avenue, near the North Loop Line of the Pacific Electric. Behind the nursery on the one-acre lot was a Japanese garden, which included a fishpond and bridge, as well as homes for his family and their guests.[11]

Perhaps because so many were involved in servicing the "outside world," whether it be wealthy patrons or luxury hotels, Japanese immigrants did not hesitate to represent their ethnic identity in public ways.

The graduation of the Pasadena High School class of 1927, for example, involved a Japanese pageant held at the Rose Bowl. The event featured traditional dancing girls in kimono and a "temple gate" constructed by Toichiro Kawai. The gateway, in fact, was mounted on the platform where the graduates received their diplomas. The torii was so impressive that the *Pasadena Star-News* reported that representatives connected with Hollywood wanted to purchase it after the graduation exercises. "A Japanese carpenter, who is gifted with fine artistic qualities, Mr. Kawai's contribution to the commencement staging greatly aided the success of the presentation, in which many Japanese people of the community and neighborhood figured," reported the article, dated June 18, 1927.[18]

The Goto Family and the Huntington

This same kind of "exotic" escapism was quite evident in the Marsh teahouse at the corner of California Street and Fair Oaks Avenue, staffed by a kimono-clad Japanese couple who served tea and Japanese treats. That husband-and-wife team is believed to have been Chiyozo and Tsune Goto (left). Chiyozo, from Hiroshima, Japan, had been in San Francisco before returning there again on November 25, 1903, this time with his wife, Tsune, by sea on the *Hong Kong Maru*.[19] Identifying himself as a thirty-three-year-old merchant, he reported in travel documents that he was headed for 418 Dupont Street in San Francisco. Now named Grant Avenue, this major thoroughfare in Chinatown could have been an area where George Turner Marsh operated one of his Asian antiquities businesses. According to Anita Brandow's history of the Huntington's Japanese Garden, Chiyozo served as a cook, while Tsune worked as a maid at the Marsh home in Northern California. Later, they were sent to Pasadena to work at the Japanese goods store and Japanese Tea Garden managed by the G. T. Marsh Company. It is not known how often Marsh, who had a Japanese-themed summer estate in California's Mill Valley and a store in San Francisco, traveled to Pasadena.

Chiyozo Goto with his wife, Tsune, and first son, Kame, ca. 1907. Photo gift of the Goto family.

Trained by a Japanese couple on how to care for the garden and serve tea, the Gotos lived in a small house on the Marsh property behind the larger Japanese house used to serve tea to paying customers. Their oldest son, Kametaro, or Kame, was born in 1907, followed by another son, Shigeo, or Shige, a year later, and then a third son, Kenny.[20]

Left: Tsune Goto and son Kame in the Marsh Japanese Garden, Pasadena, ca. 1908.

Below: Chiyozo and Tsune Goto and their sons Kame and Shige with other workmen in the Huntington Japanese Garden. Photo gift of the Goto family.

Moving to the Huntingtons' San Marino Ranch in 1913 dramatically changed the life of Chiyozo, Tsune, and their three sons. In a letter to Henry E. Huntington dated May 19, 1913, William Hertrich explained that a three-room cottage was being built for the "Japanese man" to live behind the Japanese House on the far slope of the canyon, so that he could care for the garden. Until the completion of the wooden three-room cottage in the fall, the man, presumably Goto, was apparently living in the larger Japanese House. It is unclear exactly when the rest of his family joined him, but eventually all five members of the Goto family would reside in the cottage for at least a year and a half.[21]

According to the eldest son, Kame, life for his parents was "hard": "Their living was spartan and their hours were long."[22] The children had to walk several miles to go to school in the neighboring city of San Gabriel. After a long day of tending the large Japanese-style garden surrounding the house, Chiyozo had to cut wood for fueling the iron stove to heat bathwater. Mosquitoes were plentiful during the spring and summer, so the family slept under mosquito nets. In the afternoons on hot days, they napped in the Japanese House, which was considerably cooler than their cottage.

There were advantages to living on the ranch, however. Chiyozo was paid $95 a month for his caretaking services, which was at least $30 more than what most other gardeners received. During a nationwide recession, the Goto family did not suffer from a lack of food. Twice a day, the children would receive milk from the dairy cows that were kept on the ranch. And its fruits and vegetables often fed the family. Next to the Japanese House were a large avocado tree and an *ume* tree, the latter used by Chiyozo to make plum wine.

For children, there were magical moments in this garden world. The San Marino Ranch had five entrance gates, with a house inhabited by employees at each one. When the newspaper was delivered every afternoon, the paperboy would strike a decorative gong, or bell, located at the junction of the upper road and the south path into the Japanese Garden.[23] In an interview, Kame told Brandow that he would run to get the paper, as the paperboy was a friend.

This idyllic world would sometimes clash with the active life of a six- or seven-year-old boy. One time, Kame, also known as "Tom," was with his friends in another part of the garden, throwing rocks at lotus leaves in a large pond. He thought that "it was fun to see the large leaves break into pieces," he later told Brandow. This mischief was not appreciated by the caretakers; they reported the incident to the senior Goto, who "severely punished" his son. The Gotos' second son, Shige, or "George," told his only child, Richard, about shooting rabbits with .22 rifles at the corner of Bedford Road and Huntington Drive, confirming the truly rustic and country-like nature of the environs.[24]

At times the three boys had to abandon their very American attitudes and interests to "act" Japanese. "An Oriental atmosphere . . . was further enhanced on occasion by the family's custom of dressing up in Japanese costume for special holidays," Hertrich wrote in his memoir. "But so ideal a situation, both from the aesthetic point of view and the practical standpoint, could not be carried for more than a few years."[25]

Hertrich did not articulate why the arrangement did not continue, although Kame reported that his father was in ill health. After the Gotos' departure, Hertrich noted that "[t]he house since has been abandoned as living quarters. Many of the plants of the surrounding garden have grown out of all proportion to the original intention, and no longer fit into the scale designed for them."[26] From November 1914, another person, S. Oshita, identified as the "Japanese Gardener," was listed in Hertrich's payroll records.

Indeed, passenger lists from ship manifests show that Chiyozo Goto and some of his family members left the United States in September 1914. While his wife, Tsune, most likely remained in Hiroshima, Chiyozo did return to Los Angeles on at least two occasions, most likely staying at one of the residential hotels in Little Tokyo on San Pedro Street. Their eldest son, Kame, traveled back to Los Angeles in 1919, when he was almost thirteen. In December 1920, the young teenager was even listed on Hertrich's payroll records as receiving $19.80 for his work as a "laborer" in the Japanese Garden. When the Gotos' second son, Shige, turned fifteen, he, too, made the trip from Japan on the *Shinyo Maru*. Debarking in San Francisco, he headed for his father's most likely short-term residence in Little Tokyo. It is believed that the three brothers eventually lived on their own in a rental unit in South Pasadena. By 1939, Kame was living in northern Pasadena on 866 E. Washington Street, where his flower shop, Lake Florist, was located.[27] He and his two brothers were leading American lives.

Post–World War II: The Return to Pasadena

During World War II, most of the Japanese Americans in the Pasadena area were incarcerated at the Gila River War Relocation Center near Phoenix. Sadly, Toichiro Kawai, the patriarch of his family, died there in 1943. He was eighty-one years old.

The end of the war allowed Japanese American pioneering families to return to the Pasadena area, including Kawai's widow and children, as well as some of the Gotos and Wakijis. Shige Goto, in fact, followed in his father's footsteps and became a gardener for the estate of Wilbur Collins, near the Huntington estate.[28] Others from different parts of California also decided to make a new life in the area.

Chiyozo Goto in the United States, ca. 1922.

Yaeko "May" Sakahara and her husband, Isamu "Sam" Sakahara, were among these new-comers. Born in Sacramento in 1920, Yaeko was sent to Hiroshima as a young child and completed some of her schooling there. It was in Hiroshima that her grandmother impressed on her the importance of learning the Japanese arts, including both tea and flower arranging, or ikebana. Sakahara returned to the United States in 1941 and got married. Her husband, Sam, was also a Kibei Nisei—born in the United States, but raised in Japan. The newlyweds were living in the Long Beach area, south of Los Angeles, in 1942. During the forced removal of Japanese Americans from the West Coast, the Sakaharas were sent first to Gila. As each barrack was built to accommodate at least four adults, the Sakaharas, who did not have children yet, paired up with an older couple.

When the war ended, the Sakaharas joined their wartime friends in a house in Pasadena on Del Mar Street and eventually purchased a home in Altadena, establishing their cultural and religious roots there. They first looked for other Japanese American Buddhists like themselves.[29]

Though there apparently were not enough Buddhists in Pasadena to support a temple before World War II, the resettlement period was a different story. In 1948, the Pasadena Buddhist Church (now the Pasadena Buddhist Temple), a member of the Buddhist Churches of America, was established. The congregation met in a house at 1106 Lincoln Avenue before the completion of the temple and classrooms at 1993 Glen Avenue in northwest Pasadena in 1958. Four years later, an annex, which features a gym for youth basketball and cultural activities, was added.

And then in 1964 came the treasured addition: a teahouse, Seifu-an, or Arbor of the Pure Breeze, presented to the Urasenke tea ceremony school in the United States by the fifteenth Grand Master of Urasenke, Dr. Sen Soshitsu.[30] Up to that time, Sakahara and other members of the congregation studying *chado*, or the "way of tea," under Urasenke master Sosei Matsumoto met in a classroom. But with Seifu-an on the temple grounds, the students could now practice the tea ceremony in a proper setting. After Sakahara was bestowed her tea name, "Soju," from Matsumoto, she eventually taught and led her own students, about twenty at a time.

The teahouse, located behind classroom buildings, was also used for demonstrations. Each year, on the first Sunday of January, students and teachers from all over Southern California would gather at Seifu-an to celebrate the New Year with a tea ceremony and food. The last public tea ceremony demonstration was held at the temple's annual Obon festival, a traditional Buddhist summer gathering, in 2010.

Sakahara, who is now in her early nineties, is happy to see the teahouse preserved in its new home at the Huntington. She participated in demonstrations of both *chado* and ikebana at the Huntington Library alongside the late Mary B. Hunt, who was among the members of the San Marino League who spearheaded the restoration of the Japanese Garden. And, appropriately, where the teahouse once stood on the grounds of the Pasadena Buddhist Temple will be a garden. When asked why she continues her practice of tea, Sakahara says, "It's peaceful. No matter how busy your life is, it will calm you down."

Sakahara still teaches, but she does not have to travel far. Seifu-an inspired her husband, Sam, to build an eight-mat tearoom in their home in Altadena for their twenty-fifth wedding anniversary in 1966. He subsequently built two other tearooms, including one for their daughter's home in Duarte. When the house was sold in 2011, the tearoom was apparently a pivotal selling point.

The move of the teahouse is also meaningful for Richard Goto, a retired high school teacher who is a member of the Pasadena Buddhist Temple. His grandfather Chiyozo tended the Huntington Japanese Garden, and his father, Shige, played amid the structures that were either created by Toichiro Kawai or purchased from the G. T. Marsh Company.

Toichiro's son Nobu, who was around seven when the bell tower was constructed, wrote about his father's fervent devotion to the project: "I recall his staying up night after night drawing pages of blueprints. He wanted this to be [the] one with which he would be proud to have his name identified. All his talents were directed to make each joint fit perfectly. That he was satisfied with his work was indicated when he told us he had tacked a plaque, inscribed with his name as the builder and the date of construction in the attic of the building."[31] And indeed, when the inside of the bell tower was photographed in 2010, a plain wooden plank was found nailed inside the frame. Handwritten in Japanese, next to the date, was the name: Toichiro Kawai.[32]

In its landscape and structures, the Huntington's Japanese Garden represents a remnant of Japanese America, not only from the turn of the twentieth century, when pioneers began to arrive, but also from the postwar era, when Nikkei returned to the West Coast. By adding the Seifu-an teahouse to the original Japanese Garden, two seminal periods of Japanese American history, whether intentionally or not, have been symbolically joined like a beautifully crafted, traditional Japanese home.

Tea demonstration with Mary B. Hunt (standing). Photo courtesy of Yaeko Sakahara.

Yaeko Sakahara with her daughter at the teahouse, New Year 1972. Photo courtesy of Yaeko Sakahara.

Living History

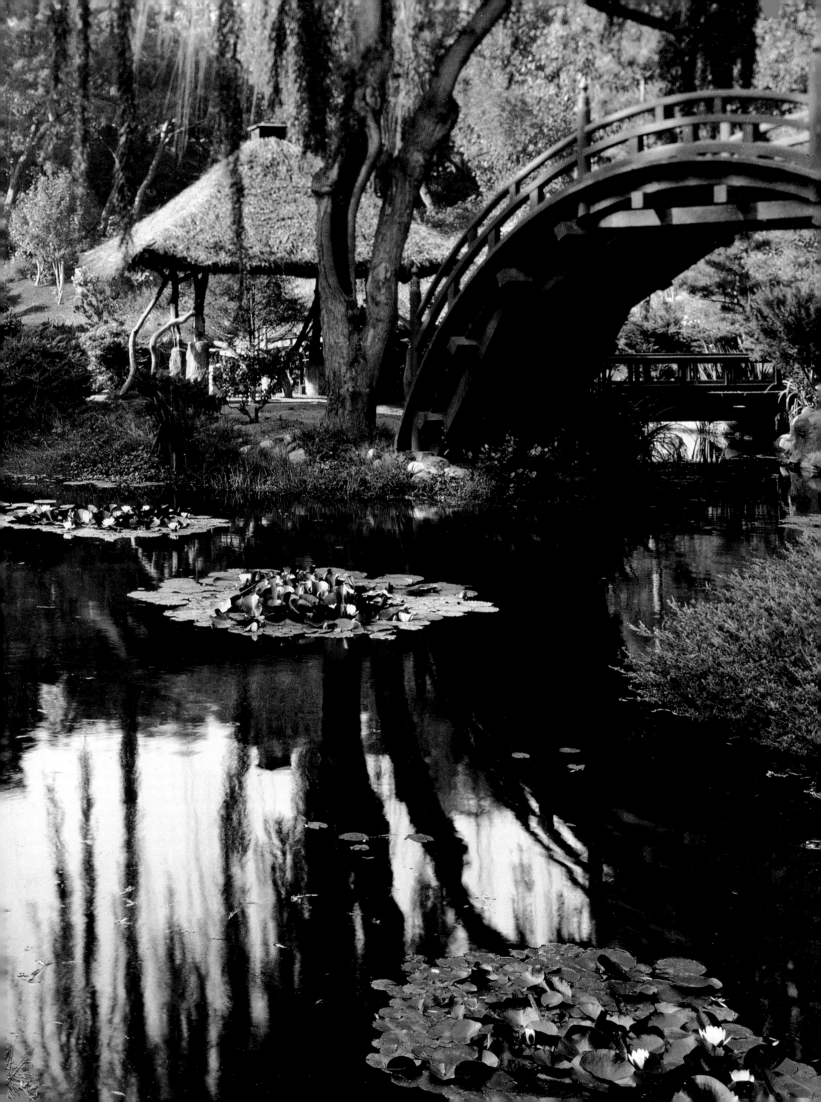

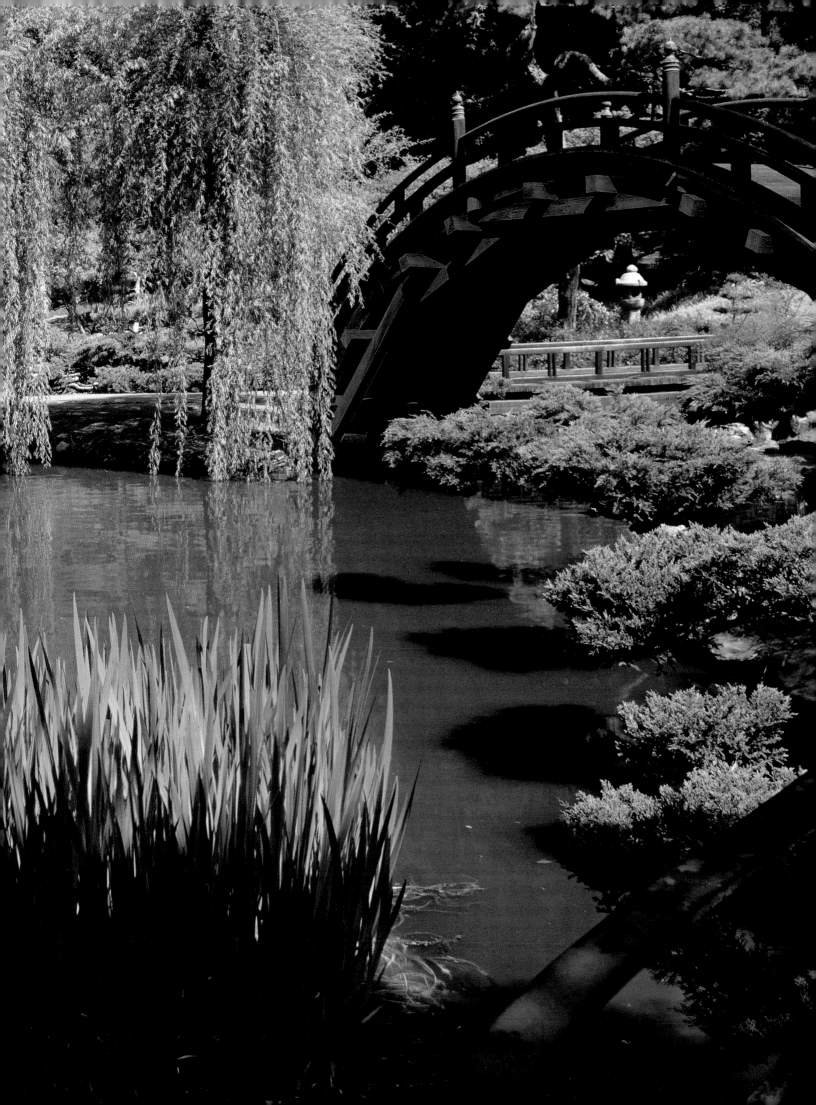

From Private to Public: An Icon Evolves

JAMES FOLSOM

The first story I ever heard about the Japanese Garden described it as a wedding gift from Henry E. Huntington to his new bride, Arabella. But the Japanese Garden was constructed before Huntington and Arabella married in 1913, so the idea that the garden was a gift seems to be a romantic fiction. As with many good stories, though, there may be some truth to the tale. In 1908, Arabella became highly engaged in selecting art for Huntington's residence in San Marino, and she would have expected his estate to include extensive gardens, as did her own country estate, the Homestead, in Throggs Neck, N.Y.[1]

Huntington had purchased 502 acres at the edge of Pasadena early in 1903 and launched into developing the landscape. It was a working estate, the San Marino Ranch. In the southeast corner, he installed the lily ponds that are still there today (overleaf). These ponds were clearly designed to give a first impression to guests arriving through the main entry, near the boulevard now called Huntington Drive. Beginning his work at the lower entry gave Huntington additional time for deliberating over more crucial matters, such as where the residence would be sited, and how the core of the property would be organized. In short order, an overall plan emerged. The palm and desert gardens fell into place on the south-facing slope. Decisions were made about the siting of the house, garage, game room, and aviary, so that the garden staff could lay out the rose garden and North Vista (the statuary-lined panel of lawn that stretches to the north from the Huntington residence). But garden-building abated between 1908 and 1911, as the focus shifted to the design, construction, and furnishing of the Huntington residence. Once the bulk of construction was completed, in 1911, Huntington turned his attention once again to the landscape, deciding to develop a garden in the beautiful canyon directly west of the residence.

Aerial view of the north section of the San Marino Ranch, ca. 1921.

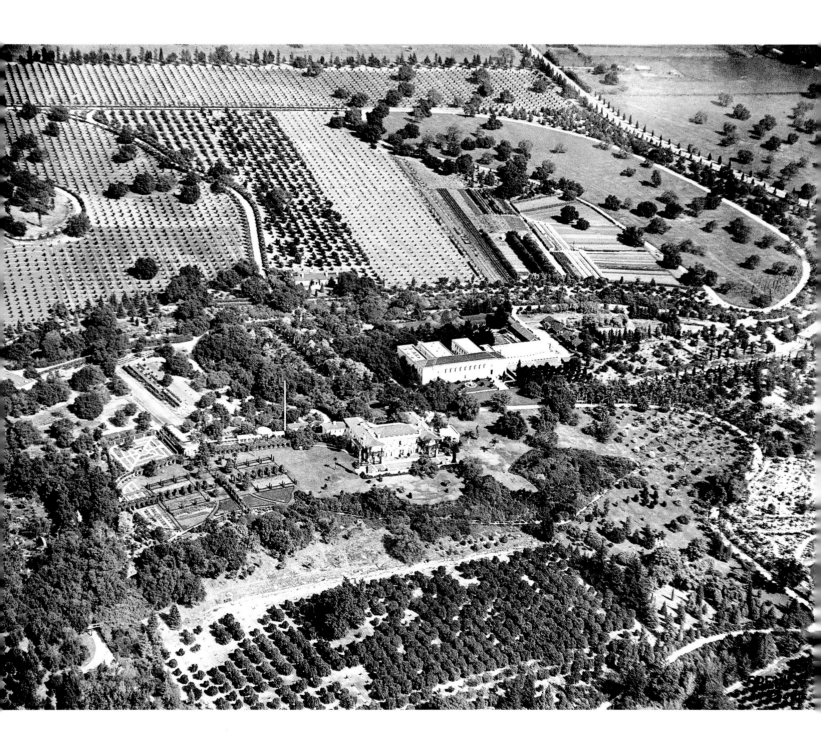

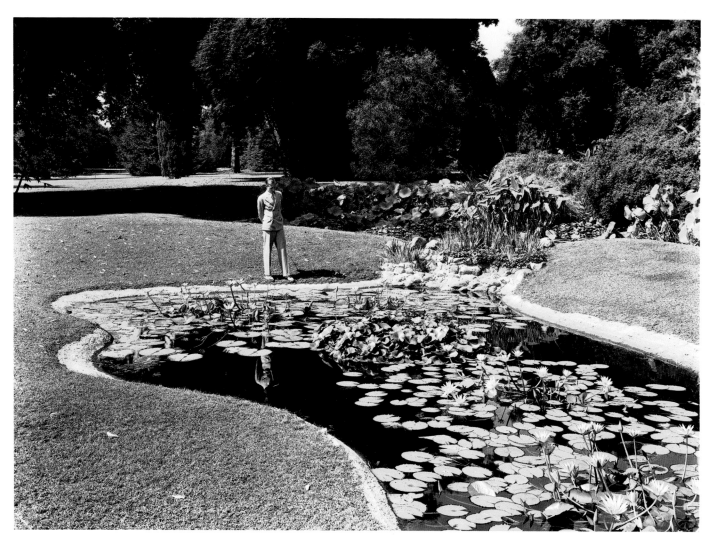

Early views of the lily ponds.

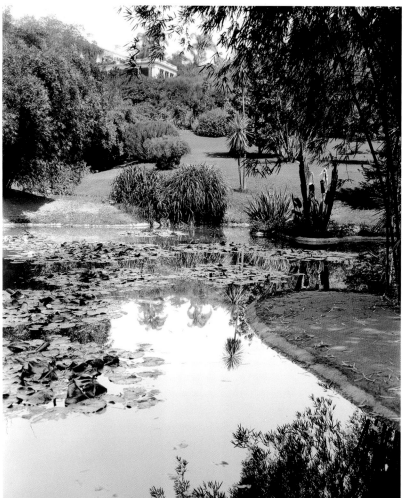

The new garden was, from its inception, envisioned as Japanese, as is clear from the earliest correspondence between Huntington and his ranch foreman, William Hertrich (below, right). This is not surprising: Japanese gardens were being created around the world, and they were in vogue in North America.[2] Indeed, Hertrich's library had many books and journals with designs for Japanese gardens, including Josiah Conder's *Landscape Gardening in Japan* (1893). And of course, the Marsh Tea Garden, less than three miles away at the corner of California and Fair Oaks in Pasadena, was a ready example. Japanese craftsmen and gardeners were available. And Asian plants, already important components of the American landscape, were generating great enthusiasm, as new introductions appeared on the market each year. This combination of skills, excitement, and opportunity made 1911 the perfect time to start the project.

But what about design and layout? How would the garden be made Japanese? What opportunities and challenges would it bring to improving the collections of plants that had come to characterize the estate? Huntington's and Hertrich's decisions on this score were documented not in writing or imagery, but in terms of the fabric of the garden. To begin, in 1911, Huntington purchased the Marsh Tea Garden lock, stock, and barrel.[3] In quick order, all of the elements of that garden were moved to their current site in the San Marino Canyon, just west of the rose garden, which had been completed in 1907. In its first incarnation, the Japanese Garden consisted of the Japanese House, ponds, a grotto, a thatched shelter, and the plants and stone ornaments that had been part of the Marsh Tea Garden. It appears that Huntington engaged Toichiro Kawai, a skilled wood craftsman from Japan, to dismantle the Marsh Japanese house and reconstruct it on his property.[4]

115

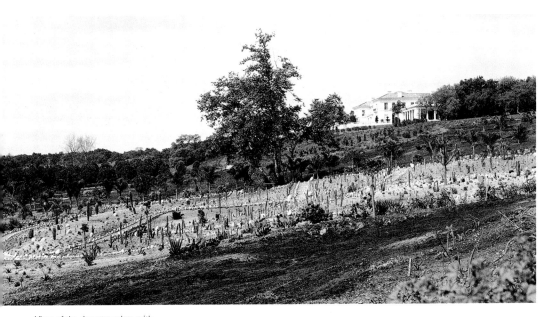

View of the desert garden, with the Huntington residence in the distance, ca. 1912.

William Hertrich in the Japanese Garden, 1962.

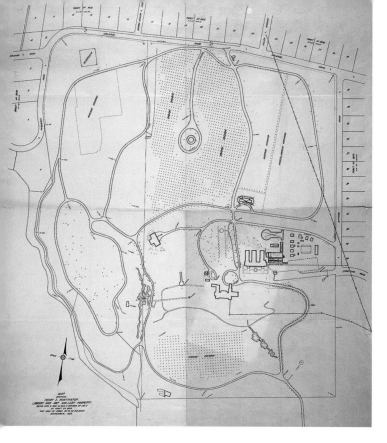

Kawai's involvement did not end with his reassembly of the Japanese House. Within a few years, the large arched wooden bridge, known as the moon bridge, was constructed across the center pond; a large bronze bell was purchased and a bell tower constructed for its display; an entry gate was built; and two massive torii gates were added at the northern and southern limits of the garden, spanning the lane that passed through the canyon. Hertrich describes the torii gates in *The Huntington Botanical Gardens, 1905–1949: Personal Recollections of William Hertrich, Curator Emeritus* (1949), even explaining that the wood was rescued from cedar logs used in the Indian Village in Lincoln Park, east of downtown Los Angeles. From what can be determined, all of these elements were constructed by Kawai and painted brilliant vermillion, with glossy black trim.

By 1927, when Huntington died and the Henry E. Huntington Library and Art Gallery became a public institution, the design and construction of the major buildings on the estate were almost completed. The main library had been built in 1919, and the mausoleum for the Huntingtons was under construction (to be completed in 1929). The Japanese Garden anchored the west side of the property as part of a series of structures and the approximately seventy acres of gardens surrounding the Huntington residence. Visitors to the new public institution (below) made the same trek to the Japanese Garden as the Huntingtons had taken, walking from the front steps of the residence through the rose garden pergola to the wooden entry gate flanked by

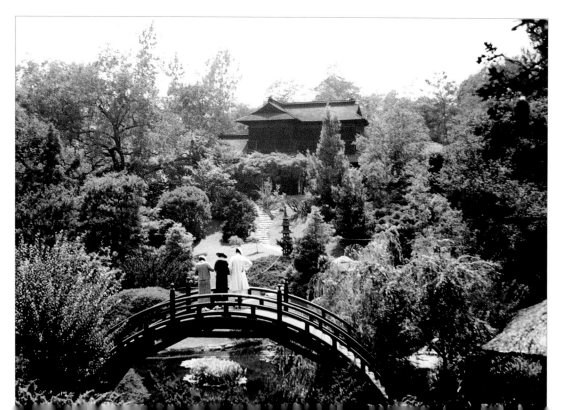

The Japanese Garden, after opening to the public.

the Japanese stone lion-dogs. From the entry, they passed by the bell tower and down the steps through the wisteria arbor to the ponds and the Japanese House. In the first year the institution was open to the public, more than 125,000 people visited the estate, and the Japanese Garden, with its colorful structures and highly trained plants, became an immediate favorite.

Decline

Prospects for the Japanese Garden would change soon thereafter, owing to the Great Depression that followed the 1929 stock market crash. Though the Depression was not disastrous for the fledgling institution, trustees' reports and letters from Max Farrand, the first director, leave no doubt that money was tight, and funding for the gardens extremely limited. Correspondence documents Farrand's request for a critique of the landscape by the Frederick Law Olmsted landscape architecture firm, but includes a clear directive that no new investments could be considered for the grounds. By the beginning of World War II, all of the gardens were in poor condition. Arabella's orchid collection had been sold, and the great lath house dismantled. Most of the desert garden was never opened for public viewing. The Japanese Garden, the most distant garden from the public entrance, was neglected to the point that the south canyon grotto and stream became overgrown and were closed to the public (as they remain today); the Japanese House was completely shuttered, seemingly abandoned. And funding, suddenly, was not the sole issue. Following the bombing of Pearl

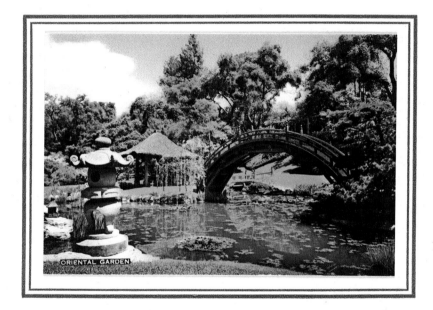

Postcard of the Huntington's "Oriental Garden."

Harbor, California's Japanese American community became subject to a misguided national hysteria against everything perceived as Japanese. Along with thousands of others, the Kawai family, after four decades in Pasadena, was forced to go to an internment camp. At about that time, and for the next decade, the Huntington's Japanese Garden became known as the "Oriental Garden," its staffing gradually diminished, owing partly to the labor shortage during the war (above). Hertrich, in his writings, acknowledged the probable loss of the deteriorating Japanese House, referring only to landscaping the canyon with a growing collection of Oriental plants.

Reawakening

In 1948, Hertrich retired from hands-on management of the grounds. His interest in camellias had been piqued in the early 1940s, and he now concentrated on them. While overseeing activities as curator emeritus, he hired a series of garden superintendents. One of these, J. Howard Asper, was a camellia specialist who worked with Hertrich to build what was envisioned as the most extensive camellia collection in the country. Over the next several years, the entire canyon north of the Japanese House as well as the forest surrounding the North Vista were planted with hundreds of camellia hybrids, all of which were painstakingly studied and described by Hertrich in his three-volume publication, *Camellias in the Huntington Gardens* (1954–59).

Asper's interest in camellias and other Asian plants, along with his work in the canyon, returned the institution's focus to the disintegrating Japanese Garden. Trustees' reports once again referred to concerns about the Japanese Garden and discussed efforts to preserve the exterior of the Japanese House. Most importantly, outside support for the garden surfaced in 1957, when several local residents who had come together to form the arts-based San Marino League took serious interest in the future of the Japanese Garden and approached John E. Pomfret, director of the Huntington, with a proposal to assist in restoration of the Japanese House. The vital partnership that emerged would underpin the preservation and future growth of the Japanese Garden.

Leaders of the San Marino League—principally Mrs. Ralph Walker, Mrs. Austin Cushman, and Mrs. Robert Taylor (Mary B. Taylor)—came to the project for the long term. Within a year, the League's volunteers had cleaned and restored the interior of the house and raised funds to hire specialists to replace the screens and mats and to supply furnishings. For the very first time, the Japanese House was open for display, and the garden could support public programs. Mary B. Taylor (later, Mary B. Hunt) began teaching ikebana classes, a role she would enthusiastically fill for nearly fifty years (opposite). League members organized ongoing activities, from tea demonstrations to exhibitions and festivals to tours for schoolchildren, which continue to this day.

In the midst of this regeneration, Myron Kimnach, the superintendent hired by Hertrich to manage the gardens in 1962, continued to promote and expand the Japanese Garden. By 1965, Kimnach had placed Robert Watson, a student of bonsai and viewing stones (*suiseki*), in charge of the garden. From then until 1968, Watson, foreman Fred Brandt, and other staff members expanded the public experience by creating the Bonsai Court and the sand-and-rock garden, later named the Zen Court. Watson systematically trained plants in the garden to be more faithful to the Japanese style, and he worked with the San Marino League and other organizations to mount exhibitions of flower arrangements, bonsai, and viewing stones. By 1973 the ikebana program had developed to such an extent

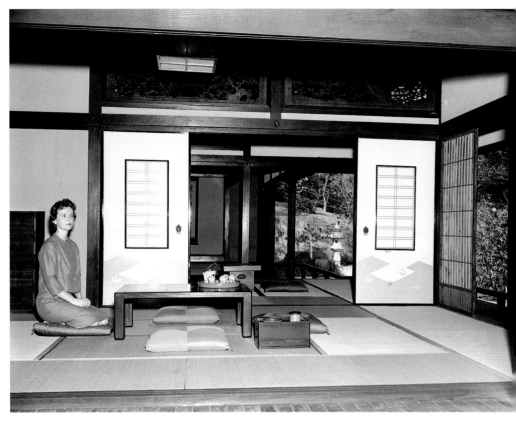

Activities in the Japanese Garden in the 1960s.

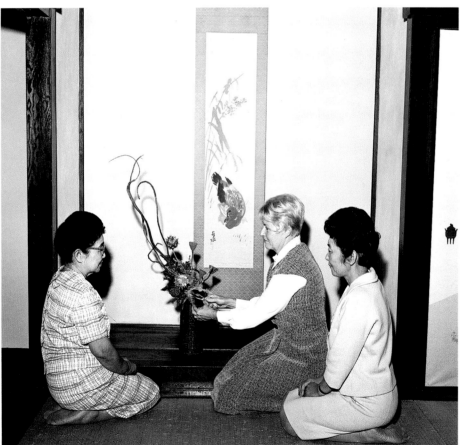

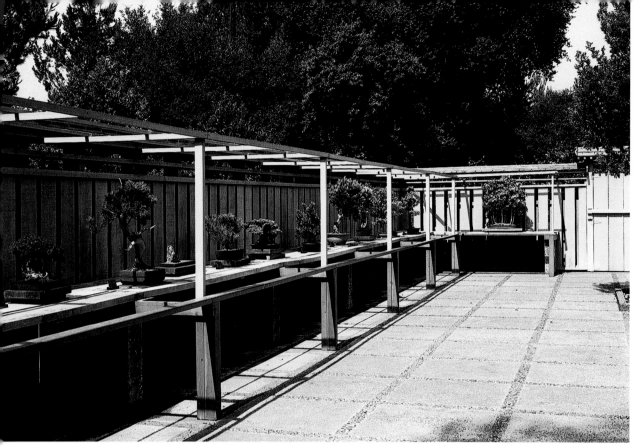

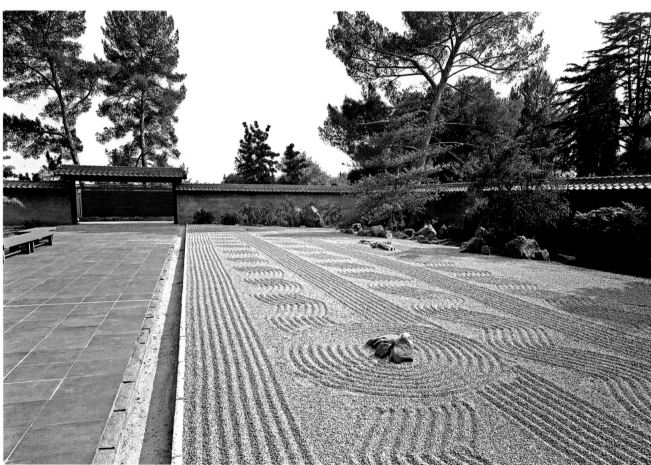

that it needed its own classroom. Through funds provided by Mr. and Mrs. Austin Cushman, construction was completed on the Ikebana House, a flower workshop designed by local architect Whitney Smith. Additions to the garden were celebrated with public openings, and, in the case of the Ikebana House, with a Shinto ceremony. The enhancements also led to a steady expansion of Japanese Garden programs over the next two decades. The postwar phase of development culminated with a major Tanabata, or Star Festival, as part of the celebrations for the 1984 Summer Olympics in Los Angeles.

There was, however, no dedicated funding to support the Japanese Garden. Every enhancement depended on donations, most of which came from fundraising efforts by the San Marino League. Recognizing the need for long-term support, the League established the first Japanese Garden endowment in 1986 to help underwrite improvements and programming.

Further Development

Above left: The Bonsai Court.

Above right: Entrance to the Zen Court.

Left: The Zen Court, 1968.

In the early 1990s, in order to assist with improving the Japanese Garden's bonsai display, local bonsai artists Khan and Kay Komai brought their talents to bear, along with those of their students. When it became clear that more staff expertise would be needed to tackle the display, Ben Oki was appointed as the founding curator. Something of a legend in the world of bonsai, Oki spends much of the year traveling around the world teaching, training gardeners, and designing and building gardens. At the Huntington, he began a program to develop and maintain the many pines in the Japanese Garden. His artistic pruning also revealed the beautiful undulations in the main trunks of the junipers in the central garden. The junipers had survived from original plantings but had gradually overgrown to engulf the pond edges in heaping green mounds.

Through the Komais and Oki, the Japanese Garden was introduced to Golden State Bonsai Federation (GSBF) board members Larry Ragle and Bill Hutchinson, who were investigating the possibilities of creating a public GSBF bonsai collection and display. Following extensive discussion, a formal Memorandum of Understanding was signed to establish a collaboration between GSBF and the Huntington. The goals were to build a quality bonsai collection and display, designated as the GSBF Collection South, and to make the Japanese Garden a center for promoting the arts of bonsai and stone appreciation.

The relationship still prospers, thanks to numerous programs and annual events. Each year begins with a handsome exhibit of viewing stones organized by California Aiseki Kai, a society of viewing-stone collectors. As a fundraiser, the Collections South GSBF Committee organizes an annual Bonsai-a-Thon—a weekend of displays, sales, presentations, and workshops

that brings skills and excitement to a growing audience of bonsai enthusiasts. The income from these events continues to build the GSBF's endowment for bonsai at the Huntington, established in 1996. Other events include the annual California Bonsai Society exhibit, featuring over fifty of the finest specimens from private collections.

These programs and collaborations have inspired significant improvements in the Japanese Garden itself. Anonymous gifts underwrote the restoration of the moon bridge and established an endowment to support its long-term care. Joan and David Traitel underwrote the refurbishment and expansion of the 1968 Bonsai Court to make that area accessible.

At the same time, the staff continued to wrestle with a simple but significant change in the look of the landscape. During Huntington's lifetime, the torii gates (now lost), the entry fence, the bell tower, the moon bridge, and a small, flat bridge nearby had all been painted a brilliant vermillion (opposite, top). In the early 1970s, the fence and bell tower were painted dark brown, leaving only the bridges and the ceiling of the entry gate in red. In 1992, through the anonymous gift, the deteriorating moon bridge was restored. As part of the restoration, paint was stripped, and the bridge was treated to preserve the wood and allow the natural grain to show (opposite, bottom). Decisions about the original structures, the need for expansion, the growth in support, and the burgeoning of programs called attention to the reality that, through a century of the garden's evolution, change had been opportunistic, and at times capricious. The Japanese Garden had grown up. As an important component of the Huntington, the garden now had a wide audience, numerous stakeholders, and greater potential than ever. In 2009, on the eve of its centennial, the Japanese Garden was overdue for a long-term plan that would celebrate its rich history and anticipate a purposeful future.

Restoration, Expansion, and the Next Hundred Years

The approaching centennial highlighted the fact that original structures were in need of restoration. Celebration plans were also affected by a bequest from longtime supporter Mary B. Hunt, who established endowment support for a new tea garden and cultural programming, as well as the gift of a ceremonial teahouse and tea implements from Pepperdine University. Study visits to gardens and specialists in the United States and Japan, along with extensive analysis of the Japanese Garden's history, site, collections, infrastructure, and facilities, provided substantive information. Huntington staff, board committees, volunteers, and collaborating partners engaged in a series of discussions, as did advisers, designers, engineers, conservators, and contractors. The issues seemed endless: establishing a clear mission and program philosophy for the Japanese Garden, confirming aesthetic goals, planning spaces and facilities to support programs, improving the public's experience and physical access to all areas, assuring the restoration and future expansion of garden features, rebuilding infrastructure and irrigation systems, and determining how these changes and improvements might be sequenced, scheduled, and funded.

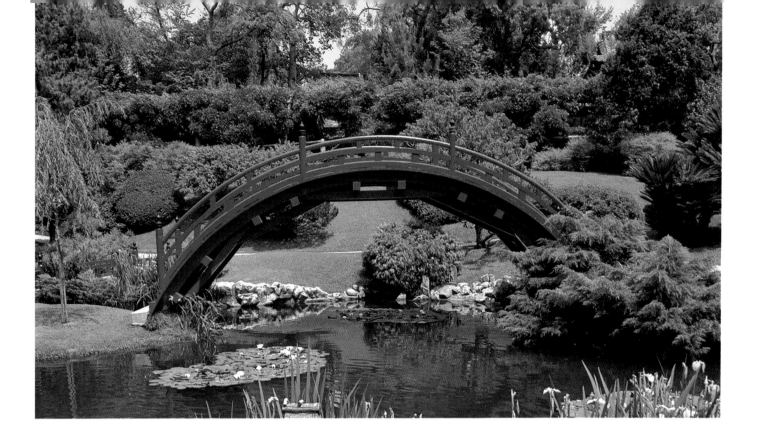

The moon bridge, before and after restoration.

Through these studies, it became apparent that a mission statement had evolved: the Japanese Garden reveals and advances Japanese garden arts through experiences that delight the senses, inspire appreciation of the plants and gardens of Japan, celebrate the American assimilation of Japanese aesthetics and crafts, and convey traditional skills that encourage personal creativity. It was this mission that informed the evolving garden master plan, which in turn defined the centennial restoration and improvement project. So what is that plan, and what history has just been recovered?

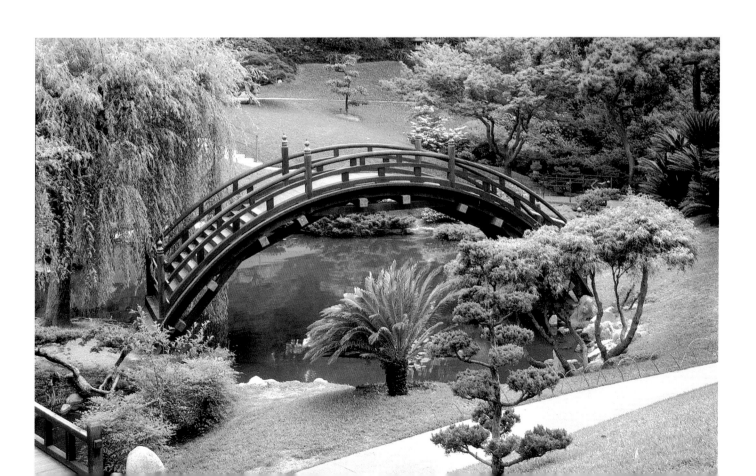

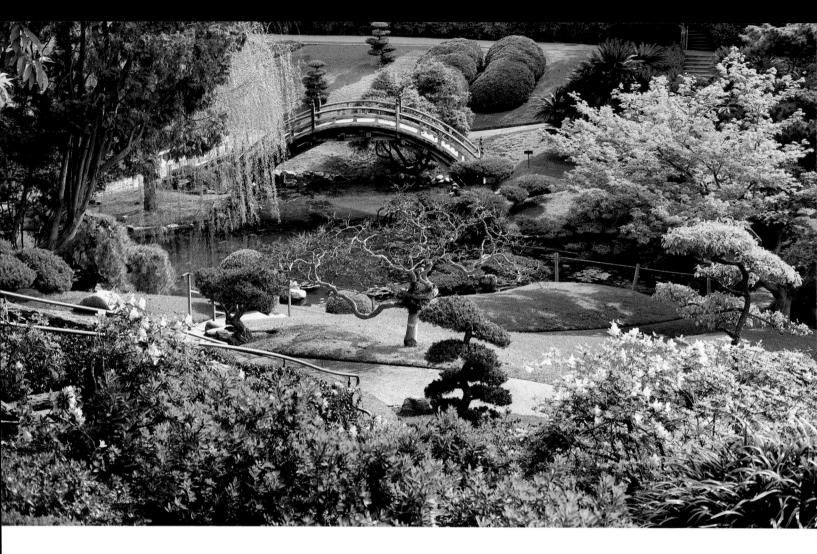

The Japanese Garden is fashioned as a series of encounters, the first being the Huntingtons' original Japanese Garden (the central stroll garden), with all of its remaining original elements honored and restored (above). This garden is, unapologetically, an early twentieth-century American interpretation of a Japanese garden. As such, it has been a wonderfully successful, even iconic, aspect of the visitor experience for a century. Substantial consideration was given to the entire scope of alternatives, from replacing or modifying major elements to make this central garden more purely or authentically Japanese, to attempting a complete re-creation of the original Huntington garden, including a re-introduction of missing elements (the torii gates and the thatch-roofed *azumaya*, or viewing pavilions) and a restoration of vermillion paint to the wooden garden elements (the entry gate, bell tower, and bridges). The consensus was to preserve all of the remaining original fabric—anything belonging to the Huntingtons' garden—and to restore those features to their earlier appearance and condition as much as possible. The exception was the decision not to reapply vermillion paint to the wooden elements, based on the assumption that restoring such bright color would radically alter the natural look. Repainting can be accomplished easily, should sentiment change.

The central ponds were replumbed and relined, while preserving their extant faux stone edging. Artisan Terry Eagan planned and modeled the faux stone restoration, while pond contractors Pacific Aquascape and ValleyCrest rebuilt the pond systems. Water feature restoration

View of the original stroll garden.

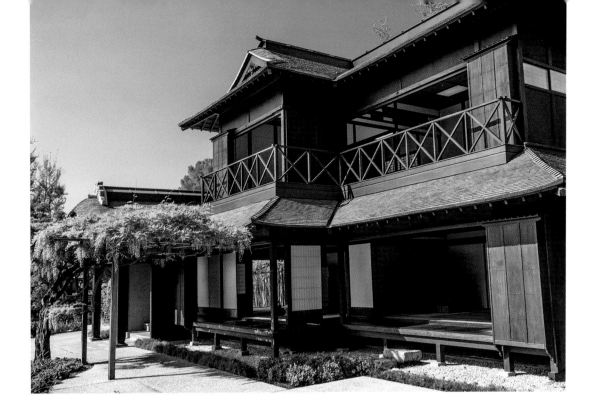

The Japanese House, after restoration.

was curiously archaeological, as entire pond elements were discovered to have been buried and rebuilt. Most intriguingly, the northernmost pond was a complete reconstruction within the shell of an earlier incarnation. The centennial project did not include restoration of the original Huntington grotto and stream in the canyon south of the central ponds—an area that has never been opened to the public.

Of course, the focal point of the historical central garden is the Japanese House, as original and important to the Huntington estate as any other feature (above).[5] Preliminary questions abounded—and issues continued to appear throughout restoration. Studies confirm that the house is a reasonable representation of a residence in the florid style of the Meiji period (1868–1912), minus a working kitchen and storage area that would have been at the rear. An understanding of the house's normal use and furnishings suggests that the three visible rooms on the first floor reflect a "flying geese" arrangement, with a leading front followed by receding flanks. The most forward room, an eight-mat space to the south, serves as the main entry and represents the most public space, an area where guests might be received and refreshments served. The central room would have been semi-private, perhaps a dining space where family or special guests would be served. The twelve-mat room, set back somewhat, would have been a private family space, furnished with personal objects and family treasures.

Leaving the house, visitors might move toward the Zen Court, crossing the newly built waterfall (left), which cuts through what was formerly a scree-covered slope. The refashioned, lightly wooded slope

View of the waterfall.

DRY GARDENS IN AMERICA

Beginning in the 1930s, garden specialists turned away from the decorative taste of Edo- and Meiji-period gardens. Impacted by Modernist and nativist ideas, Japanese garden designers and historians like Mirei Shigemori (1896–1975) focused on a rediscovered medieval aesthetic ostensibly evoked by the "dry gardens" (*kare sansui*) at Zen temples. They championed the culture of Zen Buddhism and interpreted it in terms of a spiritual-philosophic discipline founded on purity and simplicity. As Zen found favor in America from the late 1950s through the writings of D. T. Suzuki (1870–1966) and the Beat poets, so-called Zen stone gardens replaced red arched bridges and wisteria arbors in Japanese garden design.

In *The Art of Japanese Gardens* (1940), Loraine E. Kuck, an acquaintance of Shigemori and Suzuki, focused this interest with her essay on the stone garden at Ryōanji. Many other writers and artists followed suit, turning this and other dry gardens into icons. Inspired by these supposedly elemental and timeless sites, Shigemori and his fellow designers created new gardens in Japan adapting old idioms.

When the Museum of Modern Art in New York erected a Japanese house in the museum's courtyard in 1954, architect Junzō Yoshimura planned a dry stone garden. In 1960, Dr. George Avery, director of the Brooklyn Botanic Garden, hired Takuma Tono (1891–1987) to add a stone garden, eventually replicating the one at Ryōanji (below). In the multipart garden he was building in Portland, Tono created a Modernist stone garden in 1965. The dry gardens at Brooklyn and Portland established a precedent that resulted in the addition of a dry garden, often referred to as the Zen Court, at the Huntington. By the 1970s, stone gardens were ubiquitous, adapted in myriad ways and appearing everywhere from back yards to office buildings.

KENDALL H. BROWN

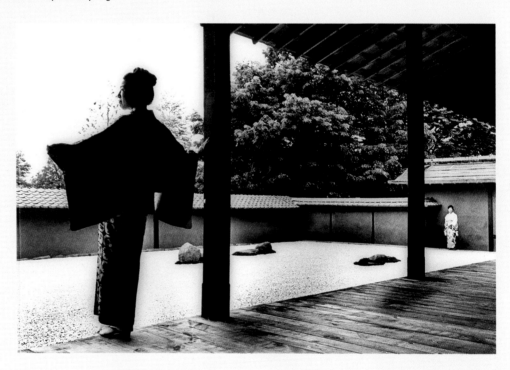

Former dry garden at the Brooklyn Botanic Garden. Photo courtesy of the Brooklyn Botanic Garden.

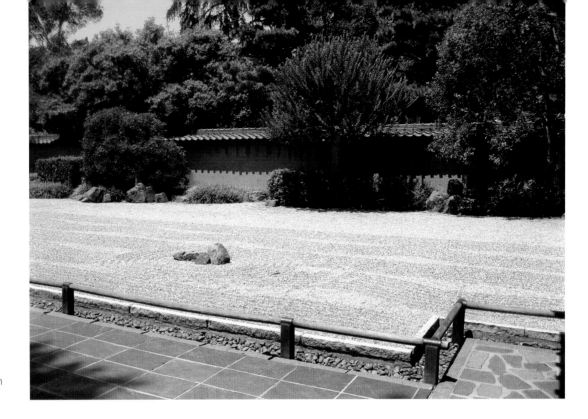

The *kare sansui*, or dry garden, in the Zen Court.

suggests the garden's new aesthetic, reflecting a conscious decision to thin out dense vegetation in an effort to connect the landscape. Visitors sense the lovely depth of the canyon, appreciating the presence of streams and ponds throughout the extent of the garden—not through sweeping vistas but through lightly forested, scantily veiled views with occasional portals that connect the several garden areas. From this slope, one takes notice of the entry to the Zen Court and the presence of the new tea garden on the plateau above.

The Zen and Bonsai Courts reflect the museum-like nature of the Japanese Garden. Visitors encounter a raked gravel garden, or *kare sansui*, as an example of the kind of contained landscape

The *kare sansui*, or dry garden.

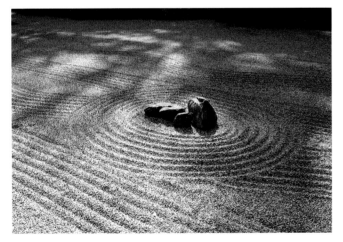

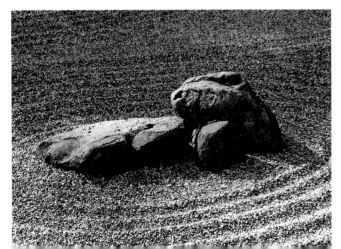

that evolved in the context of temple gardens in Japan (above and left). From that space, they are introduced to collections of bonsai and viewing stones in the Bonsai Courts, home to the Golden State Bonsai Federation's Collection South. These areas were created as Japanese-style garden "rooms"—essentially museum spaces for growing and displaying bonsai. Indeed, the need for a public form of mass display has no early precedent in Japan. Only in the last two decades have Japanese parks and gardens begun to construct public displays. The smaller court, built in 1968, was remodeled in the 1990s to accommodate the growth of the bonsai collection. At the same time, the exterior court was completely rebuilt to allow for wheelchair access and increase display space. The newest area, the Evelyn Ruth Zillgitt Bonsai Court, was dedicated in 2010. Underwritten by an endowment from the estate of Evelyn Zillgitt, it houses most

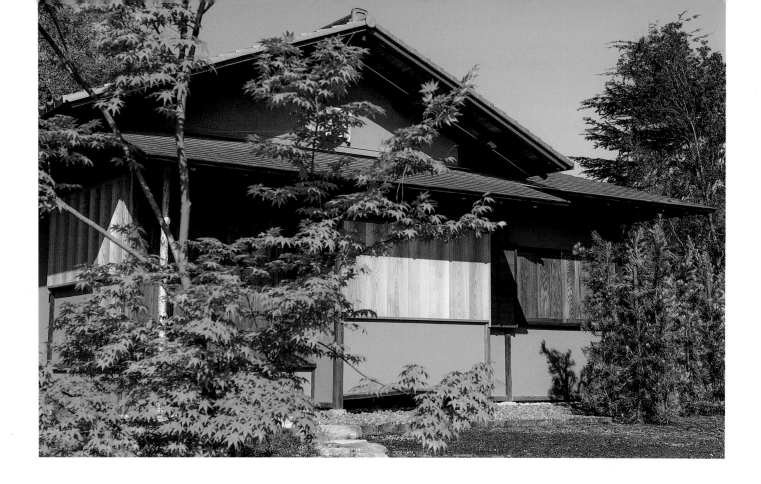

of the GSBF collection, including a display stand designed for *shohin*, or miniature bonsai, which are rotated on a weekly basis. Ongoing expansions of these spaces will allow for the display and interpretation of additional bonsai, as well as related collections of viewing stones, companion plants, bonsai pots, and temporary exhibits of ikebana and various craft items.

Passing through the courtyards, visitors reach the tea garden, completed in 2012. The story of how the teahouse and garden were created is told in the essay by Robert Hori,[6] so it will not be recounted here, but it is significant that the histories of two teahouses merged, and that the life stories of numerous people intersected in the process.

Above: The teahouse.

Below: View from within the tea garden.

Right: Cherry blossoms in the tea garden.

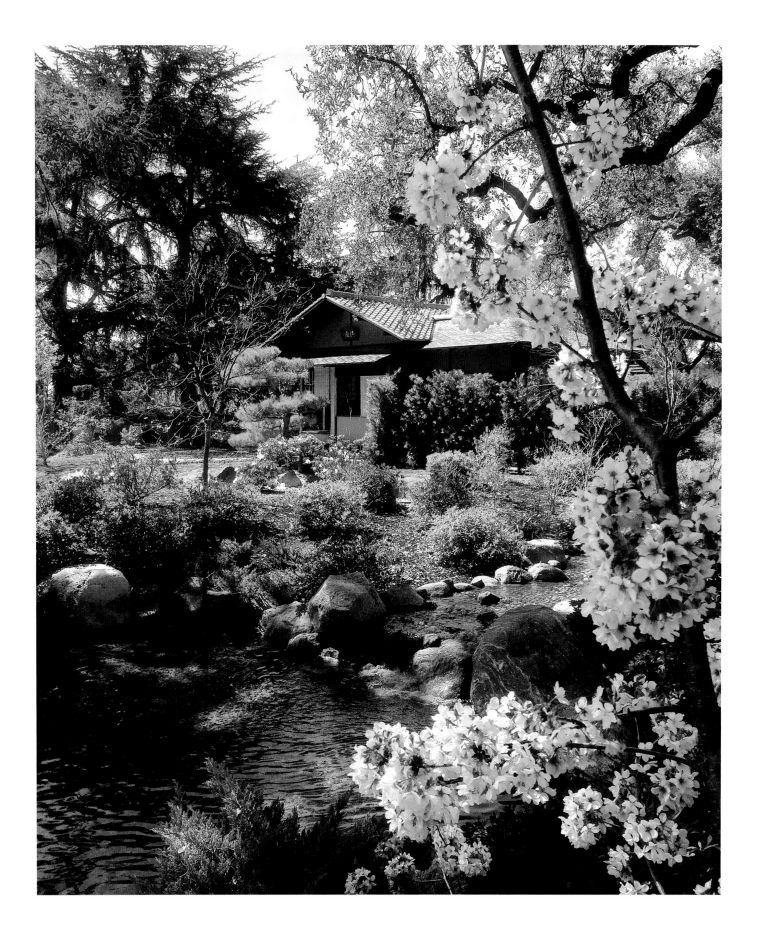

DISCOVERING SEIFU-AN

In October 2009, the tea garden design team visited the Japanese American Cultural and Community Center in downtown Los Angeles. They met with Takeo Uesugi, Chris Aihara, and Robert Hori to view the progress on renovations to the garden at the center, which Uesugi had designed. While there, Huntington staff explained the gift of the Zuiun-an teahouse by Pepperdine University and the purpose of the visit by Nakamura Yoshiaki and Yamada Takuhiro. Hori said that Zuiun-an was not the only Urasenke teahouse with an uncertain future. Seifu-an, an historically important building at the Pasadena Buddhist Temple, though beautifully kept, was seldom active. He was able to arrange a visit that very day with May Sakahara, one of two people who had helped maintain Seifu-an for decades. Sakahara met the group at the temple in the early afternoon and walked them around the corner to the small garden where Seifu-an was located.

The moment the structure came into view, Nakamura asked Hori: "Where did you get this teahouse?"

"It came from Kyoto," Hori replied.

"We built it," said Nakamura.

Those words began the discovery and inquiry that revealed the fascinating history of Seifu-an, and the eventual decision by the board of the Pasadena Buddhist Temple to give the teahouse to the Huntington to become the centerpiece of a new tea garden.

JAMES FOLSOM

Nakamura Yoshiaki and his staff restoring Seifu-an in their Kyoto workshop.

Tea utensils donated to the Huntington by Pepperdine University.

Right: tea bowl (*chawan*), Raku ware, Shoraku.

Above left: cold water jar (*mizusashi*), Seto ware.

Above right: water kettle (*kama*), cast iron with silver.

A bequest from Mary B. Hunt initiated the design of a ceremonial teahouse and garden in the style of the Urasenke school of tea. Early in that process, the Huntington was fortunate to receive Zuiun-an (Arbor of Auspicious Clouds), a Urasenke teahouse that belonged to Pepperdine University. It had been maintained inside a building on campus in support of the cultural programs led by Glenn and Carol Webb. Accompanying the gift of the teahouse was a collection of five thousand tea bowls and other ceremonial implements (above). As a result of that gift, the Webbs introduced Huntington staff to the leadership at Urasenke International in Kyoto.

Responding to the Huntington's request for assistance with garden design, Urasenke International asked Kyoto architect Nakamura Yoshiaki and Kyoto landscape designer Yamada Takuhiro to work with Huntington staff and Southern California landscape architects Takeo and Keiji Uesugi to develop the site and move the project ahead. At that point, the possibilities were endless. What

would be the correct location and design of the ceremonial teahouse? The Pepperdine teahouse was in hand, but it had been constructed as an indoor element and would best be reconstructed in the same way, inside a building. For the outside tea garden, a more resilient, larger structure was needed, suggesting that a new design be considered.

During those discussions, Robert Hori of the Japanese American Cultural and Community Center suggested that the design team visit Seifu-an, the ceremonial teahouse at the Pasadena Buddhist Temple. Seifu-an had been given by Urasenke International to the temple in 1964, shipped from Japan, and then assembled by local carpenters who were members of the temple. Seifu-an brought surprises. The teahouse, which had survived for over four decades on the grounds of the Pasadena Buddhist Temple, had a notable provenance. It was named by the fourteenth-generation Urasenke Grand Master; designed by his youngest son, Sen Otani Mitsuhiko; and dedicated by his son Sen Sōshitsu, the fifteenth-generation Grand Master, in 1965. Seifu-an was constructed by Nakamura's father, and it was Seifu-an that had inspired Mary B. Hunt to believe a teahouse should be constructed at the Huntington.

Here was a Urasenke teahouse that would be perfect for a new tea garden. After a discussion with the temple's board of directors, the decision was made to donate Seifu-an to the Huntington for that purpose. Nakamura led a team of craftsmen to Pasadena in order to dismantle the teahouse and ship its components to Kyoto. After being restored in the very workshop where it was built (see p. 130), Seifu-an was returned to California in May 2011. That summer, a team of craftsmen provided by Nakamura worked with American support staff to rebuild Seifu-an at the Huntington. Immediately afterward, Yamada arrived with two of his company's craftsmen and worked with the local team to design and install the surrounding tea garden. The teahouse was re-dedicated on April 12, 2012, by Grand Master Sen Sōshitsu (opposite).

But of course, a dedication is never the end of garden-building. After the dedication, Hori joined the Huntington staff as cultural curator for the Japanese Garden, and craftsman Andrew Mitchell assumed a formal role curating traditional structures. Yamada and other skilled garden-builders from his Kyoto workshop returned in January 2013 to complete more permanent entry paths, construct the paving around the teahouse and waiting bench, and assist with additional planting and pruning. Indeed, the assumption has evolved that the tea garden, most specifically, is a working collaboration between the Huntington, the Urasenke school of tea, and Hanatoyo, the family firm for which Yamada Takuhiro is the fifth-generation leader.

The installation of Seifu-an inaugurated a program of tea-ceremony training and interpretation for the gardens, adding to the other Japanese garden arts (ikebana, bonsai, stone appreciation, garden-building) that are already well supported. But the planning process acknowledged that further development of the tea program and the advancement of training in other garden arts would eventually require added support facilities. Thus, the master plan includes a proposal to amplify the existing Ikebana House with a cultural center, including an open-area workshop and "treasure house" to train visitors in bonsai, *suiseki*, ikebana, and tea ceremony, as well as the

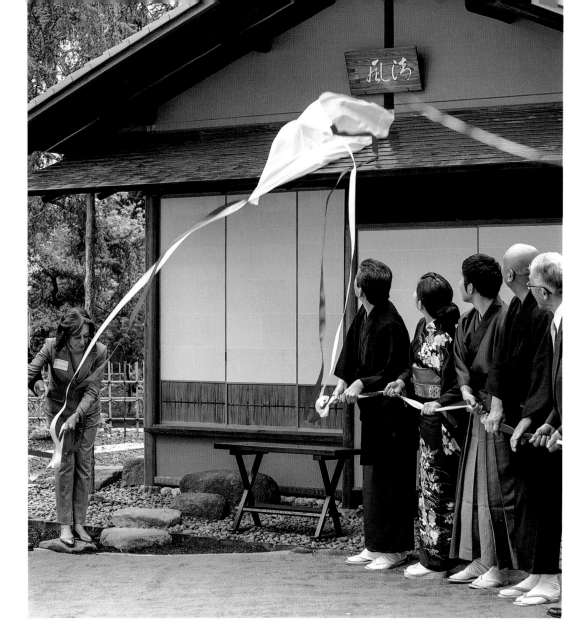

The dedication of Seifu-an, 2012.

idea that a building with tatami mats might be constructed in order to explain the proper display and use of these items.

In addition to Seifu-an and the proposed support facilities, two new garden areas are envisioned to complete this landscape. A classical stroll garden in the style of the one at Kyoto's Katsura Imperial Villa would occupy the handsome area at the top of the western plateau—a site featuring the San Gabriel Mountains as the "borrowed" view to the north. That landscape would center on a new pond as the source of a stream system passing through the tea garden and powering the waterfall. A second landscape would connect the Japanese Garden's cultural center with a hillside pavilion in the Chinese garden and with the Korean plant collections that will complete the Huntington's Asian collections. With the eventual expansion of the Japanese Garden, the completion of the Chinese garden, and the development of an area dedicated to Korean plants, the Huntington gardens will be able to provide a rich experience and greater knowledge of these three East Asian traditions.

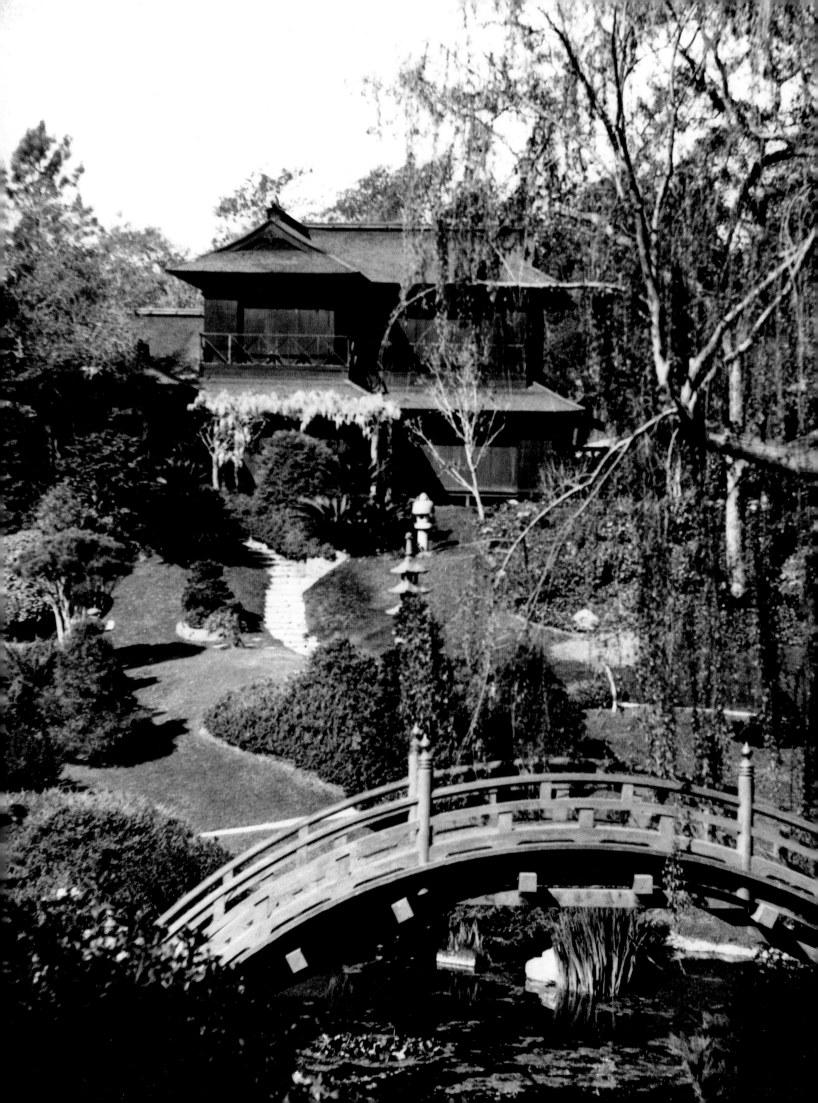

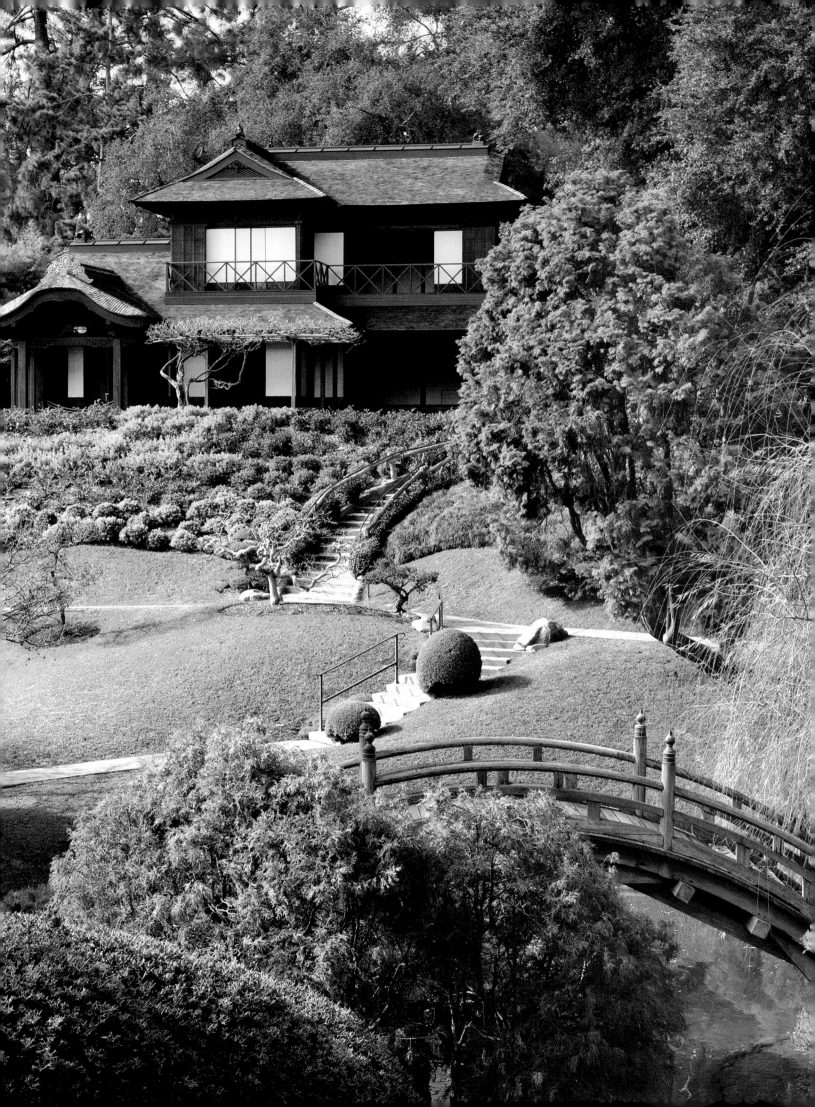

Preserving the Japanese House

KELLY SUTHERLIN McLEOD, FAIA

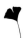

The work of preservation is like peeling away the layers of an onion; often one has to remove the outer layers in order to discover the most valuable clues inside. In the case of the Huntington's Japanese House, the investigation was especially challenging, as it was not yet known how much of the house was original, and to what extent it had been altered over the years. Through careful exploration—and help from Japanese builders and scholars who clarified the house's period and regional style—it was confirmed that its building materials, design elements, and construction techniques were in fact original and authentic, and that the house has remained relatively unaltered for the past one hundred years. Once it was determined that the house was designed as a hybrid of traditional Japanese architectural styles, the next challenge was to restore it using American preservation practices. It is my hope that the processes I describe here will not merely document the history of the project but also provide insight into other historic Japanese structures in North America.

Planning the Preservation

In early 2009, the Huntington invited Kelly Sutherlin McLeod Architecture, Inc. (KSMA), to lead the restoration of the Japanese House, in preparation for the Japanese Garden's centennial in 2012. James Folsom, the Telleen/Jorgensen Director of the Botanical Gardens, who had heard a presentation about the firm's work on the Gamble House conservation project in Pasadena, envisioned a similar preservation-minded approach for the restoration of the Japanese House. Folsom provided the overall vision and leadership necessary to successfully implement the Huntington's investment in this project. Additional support and direction was provided by several Huntington staff members, including Laurie Sowd, vice president for operations; David MacLaren, curator of the Asian gardens; and Andrew Mitchell, an accomplished carpenter with over twenty years of experience at the Huntington, especially with its Japanese House. Bill Ropp of ValleyCrest Landscape Companies played an integral role from the beginning, planning for extensive site improvements, setting the project schedule and budget, and assembling the construction team. Takeo Uesugi and Keiji Uesugi of Takeo Uesugi & Associates were the project team's landscape architects.[1]

During the initial project meetings, team members discussed the structure's significance and existing conditions. The Huntington wished the team to weigh the merits of conserving the house's original features (in accordance with the American preservation ethos) versus enhancing the building's "authenticity" by possibly commissioning replacement features from artisans skilled in the techniques of Japanese building. From the preservationist's perspective, however, the historic context and significance of the Japanese House are key. Because the house reflects a hybrid of Californian and Japanese architecture, it was decided to follow standard American preservation practices. And, as the Japanese House had been relatively unaltered since its reassembly at the Huntington site one hundred years ago, it made sense to preserve its original structure.[2] Establishing this preservation plan, planning for the house's ongoing maintenance and long-term care, and understanding the building's future use as a garden pavilion for public enjoyment were all important aspects of the restoration process.

While the Huntington staff, the general contractor, and the architects carefully deliberated future plans for the Japanese House and the Japanese Garden, the design team (assembled and led by KSMA)[3] focused on researching in the Huntington archive; gathering and analyzing data; and documenting and evaluating historically significant features, materials, and finishes. Project conservator John Griswold of Griswold Conservation Associates developed treatments for the materials, including the plaster, the wood trim, and the decorative wood elements.[4] Scholars Kuniko and Kendall Brown translated articles written in Japanese and communications with Japanese-speaking consultants, while Japanese architectural historian Atsuko Tanaka shared her research and observations on the Japanese House.

Establishing Historic Significance

The first step in any preservation project is to establish historic significance. One of the challenges with the Japanese House was the lack of research materials, such as original plans, architectural or building specifications, or alteration histories. The investigation began with basic questions: How closely did the building resemble the original house that George Turner Marsh commissioned for his Japanese Tea Garden in 1903? Had any repairs or modifications diminished its character and integrity? Which era in the house's long history rose to the level of "historic significance," in accordance with national, state, and local designation criteria?

The Huntington staff provided photographs, letters, and ranch work orders related to the Japanese House and its surrounding garden. Local archives, such as the one at the Pasadena Museum of History, were rich sources of material. Historical documents referred to Henry E. Huntington's purchase and relocation of the house from its original site, at the corner of Fair Oaks Avenue and California Street in Pasadena, to the San Marino Ranch. Interior and exterior photos of the house, taken by Will A. Benshoff around 1904—and now in the Pasadena Museum of History archives— proved invaluable. In addition, Huntington staff members who have maintained the Japanese Garden for over thirty years were interviewed for their knowledge and expertise.

Overleaf: The Japanese House, before and after restoration.

137

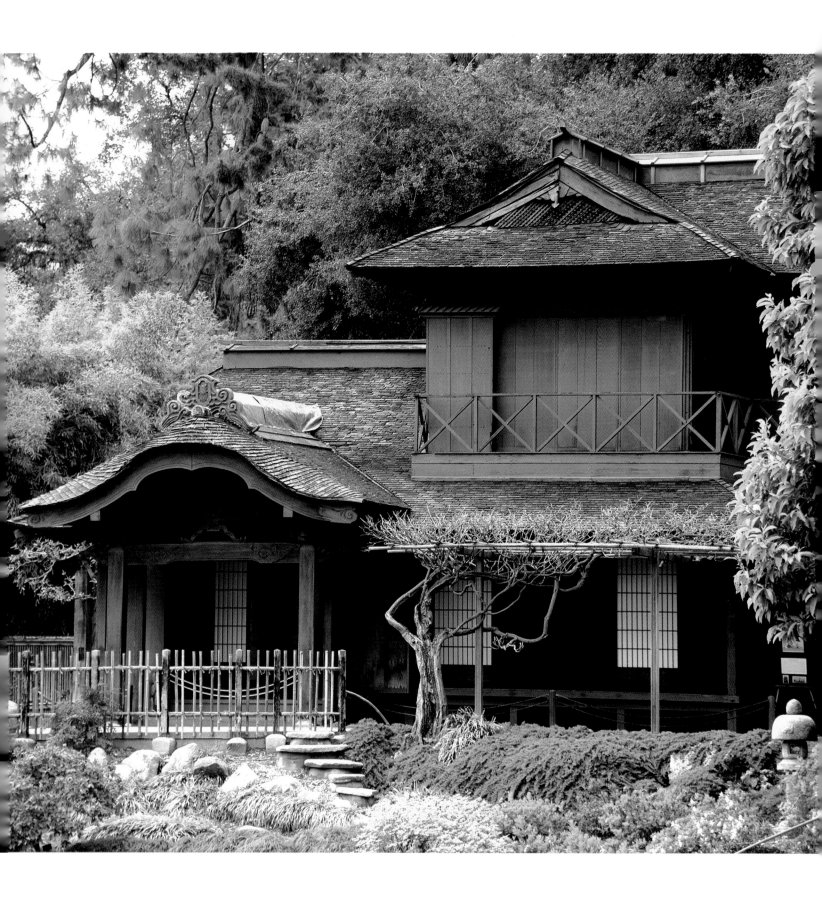

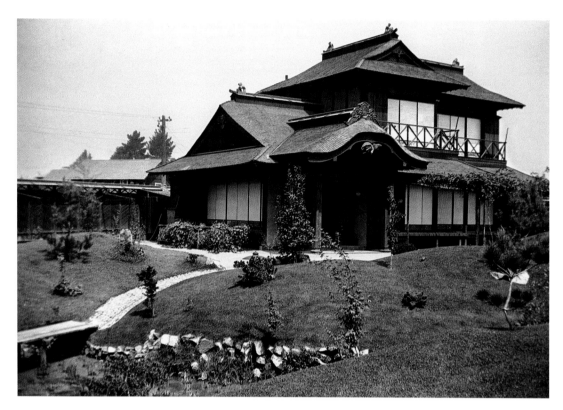

Japanese House in Marsh Tea
Garden, photograph taken by
Will A. Benshoff, ca. 1904.
Courtesy of the Archives,
Pasadena Museum of History.

In preservation, the issue of historic significance is not merely an academic one. A building's most historically noteworthy period (also known as the "period of significance") helps identify the features, materials, systems, and finishes that reflect and convey historic significance. This approach helps retain and protect the story that a building or site has to tell.

For the Japanese House, research led the team to identify a sixteen-year period of significance: from 1911, when Huntington purchased and transferred the house to his ranch, until his death in 1927. This period represents the Japanese House as Huntington envisioned it, in the context of his Japanese Garden. This decision helped us not only to focus restoration plans on physical features dating from this period but also to consider the relationship between the house and its landscape setting.

The notion of authenticity remained central to discussions about how to approach the preservation of a house that, from the beginning, was a cultural hybrid. One key resource was an article co-written by Japanese architectural historian Atsuko Tanaka. This comparative study taught us that the Japanese House is in fact one of the best examples of early twentieth-century Japanese architecture in the United States, and one of only four such structures remaining.[5] The article, published in Japan in 2006, surveys three Japanese houses built in the United States around the turn of the twentieth century, with the aim to "consider the characteristics, differences, and reception of Japanese architecture built in the United States." The authors conclude that the "modified Japanese elements, excessive decoration and the emphasis or disregard of

period styles differentiated the houses from domestic architecture in Japan," but that, among the three examples, the Huntington's Japanese House was "more authentic" in its connection with the surrounding gardens. As Tanaka explains, at the Huntington, the house

was not meant to be used as a residence, but was built for exhibition and experiencing space, which reflected the yearning for Japanese garden[s] and architecture in Southern California at the beginning of the 20th century. . . . [The Huntington Japanese House] is important because it kept the original form built and reassembled by local Japanese-American carpenters, and because it is the only existing example of [a] Japanese structure that reflected the need and acceptance of the general public [for Japanese architecture and design] in Southern California during that era.[6]

Tanaka's examination of the Japanese House led her to conclude that many of its elements and materials had originated in Japan, and that "craftsmen and technicians with knowledge of traditional Japanese architecture were involved from the initial construction."[7] Her article, as well as subsequent conversations with the author, provided a much-needed context as the issue of authenticity was weighed against concerns of visual integrity and historic significance.

Photographs from 1903 and 1950, along with tax assessor maps, helped to compare the configuration of the house at the Pasadena site in 1903 with that at Huntington's ranch in 1911–12. Yet, the house itself has proven to be the best source of information. As Frank Clark, lead carpenter on the project, has stated, the Japanese House has a fascinating past, but it "doesn't give up its history easily."[8] Even in the final stages of the project, we continued to discover details about the house's original form.

Kelly Sutherlin McLeod, FAIA (right), and Andrew Mitchell reviewing roof details.

Restoration

The U.S. government's preservation guidelines for historic buildings offer several options that can be adopted based on the significance and nature of a project.[9] Of these options, "restoration" was selected as the optimal treatment for the Japanese House. The preservation plan aimed to retain and restore the house's original features wherever possible, while accommodating the Huntington's ongoing use of the house. The restoration treatments emulate and re-create the original finishes and design intent. In addition, preservation plans sought to restore the Japanese House to reflect the cultural and historical narrative that Huntington wanted displayed to visitors of his garden, while also contributing to the educational programs and goals of today's institution.

Peeling away the Layers

When the Huntington opened to the public in 1925, reportedly only the exterior of the Japanese House was accessible to visitors, who could view it from the Japanese Garden. The structure remained closed until the 1950s, when, through the stewardship of the San Marino League, it was opened to public view. Over the years, it received spot repairs, carried out with limited resources. By the time of its approaching centennial, the Japanese House required a comprehensive preservation and maintenance program.

During the discovery phase, the team noninvasively tested and examined the house's finishes, materials, and building systems in order to identify significant features, evaluate existing conditions, and start planning for repair and restoration. Historic buildings and sites have stories to tell, and these stories often reside in the intimate details of preservation work.

One issue that the Japanese House itself helped to clarify is the question of its period and regional style. While Atsuko Tanaka's research helped place the building in the context of Japanese architecture in America, a detailed site inspection of the house with master builder Yoshiaki Nakamura also proved invaluable. Nakamura, the specialist hired by the Huntington to reconstruct the Japanese teahouse, Seifu-an, advised that the materials, design elements, and construction techniques used for the Japanese House relate to the building style of Tokyo rather than that of Kyoto. Nakamura, Kendall Brown, and Tanaka all agree that there are references to Meiji-period architecture (1868–1912), citing, as an example, that the house has a second story. Additionally, Tanaka and Nakamura identified many of the design features at the Japanese House as a mixture of *shoin* and *sukiya* styles. The ceilings of all the rooms on the first floor are surely in the less formal *sukiya* style. The main *tokonoma*, or alcove, in the north room on the first floor, with its natural tree-trunk side beam, is designed in the *sukiya* style, but the *tokonoma* in the south room, with a squared column, belongs to the *shoin* style, which embraces refinement and display.

Site inspections and conversations with Nakamura and Tanaka also clarified the significance of the interior spaces. Although the house was commissioned by Marsh to display Japanese art objects and was intended primarily as an art object itself, rather than as a residence, the size and sequencing of the rooms reflects traditional Japanese ideas about space and function in domestic architecture.

Whereas little is known about the Japanese carpenters credited with constructing the house in 1903 (besides their names, "A. Y. Okita" and "Sano"),[10] archival records say more about the person who disassembled the Japanese House in Pasadena and reassembled it at Huntington's ranch. Toichiro Kawai, a Japanese carpenter, carried out this work for William Hertrich, Huntington's ranch foreman.[11] Evidence of the hand of Japanese-trained carpenters is clear in the many Japanese characters, kanji and kana, written on wood framing throughout the house (above right). Tanaka has observed that these characters, usually sequences of numbers, reflect the traditional Japanese method for specifying the location and dimensions of each piece of wood, providing instructions for reassembly. Historical documents report that Kawai made notations on the elements of the house before he took it apart for relocation. It is not known if

Kanji and kana notations on beams, written by Japanese-trained carpenters.

multiple generations of Japanese markings were made on the structure. The characters are an older form of notation, so it is possible that at least some of the markings were made before the house arrived in California. More recently, carpenters from Japan—working nearby on reassembling the Japanese teahouse, Seifu-an—recognized these markings as part of a system still used today. These discoveries all support a supposition that the house was built in Japan before being shipped to California.

Focusing on the Details

Nearly all the building's exterior features and materials, as well as many of those in the interior and visible from the garden, contribute to its historic significance. Restoration plans called for retaining the original elements where possible and restoring most of the missing or altered significant features and finishes. This returned the Japanese House to its appearance as seen by the earliest visitors to the gardens. While structural strengthening and life-safety system improvements (such as smoke detection and fire sprinkler systems) have been installed in concealed areas as reversible additions, the preservation included all of the original structure—both seen and unseen. Original framing, finishes, and kanji and kana markings are among the elements not visible to the visitor but still meticulously documented and preserved.

The wood framing components are of two distinct types: full-size timbers that show mill markings from circular saws (common in early twentieth-century construction in the West), interspersed with more finely milled timbers (appearing to be milled in a Japanese style). The inscribed Japanese characters mentioned above are found primarily on the latter. The Japanese-style timbers also have unused notches and shaping, indicating a possible history of, or plans for, reuse in various configurations, or perhaps for other buildings in Japan.

In an effort to understand the house's exterior and interior features, Japanese terms became a routine part of the project vocabulary. As noted in Tanaka's study, this kind of two-story wooden house is known as a *wagoya* (和小屋). It is topped with a hip-and-gable roof (*irimoya-zukuri* 入母屋造). The façade faces east, with a slightly projecting entry, framed by two wood columns and accented with a distinctive curved gable (*karahafu* 唐破風). Wrapping around the south and east sides of the

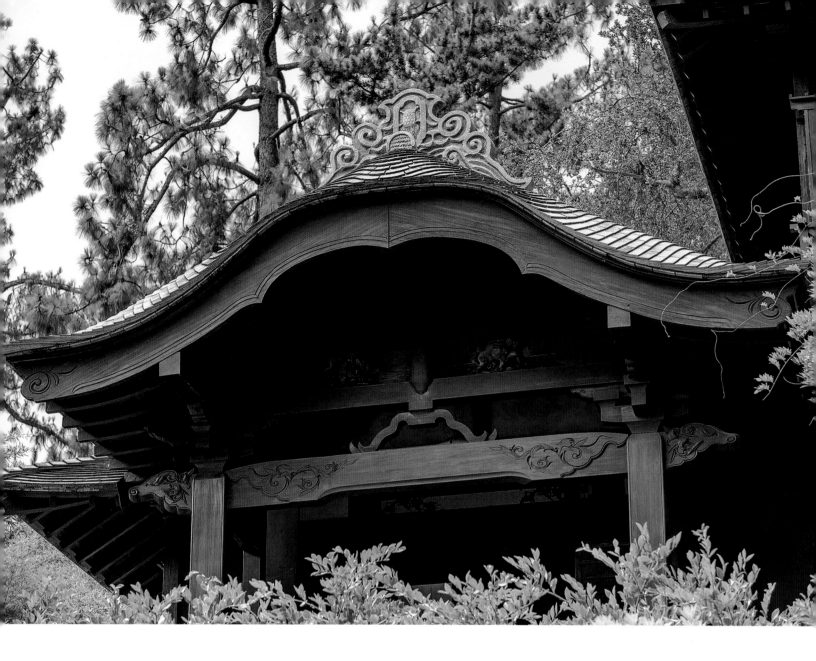

house is a narrow wooden veranda (*engawa* 縁側), enclosed by door frames (*kamachi* 框), including a sunken wooden sill at the floor (*shikii* 敷居) that holds and guides the storm doors (*amado* 雨戸).

During the first walk-through of the Japanese House, Nakamura identified several Japanese woods inside, including persimmon, red pine, and zelkova. Historical documents helped identify the original features that had a Japanese provenance. For example, a brochure for Marsh's Japanese Tea Garden lists the interior house elements that were transported from Japan, including floor mats (*tatami* 畳), perimeter sliding paper screens (*shoji* 障子), interior carved wood transom panels (*ranma* 欄間), interior sliding doors (*fusuma* 襖), and wood used for the recessed alcoves (*tokonoma* 床の間)—intended for the display of art, scrolls, and flowers. The pamphlet also points out the curved gable roof over the entrance.

Front entry to the Japanese House.

Central pond at the Japanese
Garden, ca. 1913.

THE SURROUNDING GARDEN AND POND

The Japanese House sits atop a knoll, overlooking a pond, and can be clearly seen from the surrounding ravine. This setting and context are important to both the Japanese House and the Japanese Garden, and thus views to and from the building remained strong considerations for preservation planning. As with the house, discussions about treatments of the garden and its ponds focused on mediating between American preservation practices (in which features dating from the period of significance are retained) and Japanese landscape aesthetics (in which original features not in keeping with an "authentic" Japanese garden might be replaced).

Though the central pond does not represent traditional Japanese garden craftsmanship, it does reflect the creative design approach that was taken by its builders in the face of limited resources and information about constructing Japanese gardens. It is a model of an early twentieth-century North American interpretation of a pond for a Japanese garden (below).

Study of the pond included draining it, photographing and documenting its edges, and comparing these findings with historical photos in order to map the faux rockery and boulders of Huntington's era. A faux-concrete artisan completed the detailed edging of the pond by repairing broken portions and re-creating missing areas. In some places, the historical pond edge was in good condition, needing only a minor touch-up. In others, the edge was in poor condition, with cracks, leakage, and wear, and was reconstructed with a similar look and character. Nonhistorical pond edges were removed and reconstructed to reflect their placement during Huntington's era. Other much-needed repairs included removing the pond bottom and deepening it to assist with water quality and circulation, in addition to resolving leakage issues.[12]

145

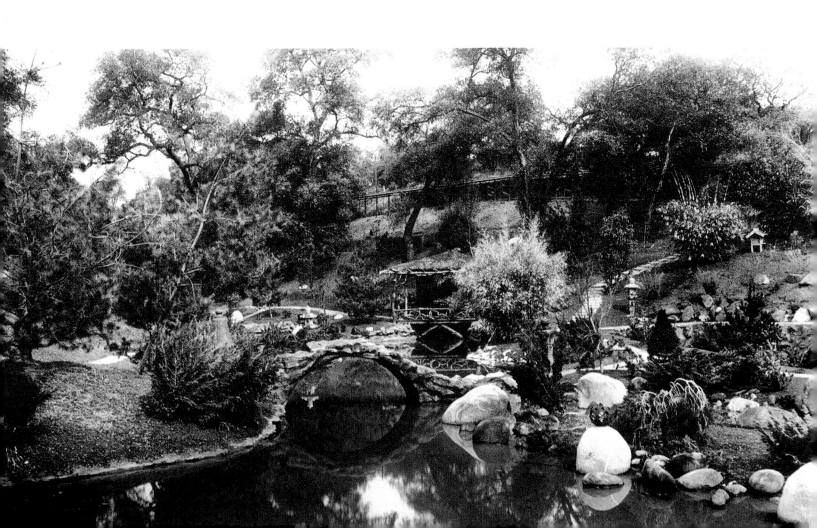

Central pond at the Japanese Garden, ca. 1913.

WOOD FEATURES AND FINISHES

As the team began considering conservation treatment for the wood features, archival information and site studies helped to design an appropriate plan. For example, correspondence between Huntington and Hertrich states that the exterior wood of the house was originally treated with stain. In subsequent years, multiple layers of opaque brown paint were applied to the exterior, including such elements as the storm doors, storm door boxes, beams, vertical posts, and trim. Isolated areas of wood stained with a rich brown color were determined to have the original finish. Additional clues in the interior, in the attic, and beneath the house revealed a similar untouched rich brown stain.

Wood beam end, before and after treatment.

Conservators removed the nonoriginal paint from all exterior wood features, including the exposed rafter tails. This delicate process protected the wood from damage and ensured that the original stain finish would be retained. A penetrating sealer provided the appearance of an appropriately aged finish. Sections requiring replacement wood were treated with a compatible stain. Decay at the rafter tails was repaired, while maintaining as much historical material as possible.

On the veranda that wraps around the building's south and east sides, we found another nonoriginal paint, this one black. Close study revealed that beneath this modern black enamel was a heavy-bodied Asian-style lacquer with a rich brown color. Nakamura theorized that this pigmented finish was applied to help disguise the Douglas fir used in the veranda's construction, since this wood may have been regarded as being below Japanese standards. As he pointed out, lacquer helps mitigate the sap found in the tree species. Furthermore, dark discoloration traditionally results from years of cleaning such an exterior space. In order to provide a practical treatment

The wood bases of the entry columns, before and after restoration.

and prepare the veranda for continued exposure, we removed only the black paint and then treated the veranda boards with brown stain (to match remnants of the lacquer), sealer, and wax.

One of the focal points of the main façade is the flared gable portico over the entry. The wood bases of its columns had been partially buried by stone paving, likely during the 1960s. Excavation revealed that the traditionally shaped wood column bases (as seen in historical photos) originally rested on granite pads. Although the wood bases had deteriorated into dust, their shape remained imprinted in the surrounding mortar.

This excavation allowed for re-creation of the wood bases for the entry columns (above). Plans also called for lowering the grade around the entry to accommodate new pathways for pedestrians, divert water from the house, and create a more generous margin between the ground and the house's wood sills and posts. With the paving returned to its lower level, the entry column bases are once again fully visible.

Another detailed treatment that returned the building's exterior to its original appearance was the restoration of the wood trim that frames the smooth plaster finish. Decades of caulking and plaster patching had diminished the space between the plaster and the projecting wood trim—a simple but important design motif. This wood was carefully cleaned, then sealed in the same fashion as the other exterior wood features. The new exterior plaster is recessed from the wood trim, conforming to the Japanese standard originally employed. The decorative wood elements at the entry, including ornate beam ends and the carved transom screen, along with other sensitive exterior wood features, received similar expert treatment from the project conservators at Griswold Conservation Associates.

Although the plan required removing nonoriginal paint from the Japanese House, it is worth noting that these layers of paint served an important purpose. When studied under a microscope, the exterior wood was found to have damage and heavy weathering that occurred prior to the application of the paint. Painting over the original stain finish may not be a preferred preservation practice today, but the paint is credited with tempering the wood's deterioration.

The exterior plaster and wood frame before restoration.

Left: The plaster before restoration.

Right: The wood and plaster after restoration.

PLASTER MATERIALS, FINISHES, AND COLORS

A treatment approach was crafted for the exterior plaster using site inspections, materials testing, archival documentation, and conversations with Huntington staff about future uses and maintenance needs. Ultimately, the new exterior plaster restored the overall appearance of the plaster to the period of significance while providing a durable, cost-effective, and easy-to-maintain finish.

The investigation of material composition, texture, and color of the existing exterior plaster showed a patchwork of various shades of brown and white, as well as differing textures and finishes. A contemporary sand-float finish, as well as an epoxy-like coating, had been applied in recent years to most of the exterior plaster surfaces; these coatings peeled away in many areas, exposing various layers down to the scratch coat (the bottom layer). Conservator John Griswold found the underlying layers of material to be consistent with traditional Japanese plaster rather than with the hydrated lime or cement-based plaster typical of Western construction. The original plaster was a porous, organic material. Unfortunately, later or recent nonporous coatings had trapped moisture, causing damage to the plaster underneath. Deterioration had further undermined its stability, so it was decided to remove and replace nearly all of it.

Archival research turned up a November 1911 letter from Hertrich to Huntington in which Hertrich describes the original exterior finish as a "very fine Japanese plaster," further explaining that "[t]he whole House [had] to be plastered over" in what proved to be "the biggest item" in the reassembly process (opposite).[13]

The project team discusses treatment options for the plaster restoration.

William Hertrich's letter to H. E. Huntington, updating him on the Japanese Garden.

Curiosity was also sparked by the smooth, burnished, dark charcoal gray patina on the plaster panels along the upper reaches of the second floor of the east elevation. Study confirmed that this plaster, present below the upper roof eaves, dates from Huntington's period and was left intact under layers of oil-based paint. Removal of this paint would have re-exposed the delicate original plaster finish, so the decision was made to apply an aesthetically compatible protective finish: a water-based paint that is a reversible material. The original plaster may be exposed again in the future.

Material analysis, coupled with studies of historical images, revealed that the Huntington-era color scheme of dark charcoal gray finish had been applied to most of the exterior plaster surfaces,[14] so it was decided to re-establish the overall dark surface.[15] Over the course of several weeks, team members reviewed plaster mock-ups in order to finalize the specifications. Finally, finishing coats of naturally hydraulic lime plaster and lime paint were applied over a modern, reinforced cement-based plaster, reversing the order of permeable and impermeable layers, as they were found. This approach maintained the equilibrium of the interior environment while eliminating the risk of trapping moisture within the wall structure. The lime mixture provided a sensual, soft texture, emulating the organic quality of the original finish, while also providing a practical material that is easy and cost-effective to repair and maintain.

During the final phases of the project, the team discovered an additional section of original dark plaster at the back of the house, by the exterior wood steps. When these badly deteriorated steps were removed for treatment, the dark original plaster panel behind was intact and in pristine condition. This exciting discovery confirmed earlier findings of the original surface, and it too was maintained as an accessible historical archive.

Tested samples of existing plaster on the panels above and flanking the entry door were found to contain only beige-colored finish layers, without any trace of the dark finish layer found elsewhere. This led to a tentative working theory that the Marsh-era plaster may have been beige,[16] and that it had been retained at the entry and relocated to the Huntington ranch intact. In keeping with the overall preservation strategy, a reversible treatment was used above the entry door to protect the original plaster while emulating the finished surface from the early Huntington period.

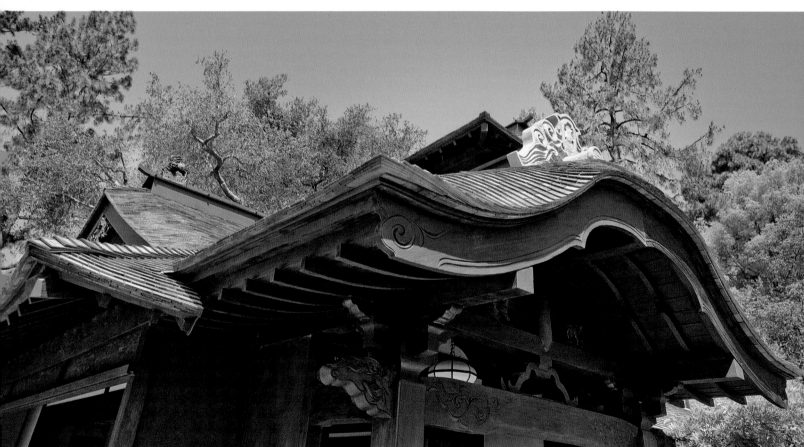

Left: The roof of the Japanese House, before and after restoration.

Above: Back of concrete end cap, with arrow showing original shingle impression.

ROOF SYSTEM, SHEATHING, AND ORNAMENT

One of the most prominent and complex features of the Japanese House is its distinctive hip-and-gable roof. The roof's wood shingles—replaced over four decades ago, with occasional spot repairs after that—were visibly worn and in disrepair. Given the importance of the roof to the overall design, the goal for treatment was to represent as closely as possible the original roof, in terms of its material, shape, texture, and pattern.

Restoring the original roof design and installation was complicated by a lack of precise documentation. Historical photos showed thick, Western-style wood shingles, unlike those traditionally used in Japan, which typically feature a thin profile. In addition, the exposed lengths of the original shingles appear to have been relatively short, giving the roof a distinctive look. Yet, extensive explorations did not turn up any shingles from the original house or similar shingles from other Japanese structures of the period.

A dramatic breakthrough occurred when we removed the ornamental concrete cap on the ridge above the entry; to our delight, we found a clear imprint of the original shingles—shape, size, and profile—molded into the mortar at the base of the concrete cap. This discovery confirmed that the original shingles had two and a half inches of exposure—that is, the amount that each shingle extends beyond the one above it. The backside of the concrete cap, once exposed, also retained the shadow of the original ridge box behind it, allowing this feature to be accurately reconstructed.

GARDEN ORNAMENTS

Stone pagodas (*sōtō*) and lanterns (*ishi-dōrō*) were common in gardens during the early Edo period (1600–1868). Both contrast manmade, hard-edged materials with the soft textures and colors of plants. In addition, with their "fire boxes" (*hibukuro*), these structures provide light for nocturnal garden viewing.

Stone pagodas—of three, five, or seven levels—vary in terms of their projecting corner decorations and ornamental patterns. One type includes relief carvings of seated buddhas, underscoring the pagoda as a symbol of Buddhist faith. The motif of Buddhas of the Four Directions (*shihōbutsu*) is also found on water basins (*chōzubachi*) made from the bases of stone pagodas. Originally used as tombstones or to store sutra texts, stone pagodas were appropriated by tea-style gardens. Along with shrine lanterns and water basins, such "re-used objects" (*mitate-mono*) add layers of historical and cultural depth.

Josiah Conder's book *Landscape Gardening in Japan* (1893) shows many of the stone pagoda and lantern types seen at the Huntington. It may have served as a model for G. T. Marsh, William Hertrich, and others who were creating Japanese gardens in early twentieth-century America. The Huntington has several examples of the tall Kasuga Shrine–type lantern and the squat, four-legged *yukimi* lantern. Some lanterns date from the Edo period, but others are from the Meiji period (1868–1912) and later. The garden also includes several Meiji-era cast iron lanterns in round and hexagonal shapes, originally from the Marsh garden.

The several pairs of Chinese lion-dogs (*komainu*) in the Huntington garden were added after World War II. Placed as guardians outside the gates of Shinto shrines in Japan, these stone statues have become a common element in Japanese gardens in America.

KENDALL H. BROWN

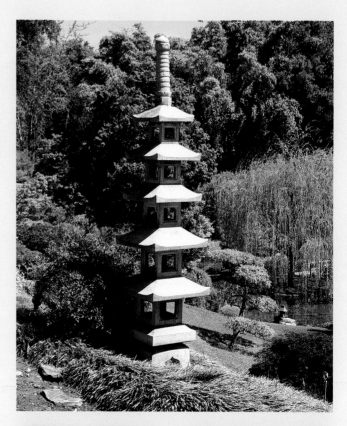

Five-tiered pagoda-style lantern (top) and Kasuga-style lantern (bottom).

A series of shingle mock-ups were studied alongside historical images of the roof, first on the ground, then in situ. After comparing various options, the team chose a shingle more typically used for wall installation: an eighteen-inch-long recut and resurfaced cedar shingle that met specifications for thickness, smooth texture, and clean edges. Fortunately, domestic wood shingles resembled those seen in historical photos of the Japanese House; they also offered affordability, fire resistance, and a reasonable life expectancy. By precisely cutting and shaping the shingle ends, we were able to re-create the building's challenging compound curves at the roof hips and eaves. Indeed, the curved gable over the entry was one of the most complicated areas of the roof to reconstruct. Shingle mock-ups were carefully fitted and closely scrutinized to replicate the original appearance of this important feature.

Knowing the conditions and history of a building is nearly impossible until we peel away the layers. For the roof of the Japanese House, the calculated removal process revealed severe deterioration, nonoriginal materials, and altered configurations of the ridge boxes and gable vents—character-defining features of the house. The treatment plan called for new wood ridge boxes (*hakomune* 箱棟), traditional Japanese features that protect the apex of the roof while providing height and elegance; these replicated the original design. The complex layering of decorative, delicate wood medallions, lattice screens, bargeboards, and roof framing required careful coordination as we treated the original materials and features and installed missing elements and shingles.

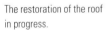

The restoration of the roof in progress.

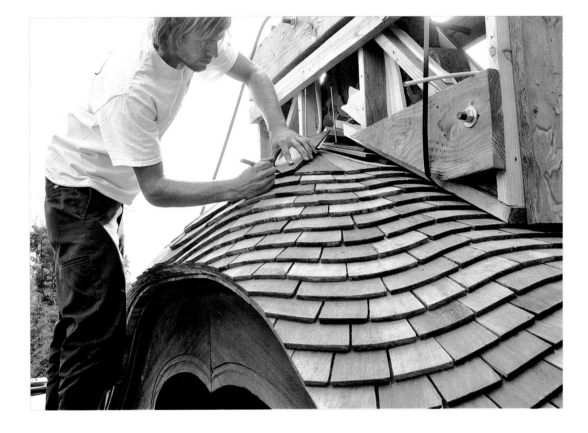

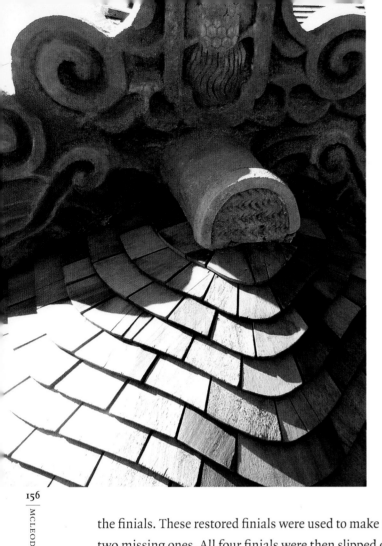

The original plan was to remove the concrete end cap for conservation, but further study caused us to revisit this plan (left). It was discovered not only that the cap consisted of a thin, delicate shell, encasing a rubble infill, but also that it had suffered a large crack. The conservators considered it too fragile to be removed safely, even with bracing. Instead, the concrete cap was treated in place and then stabilized with a custom-designed stainless-steel frame bolted to the backside of the cap and secured to the ridge beam.

The restoration plan included the four ceramic dog finials that had once adorned the ends of the roof ridges (opposite). These finials were damaged years ago, but fragments from two of them were recovered and stored. Restoration-grade mortar was used to replicate the missing ceramic portions of the finials. These restored finials were used to make molds for reinforced-concrete replicas of the two missing ones. All four finials were then slipped over wood mounts and secured to the ridge boxes to once again crown the roof.

The concrete end cap, after its treatment.

STRUCTURAL SYSTEMS

Structural Focus, the engineering firm that performed the structural evaluation of the Japanese House, found the building to be in fair condition, with its system of wood framing free of significant damage. The firm noted decay on exposed rafter tails, but they determined that it did not pose a threat to the eaves' load-carrying capacity. At the same time, they discovered significant water and termite damage in limited areas of the veranda under the roof shingles and around the lower edge of the second-floor walls.

The wood sill around the bottom of the house was found sitting directly on the soil. Excavation revealed a continuous concrete curb, in good condition and topped with a chamfered edge—that is, one cut at a 45-degree angle. The curb was originally designed to shed water and hold the wood sill above grade. Surprisingly, the sill revealed no signs of deterioration, in spite of sitting on the dirt for one hundred years. The implications of possibly raising the house were reviewed, with the option of lowering the surrounding soil and paving. Owing to the cost and the concern about potential damage to the house, it was decided to lower the soil under and adjacent to its foundation, in order to improve clearances and drainage.

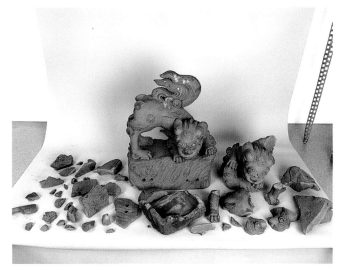

Restoration of the dog finials.

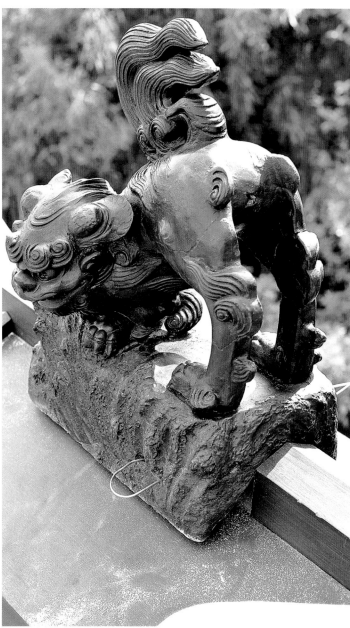

The structural evaluation found no evidence of a connection between the wood framing and the concrete foundation; the house had not been bolted to withstand an earthquake. Framing hardware was added to connect the posts and beams in the foundation and the attic, and plywood was installed on the exterior walls, where plaster had already been slated for replacement, in order to provide additional structural integrity.

SLIDING STORM DOORS AND *SHOJI* SCREENS

The sliding storm doors surrounding the perimeter of the house run on wood tracks, which had sustained considerable damage. This condition was due not only to exposure to the elements but also to frequent use (the doors and the paper *shoji* screens inside are opened on a daily basis to allow the interiors to be seen from the garden). Once the storm doors were removed for treatment, it became clear that the inner and outer tracks were not level. The inner rail of the tracks was discreetly leveled without altering the exterior appearance, to ensure that the storm doors and their tracks could sustain daily use. The original second-floor redwood plank sliding storm doors were refurbished, whereas the first-floor sliding doors—nonoriginal replacements that deviated from the sophisticated joinery, design, and materials of the original doors—were reconstructed.

The traditional wood boxes at the exterior corners of the building (*tobukuro* 戸袋), which house the wood storm doors, when in their open position, were conserved. Worn and damaged decorative metal hardware, designed to allow sliding storm doors to navigate the tracks at the exterior corners, was also treated, and missing components were re-created (opposite).

MAINTENANCE AND PROTECTION

In addition to restoring the significant visible features of the Japanese House, work included upgrading the unseen systems that maintain and protect the building. This included installing life-safety and fire protection systems throughout the house. Contemporary equipment and wiring was removed, but examples of knob and tube wiring, the system used in pre-1950s construction, were kept as historical artifacts. Lighting systems were installed that discreetly illuminate the Japanese House in a way that befits its period of significance. Soft, low interior light now glows from within through the closed *shoji* screens, while lights at the exterior perimeter allow the house to visually "float" in its garden setting, as envisioned by Jim Folsom.

The team also considered the house's long-term maintenance and care. The preservation treatments needed to be practical, so that the upkeep of the structure would not outweigh usefulness. All treatments were accompanied by guidelines for maintenance as well as training for the staff members who care for the house. Similarly, we considered the building's future use as an unoccupied, open-air garden pavilion for public enjoyment and education.

Detail of decorative metal hardware.

Looking Ahead

Throughout our work on the Japanese House, we tried to balance the principles of American preservation with our respect for the aesthetic traditions and building techniques of another culture. In addition to deepening our discussions about how to define authenticity, the project raised questions about how the restoration of the Japanese House might have been approached in Japan. As we observed Nakamura's crew reassembling Seifu-an, the ceremonial teahouse, we learned that, in Japan, the notion of preservation includes not only materials but also traditional building techniques, or the art of craftsmanship, a value I believe Americans need to more fully adopt before such skills are lost.

Phase 1 of the Japanese House project encompassed the structure and exterior of the house. Phase 2 will propose a restoration of the interior spaces, for which research and planning are already underway. The team looks forward to continuing a comprehensive preservation of the interior, conserving original materials and restoring missing elements to complete the project. A comprehensive plan for the first-floor interior, including conservation of original materials, and restoration of missing elements, would complete the visitor's experience. Our investigation suggests that images of the interior during Huntington's era are scarce, but that photographs from Marsh's era show period-appropriate Japanese design, including many artifacts now in storage at the Huntington. Original finishes found in the house, besides wood and plaster, include remnants of an early twentieth-century linen-backed paper covering on the closet walls that can be traced to the California Wall Paper Company. Wood panels throughout the interior and exterior of the house, which appear at first glance to be common plywood, are believed to be an early twentieth-century three-ply laminated material deliberately selected for its resemblance to the traditional wood of *sugi*, a Japanese cedar (opposite).[17]

Tanaka, in her 2006 study of the house, noted the variety of its ceilings and described each type by design and material—including bamboo, lattice, and root wood. Embossed paper, which lines the back of the open root wood ceiling in the north room, is visible through the naturally formed openings in the wood. This paper is called *kinkarakawakami* (金唐皮紙); *kinkarakami* (金唐紙) is also used as a short version of the word. Known as "golden western leather paper," this Japanese paper simulates calfskin decorated with hand-tooled embossing—a European material popular with Japanese feudal lords as early as the 1600s. No doubt, even more fascinating discoveries await.

In treatments that ranged from major repairs to painstaking restoration of the minutest details of finishing colors and textures, we aspired to return the Japanese House to its place of honor in the Huntington's Japanese Garden. The preservation treatments were intended to retain the historic integrity of the Japanese House as well as its relationship to the surrounding garden. After a century in this setting, the Japanese House has gained historic significance not as an architectural import from another country but as a cultural resource with a unique story to tell about the adaptation of Japanese culture in Southern California.

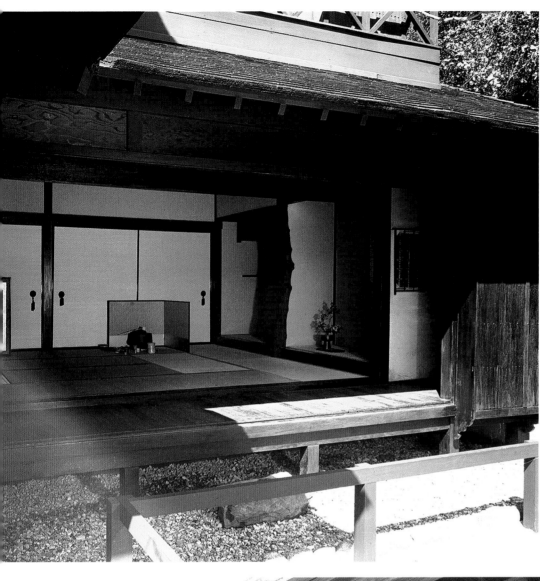

Wood panels reminiscent of Japanese *sugi*, a much valued decorative wood, in a 1958 photo (left) and after the restoration (below).

The Nature of Japanese Gardens

JAMES FOLSOM

Biologists have long noted that life on an island differs considerably from life on the closest mainland. A small body of land surrounded by water benefits from a comparatively moderate climate and experiences different rainfall patterns than continents do. Some islands are more recent in origin and have younger, less developed soils. Smaller, non-mountainous islands have less complex habitats. And of course, these are islands—lands set apart by some distance. The greater the distance from the mainland, the more profound the differences.

Depending on such variables, island flora can be less diverse than that of nearby land-masses. This is true of California's Channel Islands, for example, which have much less floral diversity than similar-sized areas of the adjacent mainland, while Madagascar, much larger than the Channel Islands, has existed under favorable circumstances long enough for a complex and unique flora to evolve. And islands sometimes prove to be sanctuaries where populations of certain plants constitute the sole remnants from a time of wider distribution. Some of Japan's most important trees, the Japanese umbrella pine (*Sciadopitys verticillata*) and *Cercidiphyllum magnificum*, are clearly relicts, known in China from fossils only. These plants dwindled to extinction on the mainland but remain common in the Japanese archipelago.

As may be expected for an island nation, many of Japan's plants are noticeably different from their nearest relatives on the Asian continent. Indeed, some plant populations have evolved so distinctly that they are now considered separate species from their mainland ancestors. Studies of islands show that these forms and species began with characteristics of the first parent population to arrive and successfully establish itself. Generations arising from that original, small gene pool evolved within the basic genetic limits of their predecessors. This impact on future generations was termed the "founder effect" by evolutionary biologist Ernst Mayr. The concepts behind the founder effect are highly relevant when one considers Japan. Many native

Trees in the Japanese Garden.

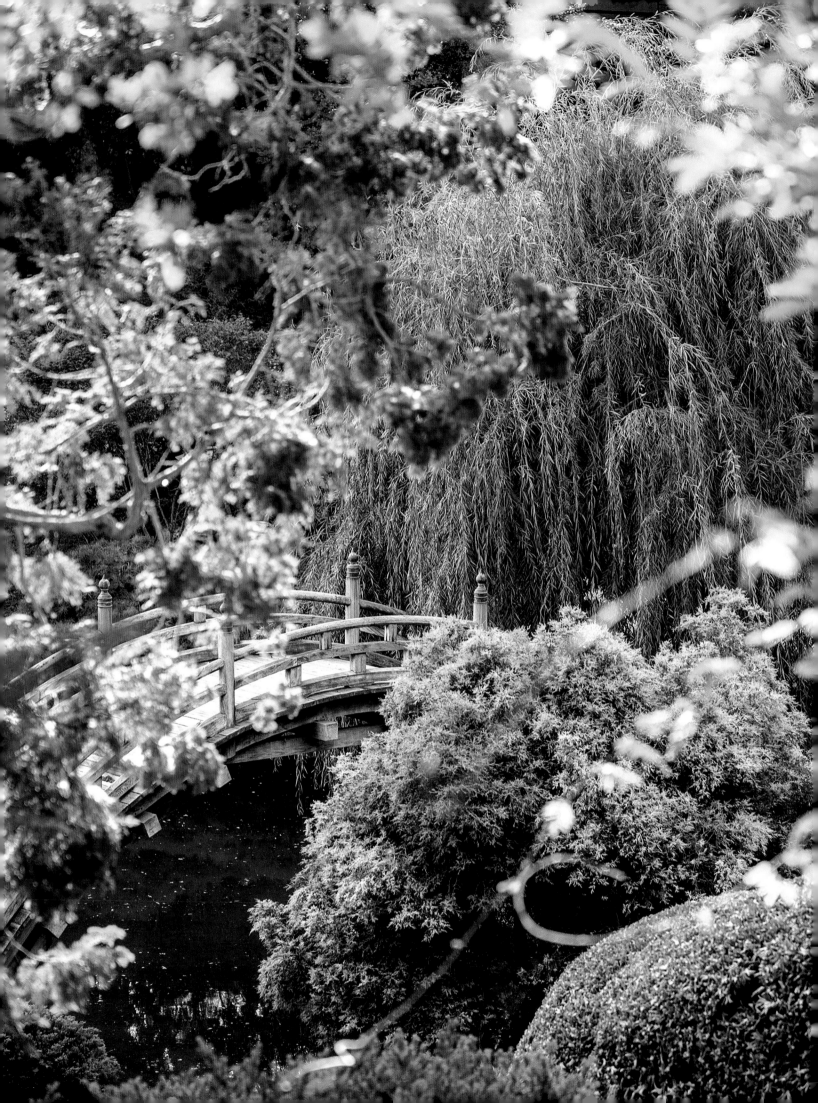

plant species and varieties are curiously distinct endemics, which means they are known only from Japan. The most common camellia in the Huntington Botanical Gardens, for instance, *Camellia japonica*, is, as a native, absent or rare outside of Japan.

In so many ways, Japan differs inherently from limitless China and the nearly contiguous Korean peninsula of the Asian mainland. Defined by mountain and seashore, the landscape of Japan is kinetic and transient, whereas China exemplifies timelessness and expanse. In general, Japan is a world of streams and springs, with no possibility of the languid rivers and canals that wander for hundreds of miles through China. Japan is known for its hard volcanic rock, washed to smooth and wrinkled stepping stones in tumbling streams; China, for its great diversity of stone, including the riddled and skeletal formations of bone-white, sedimentary limestone that characterize the Huntington's Chinese garden, Liu Fang Yuan, the Garden of Flowing Fragrance.

Though Japan is part and parcel of Asia, and fully derivative, this archipelago is singular and distinctive—evolved from its founding elements and culture as a coherent and intelligible microcosm. Exploring Asia's distant past, one can identify common origins and note points of divergence, all of which are remarkably interesting. But the task at hand is comprehension of Japanese garden culture as it is encountered in the present. That alone seems a near impossibility, for, despite the seeming cohesiveness of Japan's gardens, their diversity is just as impressive. Every garden in Japan is a unique creation, and each is, through its origin, a Japanese garden. The corollary of that simple point is that a garden outside the climate and culture of Japan can never be authentically Japanese. The best that can be done in California is to study and appreciate how and why Japanese gardens are created, to appreciate the kinds of materials used and the ways in which practical and aesthetic issues are resolved. The challenge, then, is to comprehend the materials, art, industry, and conditions necessary to create a landscape corresponding to an ideal, to the experience of being in a real Japanese garden.

In this attempt, history suddenly becomes crucial. How did gardening and horticulture take root so early in Japan, and what does that history say about the elements that make Japanese gardens look and feel consummately Japanese? What is significant about plants and climate? What is the role of land form and function? How important is Japanese art, culture, and construction? How could people around the world replicate the process and outcome? If the result is deeply satisfying, how important is the concept of authenticity?

Japan evolved from an ancient farming and gardening culture in which appreciation of plants was inseparable from lifestyle. This was true of many cultures, but something was different in Japan. Perhaps it was the incredible lushness and productivity of the islands. Or, it could have been the native philosophies that valued nature—a connection that was, to a great extent, inevitable because of Japan's wealth of plant life. Coming full circle, this plant wealth was a gift of geography and climate. With a total land area comparable to that of California, Japan's mountainous terrain is much more varied, comprising several thousand islands in an archipelago stretching from 20 to 45 degrees north, essentially from the latitude of Puerto Vallarta, Mexico, to that of Portland,

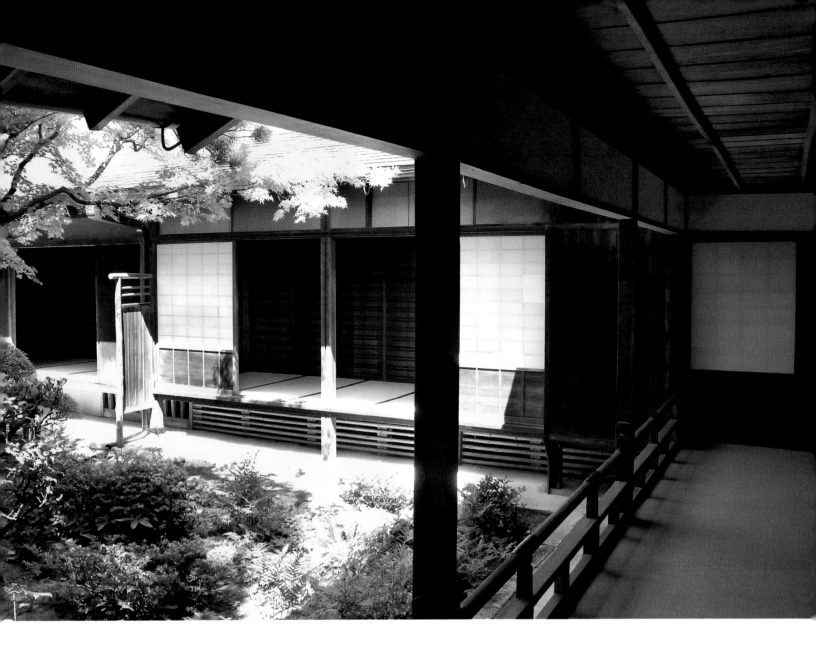

Natural woods integrated into the design of a traditional structure in Japan.

Oregon. The resulting range of habitats, from temperate to subtropical, bolstered by abundant rainfall and good soils, makes the archipelago a spectacular outpost for the historically rich flora of mainland China. Having escaped Pleistocene glaciation, plant diversity was spared the culling that impacted other temperate areas. Certainly the flora of North America, so allied with that of temperate Asia, was decimated by the ice age. But Japan seems to have remained whole, retaining deep credentials as a veritable paradise for plant life, both native and, now in the human era, exotic.

People living in these islands have understood the many benefits that come from plants, an outlook that has fostered ongoing development of unique skills and arts. Artisanship using native plant materials is fundamental to the character of Japan's gardens. Sensitivity to the quality and potential of every sort of natural product inspires creativity. Wood, for example, is treasured for the possibilities inherent in the grain and character of each sample, necessitat-

ing a richness of specialty tools as well as dedicated training for the craftsman who works it. Woodworking and carpentry, so critical to structures in the Japanese garden (and thus to the building of a Japanese garden), developed as artistry that values the quality of materials. It is hard to imagine a Japanese garden that ignores honest, high-quality materials and workmanship.

The importance of materials extends to plants as well. Specialized techniques and skills define all of Japan's garden arts, from ikebana and tea ceremony to bonsai and landscaping, each art responding to the qualities and potential of available materials. And each art celebrates its own suite of historically important plants. Crafts are not limited to native flora, however. As new plants have been introduced to Japan, and as the Japanese lifestyle has spread to other areas of the world, traditional approaches have encountered and embraced new raw materials.

Above: Bamboo fencing in Japan.

Right: Japanese plants in the Japanese garden.

Japanese Plants and Gardens and Southern California

This encounter between the traditional and the new is exactly the history of Japanese culture in Southern California. Many traditionally important plants are present and used in Japanese-style landscapes and cultural arts (right). But other plants, plants not native to Japan, have been adopted and newly adapted to the tasks at hand. For Californians, some Japanese plants arrived in North America even before Japanese settlers made an impact on the landscape. But these are somewhat recent developments. Western gardeners knew little about Japanese plants until well after 1700. A few plants were known to Europe centuries back, plants that had been brought there through trade on the Silk Road. Westerners could not have imagined, though, the vast variety and value of Asian plants. Even when seed of a very useful plant survived the lengthy

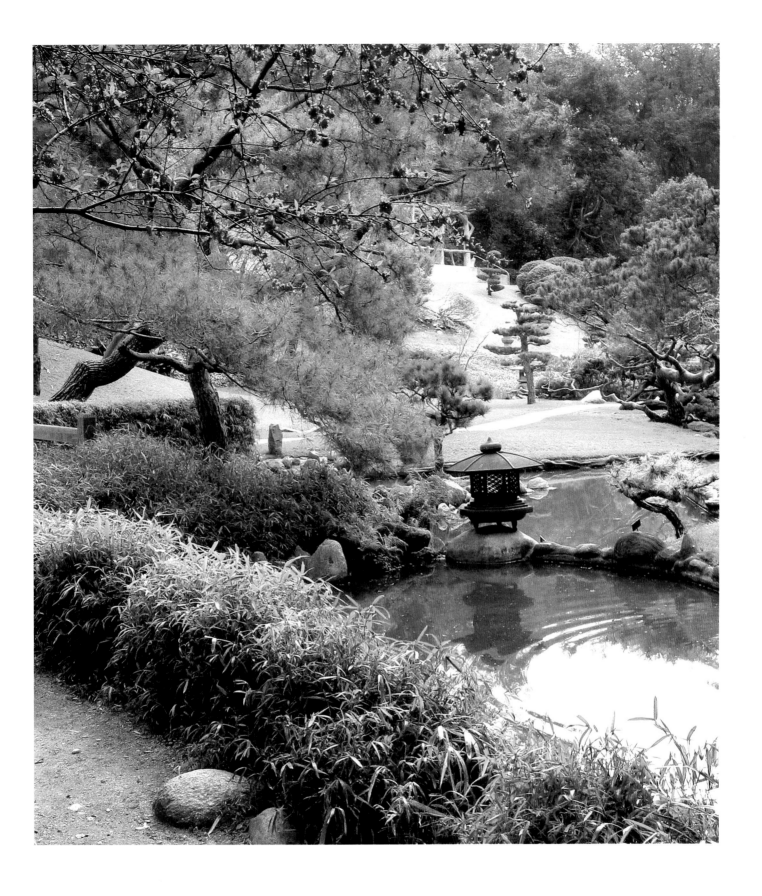

overland journey, its origin may not have been clear—such that botanists would give native Chinese and Japanese plants inappropriate names, which was the case with *Prunus persica* (peach) and *Prunus armeniaca* (apricot).

The first Western scientific record of Japanese plants, not published until 1712, was written by Engelbert Kaempfer, who had been a medical officer for the Dutch East India Company. He included plants endemic to Japan, such as *Camellia japonica*, plants that would later be found to have a much greater presence in China than Japan, such as *Cinnamomum camphora* (camphor tree), and plants he understood the Japanese knew had originated in China, such as *Camellia sinensis* (cultivated tea). A few significant living samples made it to the West. Ginkgo was cultivated in the Utrecht botanical garden by 1740, and the pagoda tree, *Sophora japonica*, was grown in England just a few years later. But not until 1784, when Carl Thunberg published a more thorough record in *Flora Japonica*, would the richness of Asia's flora become apparent. Even then, the horticultural treasures of Asia were tantalizingly unavailable. Only after the Treaty of Nanjing (1842) and the Treaty of Kanagawa (1854) opened China and Japan respectively to exploration and trade did the plant richness of Asia become widely available in the West. Though the plant wealth flowed to European and American gardens, decades would pass before it became clear that Chinese and Japanese gardening traditions were far more ancient and mature than those of contemporaneous Europe or America.

By 1912, when the Huntington's Japanese Garden was first constructed, a fascination with things Japanese had materialized across North America. Americans already knew that traditional garden plants from Japan and China are excellent for this continent, especially in the Southeast and Midwest. But Japanese plants are also important in the Southwest, which may be a bit surprising. Though Los Angeles County is on the 34th parallel, as is Hiroshima in southern Japan, it is on the western flank of North America, whereas the Japanese archipelago sits off the east coast of the Asian continent. Los Angeles, thus, has a Mediterranean climate—with mild, moist winters and hot, dry summers—as contrasted with the wet, monsoonal climate of Japan. Rainfall in San Marino, where the Huntington is, averages 14 inches a year, most of which falls from December to March. Hiroshima receives 63 inches of rainfall a year, peaking in July. Humidity in San Marino is considerably lower than in Hiroshima, particularly on hot summer days. For these reasons, California's garden flora differs significantly from that of Japan. Indeed, it is astonishing how many Japanese plants perform well for Southern California gardeners, considering the great differences in weather. But some significant Japanese garden plants simply do not thrive in California. In some cases, alternatives are available from congeners—different species in the same genus—or vicariads—closely related species that are native to North America. In other cases, unrelated plants from other floras have found a new purpose in this landscape style.

Plants in the Huntington's Japanese Garden

Crucial to the Huntington's Japanese Garden are the trees and woody shrubs that give it structure. Of added importance is the capacity of these plants to respond well to pruning and shaping. Almost every woody plant in a Japanese garden is pruned and styled, and hardly any plant grows without intervention. Sometimes plants that appear the most natural in structure have been carefully trained to give an appearance of lacy openness against others that were obviously sheared for contrasting mass.

EVERGREEN PLANTS IN THE GARDEN

Evergreen trees are important components, and fortunately, Japanese black pine (*Pinus thunbergiana*) grows well in the Japanese Garden (below). This tree takes to pruning beautifully, and it is a fundamental feature of the garden, both in Southern California and in Japan. Individuals are long-lived, which is important, because developing a handsome landscape specimen may require two to three decades of training. Maintaining beautiful form and texture demands annual pruning and thinning, so that the new growing tips—called "candles"—do not become so strong as to compete with more delicate branching.

Japanese black pine
(*Pinus thunbergiana*).

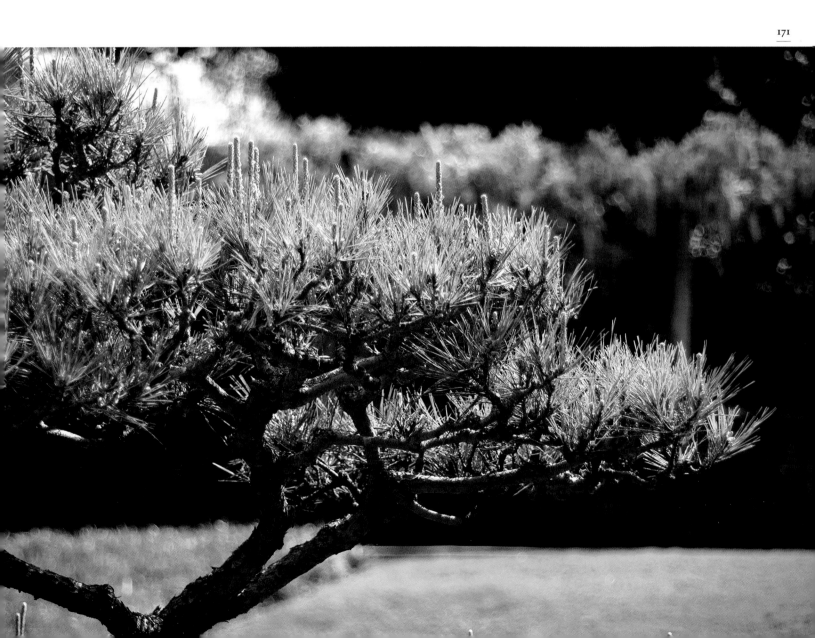

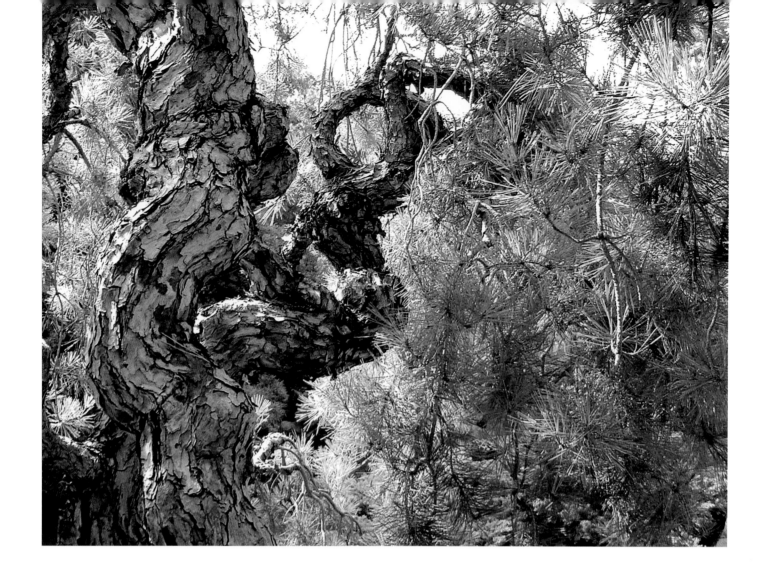

Japanese red pine (*Pinus densiflora*) also grows in the Japanese Garden (above), though these trees never reach the size and splendor that they do in Kyoto, where scores of enormous hand-pruned specimens grace the Imperial Gardens and other landscapes. The airy Aleppo pine (*Pinus halepensis*) provides the backdrop to the Bonsai Courts as a worthy larger-scale substitute.

Of other important evergreens, hinoki cypress (*Chamaecyparis obtusa*) is prominent in the Japanese Garden. Prized in Japan for its durable, high-quality wood and bark, which has been used for roofing, hinoki brings meaning and character. A specimen immediately east of the Japanese House, in the central garden, was among the original plantings in 1912. Closely related to the cypresses, junipers (particularly forms of *Juniperus chinensis*) are particularly important elements in the Huntington's Japanese Garden, where century-old specimens bear handsome, twisted branches around the margins of the central pond (opposite, top).

Some evergreens in the Huntington's garden defy simple categorization. The sago palms (*Cycas revoluta*) are prominent components, having grown to mature size from the original plant-ings of 1912 (opposite, bottom). Native to warmer areas of southern Japan and coastal China, the sago is commonly encountered in gardens throughout Japan, though plants in colder areas

Japanese weeping red pine (*Pinus densiflora pendula*).

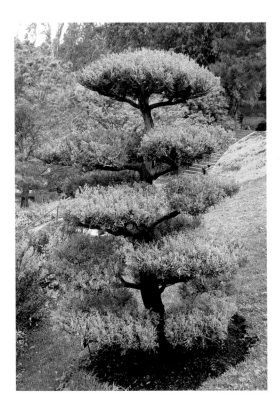

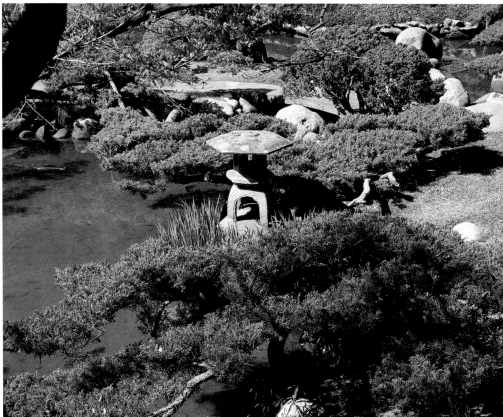

Above left: Pruned Hollywood juniper (*Juniperus chinensis*).

Above right: Chinese juniper (*Juniperus chinensis*).

Left: Sago palms (*Cycas revoluta*).

Left: The tea plant
(*Camellia sinensis*).
Below: *Camellia japonica*
'Alba Plena'.

require winter protection. These are curious plants that have the look of palms or coarse ferns, yet are completely unrelated. Some years, the stems produce beautiful fountains of new leaves that mature to leathery, dark-green fronds, while during other growth seasons, the sago makes cones instead. As with all cycads, individual plants will either be female—producing shaggy, seed-bearing cones—or male—manufacturing pollen in two-foot-long tight cones that persist for many months.

Many evergreens are flowering plants, the largest being camphor, *Cinnamomum camphora*, a laurel that is native to China, Taiwan, and a single mountain area in Japan. In Japan, camphor has taken on great meaning, as specimens several hundred years old are planted near Shinto shrines. The camphor is the city tree of Hiroshima, where it was among the first trees to recover following the devastation of the atomic bomb. In the United States, camphor wood is prized as a lining for silver cabinets, based on the assertion that it retards tarnishing; it is also used for clothing chests. It grows beautifully in Southern California, and several larger specimens help create the canopy in the canyon north of the Japanese house.

The most noteworthy evergreen flowering trees and shrubs associated with Japanese gardens are the camellias,

Above: *Camellia japonica 'California'.*
Right: Azalea (*Rhododendron*).

azaleas, and hollies. Camellias grow particularly well in Southern California, and the Huntington cultivates North America's largest collection of cultivars and species. Most common in the Japa-nese Garden are forms of *Camellia japonica* and *Camellia sasanqua*, both native to Japan (above and opposite). Though in the wild, *Camellia japonica* is a small understory tree, sometimes reaching thirty to fifty feet, Japanese gardeners have selected and culti-vated hundreds of forms as garden shrubs, now adopted for land-scapes around the world. *Camellia sasanqua* is naturally mounding to great size, while still seeming somewhat delicate, with its twisted trunk, willowy branches, smaller leaves, and fragile flowers. Both species are significant components of the Hunting-ton's Japanese Garden.

As prominent as camellias may be, the most common woody shrubs in the garden are the many forms of azaleas (*Rhododendron* cultivars, right). Small-leaved Kurume types can be sheared to create boulder-like masses. Fifty-year-old "drifts"

of these forms create the shrubby understory to ginkgos in the rock-and-sand garden (sometimes called the Zen Court). In other garden areas, larger-leaved azaleas are allowed freedom to mound loosely, producing their handsome flowers in mid- to late spring. Occasionally, visitors to the garden encounter plantings of the curious Satsuki forms, with their exotic flowers and coloration. All azaleas benefit from acidic soils, which must be maintained through ongoing use of peat and other organic amendments.

Another flowering evergreen of note is the shrubby tea olive, osmanthus, so important in the Chinese garden. A specimen in front of the Japanese House tops twenty-five feet, by any standard a small tree. The lovely aroma of its small white flowers can be mysterious, as visitors know quite well, searching for a fragrant plant, yet seldom discovering the source high above them. But that height results from many decades of unchallenged growth. In other places, various kinds of osmanthus are kept to much smaller scale.

DECIDUOUS PLANTS IN THE GARDEN

Deciduous trees are important elements in Japanese gardens, evidencing the four seasons through spectacles of fall color, spring flowering, winter openness, and summer shade. Many of the flowering trees and shrubs native to Japan are deciduous, creating much of the character associated with temperate forests. Several major groups grow successfully for Southern California gardeners, but to achieve a range of textures and forms for the Japanese Garden, substitutes are necessary.

The deciduous trees that most characterize Japan's gardens are the many forms of Japanese maple (*Acer palmatum*), which spread like lingering clouds of intricate branching and lacy delicacy in the landscape, and in autumn simply astonish visitors with vivid colors (opposite). The same Japanese maple grows for California gardeners, and it is common to the Huntington garden. But in a dry climate, these trees yield grudging success and undistinguished fall color compared to their counterparts in Japan.

Only a few of the gymnosperms (ancient seed-bearing plants, conifers, and their relatives) that can be grown in Southern California lose their leaves in winter. The most prominent is *Ginkgo biloba*, a tree noted for its unique leaf shape and dazzling fall color (overleaf). Native to China, the ginkgo has long been popular in Japan, where the trees are planted near temples; folklore grants ginkgo the ability to protect structures from fire and lightning strikes. Because so many other Japanese plants change to lovely color in the fall, the ginkgo is not so singular there, but in California gardens it is one of the most striking signs of autumn. The small forest of ginkgos in the Zen Court showers the slate paths each November with a carpet of golden leaves. The ginkgo leaf is the symbol for the Urasenke school of tea.

Above and opposite: Japanese maple (*Acer palmatum*).

Overleaf: Ginkgo (*Ginkgo biloba*) in fall.

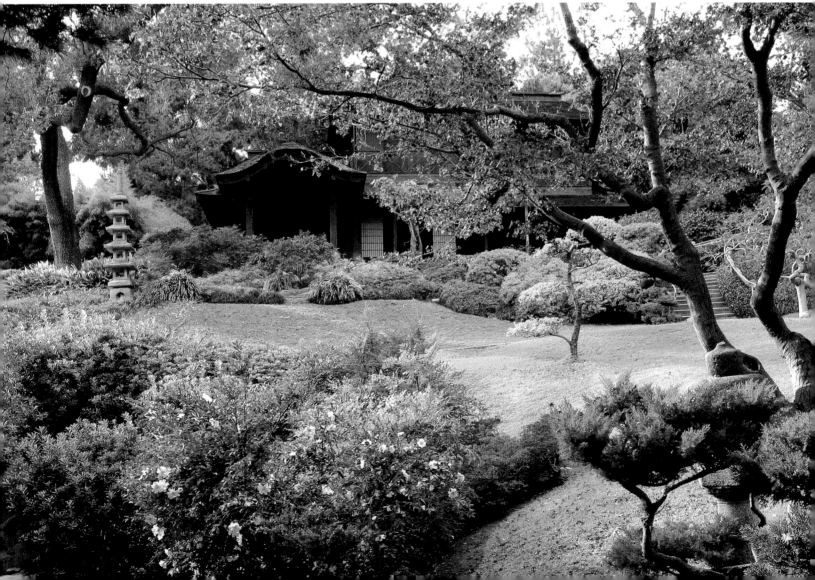

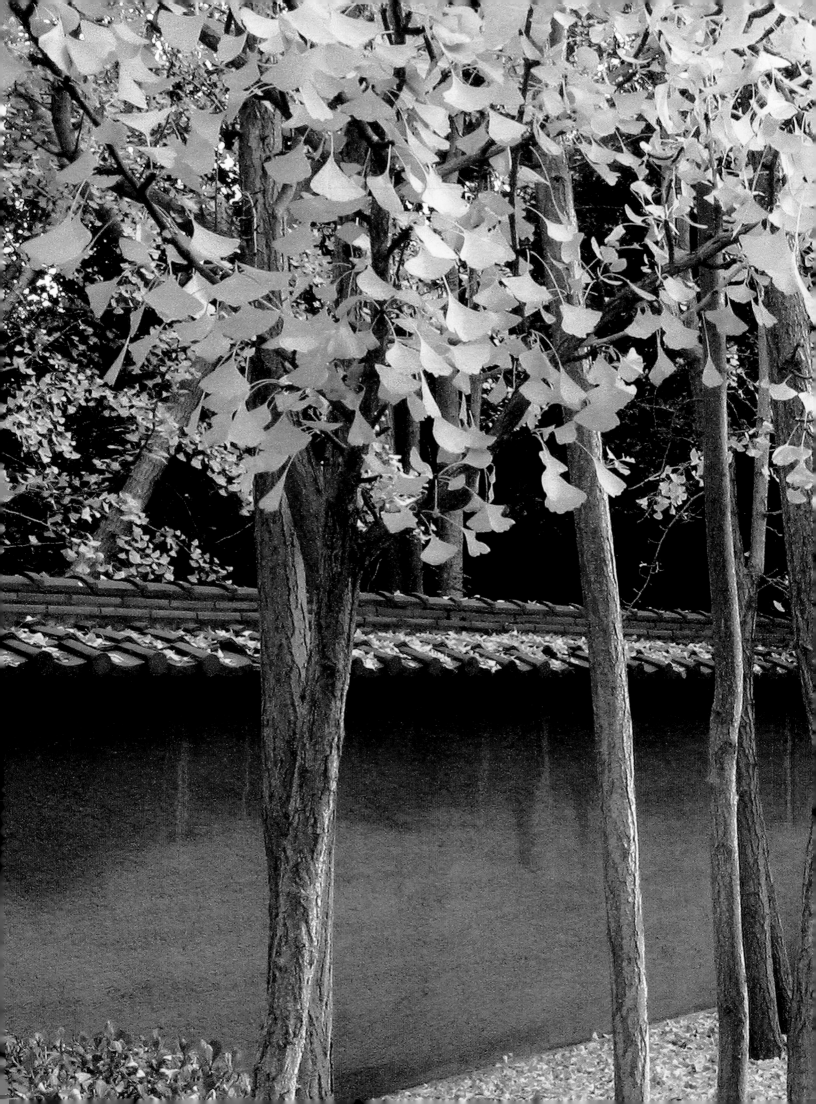

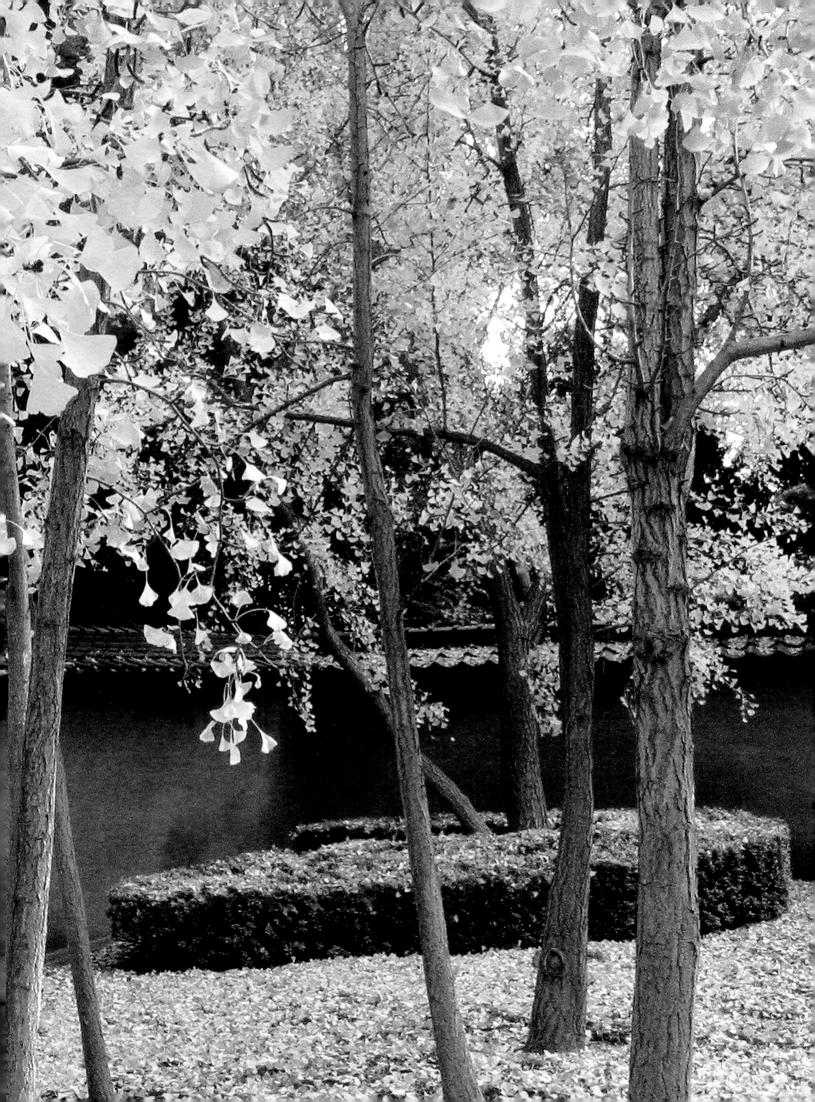

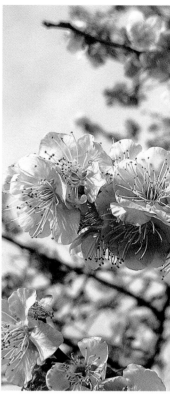

The Japanese Garden is fortunate to have ginkgo, but this is not the sole source of autumn color. The North American sweet gum (*Liquidambar styraciflua*) provides good foliage, similar in shape to that of the maples, and it yields excellent yellow, pink, red, burgundy, and rich brown fall color. The form and branching of sweet gum does not equal the spreading elegance of maples, but it is a handsome substitute. Another Asian tree, crepe myrtle, is an excellent candidate for the Japanese Garden. It provides delicate branching, beautiful bark, and handsome fall color.

Of course, if any tree is associated with Japan, it has to be sakura, the spring-flowering cherry. Available in hundreds of forms, the flowering cherry is abundant in public parks, byways, and larger gardens (above). Though few forms that have been developed over the centuries by Japanese gardeners thrive in Southern California, there are cultivars that are very successful. Several decades ago, a volunteer seedling was discovered in the Huntington's Japanese Garden, a spectacular flowering cherry that subsequently was named 'Pink Cloud'. Believed to be a hybrid between *Prunus serrulata* (sakura) and *Prunus campanulata* (Taiwan cherry), Pink Cloud gives Southern Californians the best of the season, and it has been planted throughout the region.

Above left: Japanese cherry (*Prunus serrulata*).

Center: Flowering apricot (*Prunus mume*).

Below, left and right: Flowering peach (*Prunus persica*).

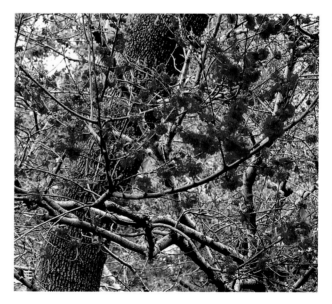

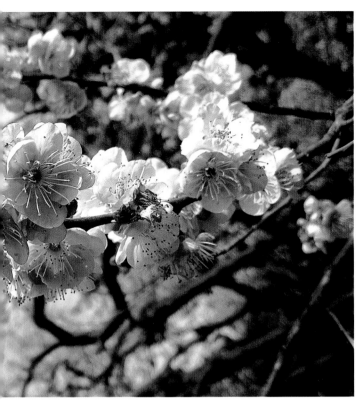

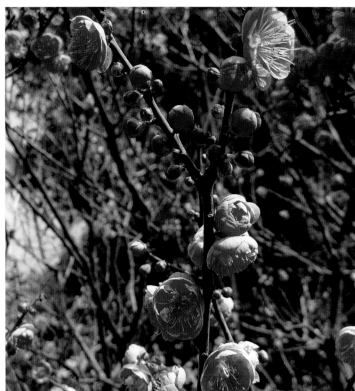

Above right: Flowering apricot
(*Prunus mume*).

Overleaf: Japanese wisteria
(*Wisteria floribunda*).

Another important *Prunus* in Japan is *ume*, the flowering apricot (*Prunus mume*). Said to have been brought from China, *ume* is revered in Japan for its early flowering and useful fruit, and it is represented by hundreds of cultivars. As in China, along with pine and bamboo, *ume* is known as one of the three friends of the cold season. Many forms are available in Southern California, and two large stands cover the slope east of the main ponds in the Japanese Garden (above). A legendary stand of *ume* was planted on the banks over Lake Senba in Ibaraki Prefecture as a food supply for the Japanese military in 1841. Of course, the peach, *Prunus persica*, a native to China, has long been cultivated in Japan for both flowers and fruit. The flowering peach is the perfect tree for Southern California, and it brings great delight to visitors in February and March (left). Several ancient specimens of the double white-flowered cultivar 'Icicle' create a sensation each year when they come into bloom.

Not all woody plants in the Japanese Garden are trees or shrubs. Because of its beautiful flowers, wisteria, which is native to both Japan and China, has a long history in gardens and in floral iconography. Simple wisteria trellises are common features in gardens throughout Japan, creating bowers for pendent flowers in the spring and stark architectural branching in winter. At the Huntington, a pink-flowered form planted at the front of the Japanese House in the earliest days of the garden still provides shade, while the long cement faux bois overlook at the garden entrance beckons visitors each year during flowering (overleaf).

Bamboos are curious. Most people know that bamboo is a grass, in the same family as corn, sugar cane, and bermuda. But what is a grass, why are bamboos considered grasses, and what about grasses makes bamboo special? Grasses are a massive group of over five thousand kinds of closely related flowering plants. But their flowers, in all instances, are so derived and reduced that most botanists find them difficult to understand. The blossoms consist of sexual parts only, with hardly any petals or sepals, which is why one is barely aware that grasses have flowers. They are, by and large, wind-pollinated, a way of life that makes sepals and petals superfluous. Wind pollination means that growing in drifts, fields, or even entire prairies, as grasses do, works well for pollen distribution. And it is the rhizomatous habit of many grasses—producing stems that creep along the ground and root at every joint—that makes growth of huge stands possible (opposite). That is the habit of bamboo. But its strength comes from tough, fibrous stems that grow in hollow sections, yielding large, lightweight tubular constructions arising from stems that crawl above ground or underneath it.

There are bamboos large and small, with a wide range of gauges and leaf sizes. But they are invariably recognizable by their jointed, gently arching stems and flat, lance-like leaves. Bamboos are useful in gardens, and even more valuable as models and materials for everyday life. The importance of bamboo pretty much escapes most Westerners, but anyone from Asian or tropical regions would have little difficulty appreciating these plants. There seems to be a bamboo for almost every use, from building a structure, to erecting the scaffolding that is needed to do the work. In the kitchen, bamboo provides material for cutting boards, tongs, stir bars, and even skewers. One may eat bamboo shoots from a bamboo plate with bamboo chopsticks while drinking sake from a bamboo cup. This would be a nice repast before picking up a quill formed of bamboo to paint on a bamboo stem with arcs and characters whose ideal shape derives from the form of bamboo leaves and culms. Bamboo is beloved. It is one of the three friends of the cold season, symbolizing both strength and flexibility. A garden without bamboo, both alive and used in design and construction, could hardly be Japanese or Chinese.

Out of the Garden: Plants and Garden Arts

BONSAI

Though totally evocative of Japanese style, bonsai plants are not normal garden elements. Rather, they are grown in nurseries and used for decoration in and around homes. The bonsai display at the Huntington was developed in collaboration with the Golden State Bonsai Federation, an association of California's bonsai societies and artists. It is one of two collections built and supported by that organization.

Bonsai seems to have originated in China by the seventh century as an artform called *penjing*, literally, "scene in a pot," or *penzai*, which means "potted cultivated plant." Introduced to Japan centuries ago, the art evolved to feature highly stylized forms that are strongly defined. Most specimens respond to at least one basic style, such as informal, formal, cascade, grove, landscape, or free form.

Right: Bamboo (*Phyllostachys nigra*, left, and *Phyllostachys vivax*, right).

BONSAI AND BEN OKI

Bonsai artist Ben Oki has led a charmed life. Born in Sacramento in 1927, he was sent by his parents to attend school in Hiroshima, Japan, where he remained as an American citizen throughout World War II. On August 6, 1945, deferring a job interview in the city until later that day, Oki and a friend rowed into the bay in the dark hours of early morning to fish. Instead, the two men watched in horror as Hiroshima exploded in flames when American planes dropped a nuclear bomb on the city. In 1950, Oki returned to the United States with his new bride, Sadako, raised a family, gardened for a living, and trained under bonsai master John Naka beginning in 1958. That legacy and Oki's skills provided fundamental strength for the expanding Huntington display and collection.

JAMES FOLSOM

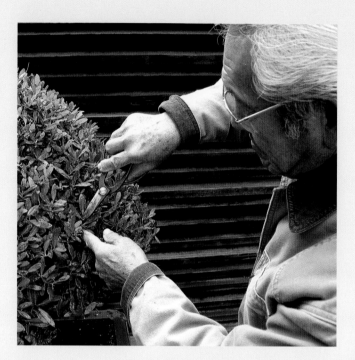

Japanese black pine is the most flexible of the materials available, and it can be used for most styles. The Huntington's collection features several upright specimens of this pine, both formal and informal, including a handsome corky-barked specimen styled by John Naka and Ben Oki (opposite, top right).

Juniperus chinensis, especially the very tight Sargent's variety native to Japan, is also widely used in California (opposite, bottom). But California juniper, Juniperus californica, has become the icon of regional bonsai arts (overleaf). Through collecting well-shaped, naturally rooted branches from wild trees in mountain forests, California artists have developed a wholly new style that brings dramatic driftwood-like deadwood to the composition. This plant grows well at the Huntington and is represented by impressive specimens in the collection.

Among deciduous trees, several kinds of maples are used to create beautiful bonsai in Japan. But Japanese trident maple (Acer buergerianum) is the most manageable species in a Southern California climate. A root-over-rock trident maple, created for the garden in 1968 by Head Gardener Robert Watson, remains on display in the collection (overleaf, top right).

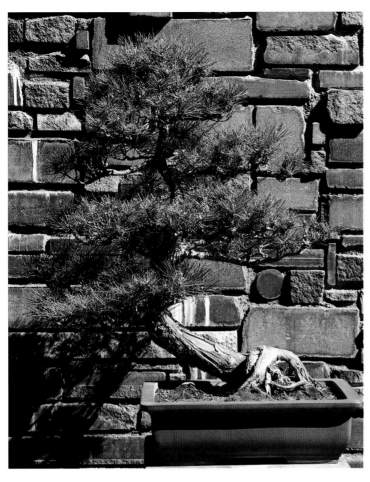

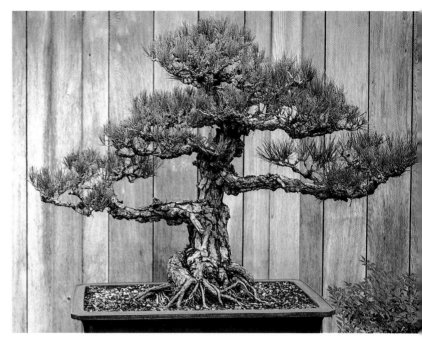

Above left: Japanese black pine (*Pinus thunbergiana*), donated by Ed Murakami.

Above right: Cork bark Japanese pine (*Pinus thunbergiana*), designed by John Naka and Ben Oki.

Right: Chinese juniper 'San José' (*Juniperus chinensis*).

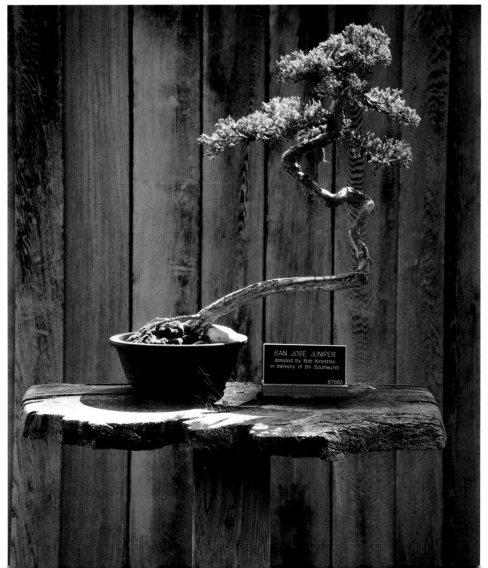

SAN JOSE JUNIPER
donated by Bob Kinoshita
in memory of Bill Southworth

87883

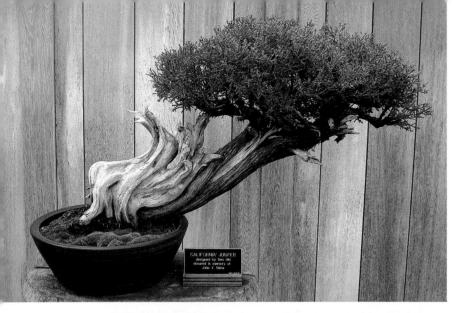

Left: California juniper (*Juniperus californica*), designed by Ben Oki, donated in memory of John Y. Naka.

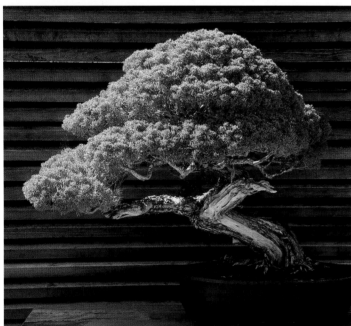

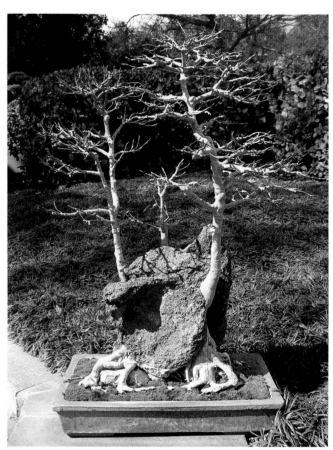

Above left: Chinese juniper 'Shimpaku' (*Juniperus chinensis*).

Above right: Japanese trident maple (*Acer tridentata*), designed by Bob Watson, 1968.

Left: California juniper (*Juniperus californica*).

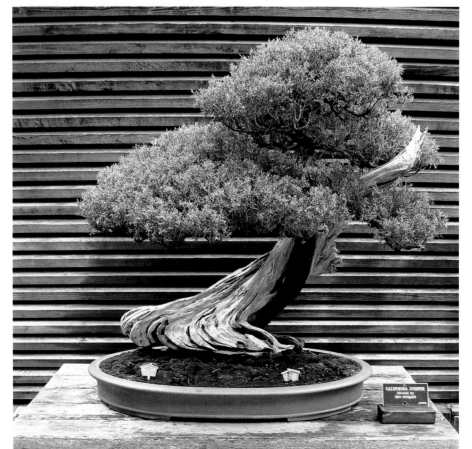

IKEBANA

Almost every aspect of Japanese interest in plants, and every aspect of aesthetic style, is showcased in flower-arranging, called "ikebana," or giving life to flowers. Ikebana embodies beautiful materials with beautiful lines; the expression of philosophy and meaning; a manipulation of the void that is as dramatic as the use of mass or line; and celebration of the moment. Throughout, traditions are strong. Seasons are critical, and certain flowers and greenery are used only in their season. But with regard to what kind of material might be used, a flower, branch, or leaf from any available source is welcomed by ikebana artists. The wide range of possibilities helps to explain how hundreds of schools of Japanese flower-arranging have developed over the years.

Students of ikebana at the Huntington (members of the San Marino League) follow the teachings of Ikenobo, the oldest and largest floral school. As part of their study and service, students maintain fresh arrangements daily in the *tokonoma*, or alcoves, of the Japanese House, paired with appropriate scrolls and objects to reflect the traditions of the season. This practice began in 1957 and it continues today, such that when the Japanese House is open, there are fresh flowers to bring life to the house, mark the season, and welcome the visitor.

Ikebana arrangement in the Japanese House.

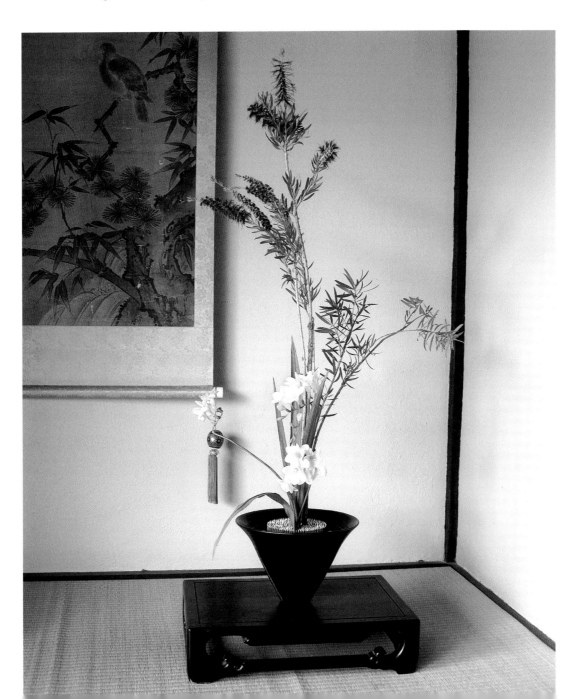

THE LIVING ART OF KOI

Koi are frequently referred to as "living jewels," owing to their vibrant colors. They might also be called "living art," as their dozen or so colorful varieties, quite unlike the original brown carp, have developed over centuries of breeding in Japan. The most highly prized type of koi is the *kohaku*, with its dramatic red-and-white pattern that evokes the colors of Japan's flag. The other two most valued varieties are much like the *kohaku* but with the addition of black in unique patterns.

Size is another prized characteristic. Healthy koi can grow more than four inches annually, up to a length of about three feet. The primary influences on their growth are food and clean, well-oxygenated water. Feeding the koi several times a day, removing waste from the water, and adding plenty of oxygen to it is the only way to achieve robust growth. Unsurprisingly, commercial breeders go to great lengths to achieve ideal conditions.

The value of a particular koi is based on three factors: pattern, conformation, and condition. Each koi variety has general characteristics that breeders strive to achieve, and pattern is the most obvious one. This refers to the sharpness of the design and the uniformity and saturation of the colors. For example, in the *kohaku*, the pattern should be red over white in a pleasing design; when viewed from above, the red and white should appear in approximately equal amounts. The nose and tail joint should both be white, in order to keep the red color within the body of the fish. Conformation and condition of the fish are somewhat related. Healthy koi have a uniform color, a natural sheen, and a robust size. Conversely, fish kept in unhealthful water have irritated skin and are thin and undernourished.

VERGIL HETTICK

Curator

The Earl Burns Miller Japanese Garden

California State University, Long Beach

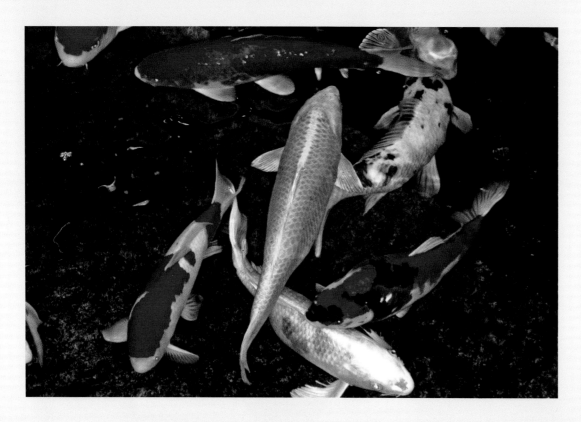

Koi at Konko Church, Gardena, California.

Conclusion

As stated earlier, any garden in Japan is a Japanese garden. But garden historians suggest that Japan gave rise to three basic types of gardens that were not known from other cultures: the stroll garden, the dry garden, and the tea garden. A stroll garden is an immersive and calculated arrangement of water, stone, and highly trained, carefully scaled plants that invents a perfected nature. The dry garden brings sea and sky into a composition of gravel and stone. The tea garden celebrates rustic nature as a place of retreat. Visitors to Japan could travel the country and never agree that any particular garden was the most beautiful or most representative of any style. They might even find difficulty agreeing with historians that one could so simply categorize or summarize the gardens of Japan.

I wonder what the original creators of those gardens would make of the Japanese garden diaspora. Would they be pleased to see the thousands of landscapes and niches around the world inspired by Japanese style? Would they be amused at today's concerns over correctness or authenticity in building Japanese-style gardens in foreign lands? Probably, I think. My opinion, admittedly, is shaped by the knowledge that the Huntington's Japanese Garden could never pretend to represent a garden in Japan, or of Japan. Others may create a landscape in North America that can claim to be a pure and perfect example of a Japanese garden. The Huntington's objectives are more functional: to emulate the magic of Japanese gardening, to inspire others in appreciating the beautiful creations of Japanese culture, and to learn and pass on the skills needed to cultivate gardens and use plants in a traditional Japanese style.

Snow-viewing, or *yukimi*-style, lantern.

191

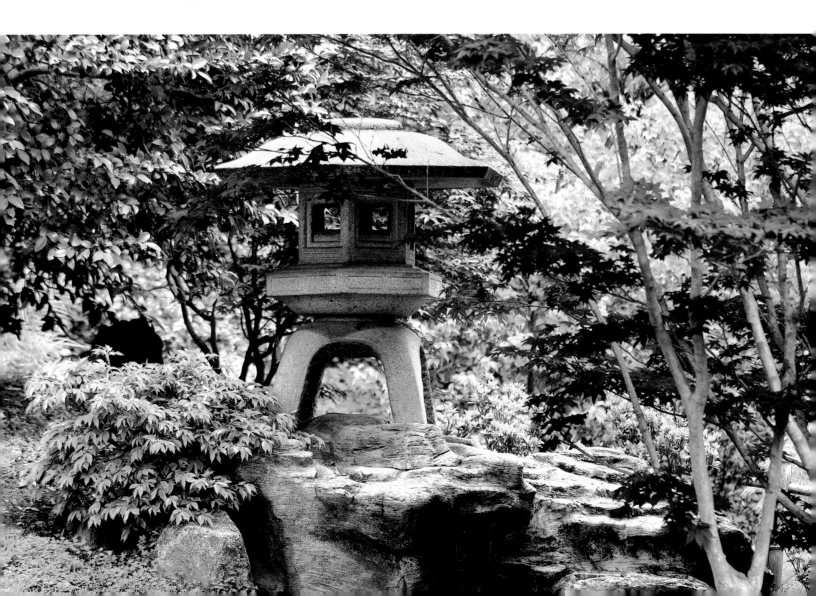

Notes

TRADITIONS OF TRANSFORMATION: GARDENS IN JAPAN BEFORE 1868

1. For histories of gardens in Japan, see Wybe Kuitert, *Themes in the History of Japanese Garden Art* (Honolulu: University of Hawai'i Press, 2002); Marc P. Keane, *Japanese Garden Design* (Rutland, Vt.: Tuttle, 1996); and Loraine E. Kuck, *The World of the Japanese Garden: From Chinese Origins to Modern Landscape Art* (New York: Walker/Weatherhill, 1968).

2. The excavations at the Tō'in garden at Nara, and the re-creations of ceremonies held there, are introduced at the Nara Explorer website, http://www.naraexplorer.jp/special/.

3. The classic example of this so-called *shinden-zukuri*, or sleeping hall–style garden, is the Fujiwara family's Tōsanjōden compound, long defunct but known through records. Its design, and the kinds of activities held in the garden, are described in Kuitert, *Themes in the History of Japanese Garden Art*, 8–17.

4. For translations of *Sakuteiki*, see *Sakuteiki: The Book of Garden*, trans. Shimoyama Shigemaru (Tokyo: Kodansha, 1976); Jirō Takei and Marc P. Keane, *Sakuteiki, Visions of the Japanese Garden: A Modern Translation of Japan's Gardening Classic* (Boston: Tuttle, 2001); and *Infinite Spaces: The Art and Wisdom of the Japanese Garden, based on the Sakuteki by Tachibana no Toshitsuna*, ed. Joe Earle (Boston: Tuttle, 2000).

5. See P. Richard Stanley-Baker, "Mythic and Sacred Gardens in Medieval Japan: Sacral Mediation in the Rokuonji and the Saihōji Gardens," in *Sacred Gardens and Landscapes: Ritual and Agency*, ed. Michel Conan (Washington, D.C.: Dumbarton Oaks, 2007), 115–51.

6. Mt. Lu, the famous peak associated with Pure Land Buddhism and the poet Li Bai, was represented as a rounded hill, whereas the West Lake in Hangzhou was denoted by a shallow pond with a "dyke," signaling the ones built by the governor-poets Bai Juyi and Su Shi. Amanohashidate, the "floating bridge of heaven" on the Japan Sea north of Kyoto, was signaled in gardens by a long spit of land planted with pines, whereas Mt. Fuji was represented as a conical hill with a flat top.

7. The poem is included in *Tales of Ise: Lyrical Episodes from Tenth-Century Japan*, trans. Helen Craig McCullough (Stanford, Calif.: Stanford University Press, 1968), 74–75.

8. For studies of the social functions of *daimyō* stroll gardens, see the final chapters in Seiko Goto, *The Japanese Garden: Gateway to the Human Spirit* (New York: Peter Lang, 2003), 155–92; and Shirahata Yōzaburō, *Daimyō teien, Edo no kyōen* (Daimyō Gardens, Edo Banquets) (Tokyo: Kodansha, 1997).

9. The modern interpretation of dry gardens as expressions of Zen, seen in books like François Berthier, *Reading Zen in the Rocks: The Japanese Dry Landscape Garden* (Chicago: University of Chicago Press, 1997), has been challenged in such studies as Shōji Yamada, *Shots in the Dark: Japan, Zen, and the West*, trans. Earl Hartman (Chicago: University of Chicago Press, 2009); and Kuitert, *Themes in the History of Japanese Garden Art*, 129–38.

10. For a thorough study, see Marc P. Keane, *The Japanese Tea Garden* (Berkeley, Calif.: Stone Bridge Press, 2009).

11. Josiah Conder, *Landscape Gardening in Japan* (London: Kelly and Walsh, 1893; Tokyo: Kodansha, 2002).

FROM RANCH TO ESTATE: A JAPANESE GARDEN COMES TO SAN MARINO

1. Collis P. Huntington reportedly offered to transport the Japanese and Chinese objects free of charge to Philadelphia from San Francisco on his railroad. He visited the fair, and later furnished his home at 65 Park Avenue in New York City with pieces in the "Anglo-Japanese style" from the Herter Brothers firm. Arabella Huntington was familiar with these objects, and she commissioned the Herter Brothers to create similar "Anglo-Japanese" pieces for the bedroom of her home at 4 West 54th Street. (See also notes 9 and 19.) I am indebted to Shelley Bennett for this information, which appears in her book on the Huntingtons' collecting, *The Art of Wealth* (San Marino, Calif.: Huntington Library, 2013).

2. See Kendall H. Brown, "Fair Japan: Japanese Gardens at American World's Fairs, 1876–1940," *Site/Lines* 4, no. 1 (2008): 13–16.

3. The Nio Gate is discussed in Yuichi Ozawa, *Story of Shofuso: A Cultural Bridge between Japan and the United States* (Philadelphia: Friends of the Japanese House and Garden, 2010), 28; the Shofuden villa in the Catskills is analyzed in Clay Lancaster, *The Japanese Influence in America*, 2nd ed. (New York: Abbeville, 1983), 149–53. That structure, along with the Japanese House at the Huntington, are discussed in Japanese in Tanaka Atsuko et al., "The Reception and Understandings of Japanese Architecture in the United States: Three Specific Examples," *Jūtaku sōgō kenkyū zaidan, kenkyū ronbunshū* (Journal of Housing Research Foundation) 33 (2006): 99–110.

4. For more on Marsh's contributions as a leading art dealer, see Barry Wolf and Annabelle Piercy, "George Turner Marsh and Japanese Art in America," *Orientations* 29, no. 4 (1998): 47–57. Marsh reportedly sold a group of Japanese artworks to Arabella Huntington in 1890. See James Thorpe, *Henry Edwards Huntington: A Biography* (Berkeley: University of California Press, 1994), 328.

5. For a longer description of the Japanese Village and press coverage of it, see Kendall H. Brown, "Rashōmon: The Multiple Histories of the Japanese Tea Garden in Golden Gate Park," *Studies in the History of Gardens and Designed Landscapes* 18, no. 2 (1998): 93–119.

6. Marsh likely met Spreckels when the latter was on the San Francisco Park Commission at the time that Marsh donated the objects in the Japanese Village to the city. The Marsh-Spreckels Coronado garden is illustrated in Lancaster, *The Japanese Influence in America*, 209. In 1902 Edith Huntington, daughter of Huntington's younger brother Willard, married John D. Spreckels Jr.

7. A news brief in the *Los Angeles Times* from August 26, 1908, suggests the clientele and atmosphere of one tea garden at a hotel in Santa Monica: "Miss Nettie Gephart, who is spending the summer at the Arcadia, entertained a few friends Saturday evening after the hotel dance at a delightful supper at the Japanese tea garden. The table was decorated with pink carnations, while many Japanese lanterns cast their soft pretty light throughout the garden."

8. Kushibiki ran concessions, often called "Fair Japan," at the expositions in Chicago (1893); Atlanta (1895); Nashville (1896); Omaha, Nebraska (1897); Buffalo, New York (1901); Charleston, South Carolina (1901–2); St. Louis (1904); Portland, Oregon (1905); Norfolk, Virginia (1907); Jacksonville (1908); Seattle (1909); London (1910); and San Francisco (1915).

9. "News of Plays and Players," *New York Times*, June 24, 1903, 9; "Guests at Adirondack Camps," *New York Times*, August 9, 1903, 22. Frederick Vanderbilt's older brother William K. Vanderbilt had kicked off the craze for Japanese interiors in 1879 when he hired the Herter Brothers to create a Japanese room in his mansion at 640 Fifth Avenue. This room postdated Collis Huntington's commissioning of the Herter Brothers and slightly predated Arabella's work with them.

10. The progress of the garden is reported in "A Japanese Tea Garden Will Greet Winter Season," *Pasadena Daily News*, July 2, 1903, 1, and "Work of Constructing Japanese Tea Garden Down in California Street," *Pasadena Evening Star*, November 5, 1903, 5.

11. The advertisements appeared in the *Pasadena Evening Star*, March 17, 1905, 3, and the *Pasadena Evening Star*, March 10, 1905, 3, respectively. "G. T. Marsh and Co., Japanese Tea Gardens and Art Goods" appears in the annual Pasadena City Directory from 1905 to 1911. George W. Marsh is listed as manager. In 1903, hotelier Walter Raymond also planned to open a Japanese tea garden, at a projected cost of $25,000, at his Pasadena hotel. The venture never came to fruition, but his plan demonstrates the vogue for Japanese gardens in Pasadena at the time. See "Raymond's Very Latest Scheme," *Pasadena Evening Star*, April 7, 1903, 6. The Marsh brothers also competed with other Oriental art dealers in Pasadena, including F. Suie One and Toshio Aoki. By 1911, the Kisen Co., J. C. Bentz, A. O. Bosley, and Grace Nicholson were also selling Asian art in Pasadena, and this competition likely led to the demise of the G. T. Marsh Tea Garden.

12. The garden's appearance can be reconstructed based on the untitled pamphlet published by the G. T. Marsh Co., and through photos of the new garden taken by Pasadena architect Will A. Benshoff, now in the collection of the Pasadena Museum of History. A retrospective but detailed description of a tour of the garden around 1905, guided by a Mr. Togo (presumably Goto), was written by Polly Pratt, "The Dream Garden That is but a Memory," *Los Angeles Times*, January 9, 1921, sec. viii, 6. Pratt ends by briefly discussing the rapid dismantling of the garden, the carting of its contents to "millionaires' gardens," and the construction of stores on the garden's site.

13. Nothing else about Okita has been found. Presumably he left Pasadena after receiving little business in the wake of the Marsh Tea Garden.

14. According to the *Pasadena News*, March 31, 1911, 1, there was an auction of N. J. Sargent's Oriental curios from the garden on Fair Oaks. An article in the same paper, on May 13, 1911, 1, states that according to Sargent, who operated the bazaar at Marsh's garden, Marsh planned to subdivide the property. Apparently by 1911, Marsh had sublet the struggling antique business to Sargent. Prior to that, Marsh had also raised revenue by renting out the garden for events. *The Los Angeles Times* article "Some Notable Festivities" of May 2, 1909, mentions a reception held at the Marsh Japanese Garden, with 150 guests "served in the small tea house by Japanese girls in native costumes." It was hosted by Mrs. Benjamin Huntington and Mrs. Thomas Bishop, who received guests in the "large tea house." Other newspaper accounts reveal activities in the garden, including a tea and lecture for the Women's Union of the West Side Congregational Church (August 12, 1910), the annual meeting of the Washington Heights Club (June 18, 1910), the Wednesday Afternoon Card Club.

(May 20, 1906), as well as many private teas by local women. As evidenced by the garden party hosted there on April 5, 1904, by a Miss Harrison of South Pasadena, these events could include Japanese-themed events, with the hostess and her friends dressing in kimonos and decorating the tables with flowers in a way befitting "the home of a high class family in Japan." Nearly a hundred guests were led through the garden by "a Japanese servant in native costume," and a "Japanese maid served tea and dainty Japanese cakes and confections." The "memory card" gifts given to the participants were paintings of gardens and geisha girls brushed by a local Japanese artist ("Japanese Tea," *Los Angeles Times*, April 5, 1904, sec. A, p. 7).

15. *Pasadena Star*, August 19, 1911, 19. The sale, brokered by the William R. Staats Company, was covered in the *Pasadena Daily News* of the same date, with the headline, "Prize for Huntington: Famous Japanese Tea Garden Treasures to Oak Knoll Mansion," and in the *Los Angeles Times*, August 20, 1911, sec. v, p. 18, under the headline, "Famous Grove Changes Hands: Huntington Acquires Japanese Tea Garden." In a letter from William Hertrich to H. E. Huntington on November 18, 1911, Hertrich speculated that the house must have cost around $8,000. And, on November 25, 1911, he wrote to his boss, "That place was a bargain alright."

16. Schiffmann's garden was made public in the self-published booklet "Grand View: Residence and Gardens of Dr. Rudolph Schiffmann, South Grand Avenue, Pasadena, California" (1911). A copy is owned by the Pasadena Museum of History.

17. For a biography of Henry E. Huntington, see Thorpe, *Henry Edwards Huntington*.

18. For a historical overview of Huntington's horticultural and gardening plans, see James Thorpe, "The Creation of the Gardens," *Huntington Library Quarterly* 32, no. 4 (1969): 333–50.

19. Arabella Huntington (1850–1924), who labored to hide the early circumstances of her life, married Collis nine months after the death of his first wife, Elizabeth, in 1884. She had occupied one of his properties since at least 1872 and had long been his mistress. Arabella also lived in a house at 4 W. 54th Street, sold to J. D. Rockefeller in 1884. (Arabella's bedroom from that house is now displayed at the Virginia Museum of Fine Arts.) With Collis, she erected a large house at 57th Street and 5th Avenue in New York. For an illuminating study of the dark corners in Arabella's biography, see James T. Maher, *The Twilight of Splendor: Chronicles of the Age of American Palaces* (Boston: Little, Brown, 1975), 215–310. Most of the paintings purchased by Arabella for display in her houses were, on her death, gifted by her son Archer Huntington to the Metropolitan Museum of Art; Archer donated his mother's collection of French decorative arts to the California Palace of the Legion of Honor in San Francisco. Both collections were given in memory of Collis Huntington, who some believe was Archer's biological father. For Archer's life, see Mary Mitchell and Albert Goodrich, *The Remarkable Huntingtons, Archer and Anna: Chronicle of a Marriage* (Newtown, Conn.: Budd Drive Press, 2004). For an introduction to Arabella's art collecting, see Shelley M. Bennett, "The Mysterious Arabella D. Huntington and Her Passion for Collecting," in *Powers Underestimated: American Women Art Collectors*, ed. Inge Reist and Rosella Zorzi (Venice: Marsilio Ediori, 2011), 103–20.

20. See Robert R. Wark, "Arabella Huntington and the Beginnings of the Art Collection," *Huntington Library Quarterly* 32, no. 4 (1969): 309–32.

21. *Los Angeles Times*, March 20, 1898. I am indebted to Shelley Bennett for this reference and for drawing my attention to Arabella's horticultural interests.

22. For some connections between American women and Japanese gardens, see Kendall H. Brown, "Constructing Japan in America: American Women and Japanese Gardens," in *Inventing Asia*, ed. Noriko Murai and Alan Chong (Boston: Isabella Stewart Gardner Museum, 2013).

23. Thorpe, "The Creation of the Gardens," 349. This oral tradition dates back to Huntington's wooing of Arabella. For instance, the lead article, "Magnate Takes Bride, Weds Uncle's Widow" in the *San Francisco Call*, July 17, 1913, 1, states, "Mr. Huntington recently completed a splendid villa near Pasadena, filled with rare works of art and wonderful gardens. That the great expense and care to be lavished on this country home were prompted by a desire to make it suitable to the taste of the bride is now generally commented on by the couple's social acquaintances." It continues, "A common love for art and literature drove Mr. Huntington and the widow of his uncle together. Friends were aware for several years of this artistic kinship and freely predicted that eventually Mrs. Collis P. Huntington would become the mistress of the magnificent villa in Pasadena."

24. William Hertrich, *The Huntington Botanical Gardens 1905–1949: Personal Recollections of William Hertrich* (San Marino, Calif.: Huntington Library, 1949; reprint, 1988), 78. Hertrich does not explain how he came by knowledge sufficient to build a Japanese garden, but reportedly he owned a copy of Josiah Conder's popular book, *Landscape Gardening in Japan* (1893). See *The Botanical Gardens at the Huntington*, ed. Peggy Park Bernal, 3rd ed. (San Marino, Calif.: Huntington Library, 2009), 116.

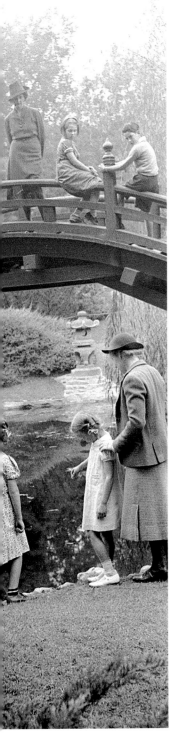

25. Hertrich, *Huntington Botanical Gardens*, 78–79.

26. Hertrich to Huntington letters, Box 1, William Hertrich Collection, Huntington Library: September 21, 1911; October 7, 1911; October 14, 1911; October 21, 1911; October 29, 1911; November 4, 1911; November 11, 1911; November 18, 1911; November 25, 1911; December 2, 1911; December 9, 1911; December 16, 1911; December 23, 1912; January 7, 1912; January 13, 1912; January 20, 1912, January 28, 1912; February 3, 1912; February 10, 1912; February 18, 1912; March 4, 1912.

27. For more on Kawai, see Naomi Hirahara's essay in this volume.

28. The Indian Village was one of several attractions in the city park. A very humble Japanese garden was built around 1900, and in 1910 the Los Angeles Park Commission contacted Huntington about purchasing eighteen acres east of the park, where they hoped to build a "Japanese garden that will surpass anything in the country." To that end, they asked Makoto Hagiwara, G. T. Marsh's nemesis at the Japanese Tea Garden in San Francisco, to select a site. The plan, never realized, was to spend $100,000 in creating the garden. See "Plan Japanese Garden Adjoining Eastlake Park," *Los Angeles Herald*, October 18, 1910, 1.

29. Kawai's name appears on one of the work orders for the bell tower, and other work orders suggest that it cost about $650 to make over the last half of 1914. For more on the bell tower, see page 98.

30. The south and north gates as well as the thatched *azumaya* and flat bridge were removed in the 1960s. The red pigment was stripped from the moon bridge in 1992.

31. For more on the stone carvings, see page 58.

32. In the same letter to Huntington on October 7, 1911, Hertrich writes of finishing the concrete by hand in some areas to make it look natural. He gives the name of only one member of the crew, Barnett, whose job was to make the wood forms for molding the concrete. He also boasts that he has "no expensive men in the whole crew except the one marble man who worked at the waterfall."

33. For instance, the Japanese garden at the Brooklyn Botanic Garden, designed by Takeo Shiota in 1915, features several waterfall grottos made of poured concrete. An "artificial rockery" in Tokyo, echoing some features seen at the Huntington garden, is illustrated as plate xl in Josiah Conder's *Supplement to Landscape Gardening in Japan* (1893).

34. P. D. Barnhart, "A Southern California Estate," *Gardener's Chronicle of America* 16 (1913): 597–601 at 601.

35. Porter Garnett, *Stately Homes of California* (Boston: Little, Brown, 1915), 40. Three photos of the Japanese Garden illustrate the article "The Garden Beautiful in Southern California," *Los Angeles Times*, September 3, 1922, sec. ix, p. 20.

36. "Huntington, the Industrial Genius and Creator," *Los Angeles Times*, January 1, 1913, sec. vii, p. 166. The spirit of the article is indicated by the subhead: "What the Man of Great Achievements Has Done and Is Doing in Southern California—He Builds Here the Finest Country Home in America—Surpassing Accomplishments."

37. The article, published in the *Ogden Standard* on November 7, 1912, was also reproduced in other newspapers. The complete paragraph is found in Thorpe, *Henry Edwards Huntington*, 287.

38. Hertrich, *Huntington Botanical Gardens*, 79–80.

39. For more on the Goto family, see Naomi Hirahara's essay in this volume.

40. This information is found in Anita Brandow's "Biographical Sketch II" in the appendix of her unpublished "Guide to the Japanese Gardens of the Henry Edwards Huntington Botanical Gardens," prepared in 1971 for use by docents. In conversations with the author, Brandow recounted that her research involved interviews with Goto family members. Brandow's history gives Chiyozo's salary as $95 per month (whereas others received $65) and states that the family also received fruit from the estate's grounds and milk from its dairy cows. Kame Goto, one of Chiyozo's sons, recalled that his father often slept on the cool ground floor of the house on hot afternoons, refusing to open the sliding door panels even though the Huntingtons requested that they remain open. He also remembered that the original wood posts for the wisteria arbor rotted, and that poured concrete ones were made with wire shaped around steel posts and then covered with concrete to create tree-like forms.

41. HEH 6/10 (1911–1939), Henry E. Huntington Collection, Huntington Library, San Marino.

42. *Los Angeles Times*, June 21, 1912.

43. "Opening Date in January," *Los Angeles Times*, November 2, 1913, sec. vi, p. 1. See also "Fine Progress is Made on Hotel," *Pasadena Star*, November 3, 1913, 5.

44. James Thorpe, "The Founder and His Library," *Huntington Library Quarterly* 32, no. 4 (1969): 291–308 at 306.

45. "All Huntington Art a Gift to the Public," *New York Times*, April 9, 1922, 1.

1. Okakura Kakuzō, *The Book of Tea* (New York: Fox Duffield & Co., 1906).

2. *Wind in the Pines: Classic Writings of the Way of Tea as a Buddhist Path*, comp. and ed. Dennis Hirota (Fremont, Calif.: Asian Humanities Press, 1995), 290–93.

3. Okakura titled the first chapter of his book "The Cup of Humanity." He coined the term "teaism" to refer to the culture of tea and its practice.

4. There are three branches of the Sen family that descended from Sen Rikyū, who codified the *chado*. His great-grandson Sen Kōshin Sōsa (1613–1672), who inherited the front (*omote*) of the property, established the Omote Senke School. Sen Senso Sōshitsu (1622–1697), the youngest of four great-grandsons, whose teahouse was located at the back (*ura*), established Urasenke. The Mushanokōji Senke takes its name from the location where Sen Ichio Sōshu (1605–1676), another great-grandson, established his residence. Each successive generation of grand masters assumes the same names as their forebears.

5. Sen Otani Mitsuhiko designed numerous tearooms and teahouses, including the Western-style tearoom Yushin within the Urasenke complex in Kyoto.

6. The phrase *seifu*, or "pure breeze," appears in numerous poems and Zen couplets—for example, "Seifu Meigetsu wo Harau" (The pure breeze sweeps the bright moon) and "Yōyō Seifu wo Okosu" (The rustling of the leaves creates a pure breeze). It is not known whether the name is a literary allusion.

7. The Nakamura workshop constructed a teahouse in Honolulu in 1959–60; it has since been demolished. Two other teahouses constructed in the early 1960s and installed in public parks were destroyed by arson.

8. Herbert E. Plutschow, *The Grand Tea Master: A Biography of Hōunsai Sōshitsu Sen XV* (Trumbull, Conn.: Weatherhill, 2001), 127.

9. Konnichian, *Otani Mitsuhiko Ihōushu* (Tokyo: Tankosha, 1988), 59–61.

10. Sōsei Matsumoto, interview with the author, May 14, 2011.

11. Sasaki Sanmi, *Ochaji* (Kyoto: Tankosha, 1966), 6–74.

12. Yasuhiko Murai, "A Brief History of Tea in Japan," in *Chanoyu: The Urasenke Tradition of Tea*, ed. Sen Sōshitsu (New York: Weatherhill, 1988), 12–16.

13. Sen Sōshitsu XV, *The Japanese Way of Tea: From Its Origins in China to Sen Rikyu* (Honolulu: University of Hawai'i Press, 1998), 57–74.

14. *Wind in the Pines*, ed. Hirota, 30–37.

15. Michael Cooper, "The Early Europeans and Tea," in *Tea in Japan: Essays on the History of Chanoyu*, ed. Paul Varley and Kumakura Isao (Honolulu: University of Hawai'i Press, 1989), 124.

16. Sen, *The Japanese Way of Tea*, 119.

17. Cooper, "The Early Europeans and Tea," 125.

18. Murai, "A Brief History of Tea in Japan," 19–25.

19. Theodore M. Ludwig, "*Chanoyu* and Momoyama: Conflict and Transformation in Rikyu's Art," in *Tea in Japan*, ed. Varley and Isao, 71–100.

20. Sekine Sochu, *Cha no Yu to Eki to Inyogogyo* (Tea, I-Ching, Yin and Yang, and the Five Elements) (Kyoto: Tankosha, 2006).

21. Plutschow, *The Grand Tea Master*, 15–29.

22. Sen Sōshitsu XV, *Tea Life, Tea Mind* (New York: Weatherhill, 1979), 9–14.

23. Sasaki, in *Ochaji*, his book on the formal tea ceremony, details seven set times for tea gatherings, beginning with dawn and ending at nightfall. He also describes another dozen types of tea gatherings held on special occasions, such as moon viewing and flower viewing outdoors.

24. Sen, *Tea Life, Tea Mind*, 45.

25. Ibid., 72.

26. Sen Sōshitsu, *The Spirit of Tea* (Kyoto: Tankosha, 2002), 49.

27. Cooper, "The Early Europeans and Tea," 100–132.

28. Sen Sōshitsu, *The Urasenke Tradition of Tea* (N.p: n.p., n.d), n.p.

1. Integral to the research for this essay were the passenger lists of ships sailing to San Francisco from Japan (1893–1934), archived at the Manabi and Sumi Hirasaki National Resource Center at the Japanese American National Museum in Los Angeles. These lists had interesting information about the travel dates and plans of Toichiro, Hama, and Kimi Kawai as well as Chiyozo, Kame, and Shige Goto. See also "Gaelic Brings a Valuable Cargo and Many Passengers from Orient," *San Francisco Call*, August 27, 1902, 10.

2. Anita Brandow, a former docent at the Huntington Library, compiled a comprehensive history of the Japanese Garden based on interviews she had conducted with Kawai's sons Nobu and Shigeru (November 16, 1970) and Chiyozo Goto's son Kame. The manuscript, completed in 1971, is titled, "Guide to the Japanese Gardens of the Henry Edwards Huntington Botanical Gardens." Nobu Kawai compiled a history of the Kawai family, called "Kawai Family Background," in January 1985.

3. Kawai, "Kawai Family Background," 1.

4. Kendall Brown discusses the Marsh brothers' business concerns in Pasadena on page 44 of this volume.

5. "Marsh Block Contracts," *Pasadena Evening Star*, May 7, 1902, 1.

6. This information is derived from passenger records and from an article in the *Pasadena Evening Star*, "Victor Marsh Talks of Japan: Home from His Interesting Business Trip in the East," September 11, 1903, 6. See also "Occidental and Oriental Steamer Gaelic Spared by Russian Novik," *San Francisco Call*, September 24, 1904, 7.

7. "Victor Marsh to Give Up His Art: Pasadenan Will Sell Out and Devote Time to His Private Interests," *Pasadena Star*, February 3, 1910, 1.

8. Kendall Brown discusses the relocation of structures from Marsh's Japanese Tea Garden to the Huntington estate on page 54 of this volume.

9. William Hertrich, *The Huntington Botanical Gardens, 1905–1949: Personal Recollections of William Hertrich* (San Marino, Calif.: Huntington Library, 1949), 79.

10. Payroll records and work orders archived at the Huntington Library were helpful in determining the dates that certain personnel were retained for particular projects.

11. Takeko "Tachy" Wakiji (Hanhichi's third daughter), interview with the author, Pasadena, June 6, 2011. See also George Wakiji (Hanhichi's younger son) with Raymond Chong, "My Family Values as a Nikkei in the Southland," *The Japanese American Family*, Nanka Nikkei Voices 4 (Torrance, Calif.: Japanese American Historical Society of Southern California, 2010).

12. "From Flowery Japan," *Tournament of Roses, Pasadena, California, New Year's Number, Pasadena Star*, January 1, 1910.

13. Other early Issei, or first-generation Japanese Americans, were concentrated in the central business district, where they lived and worked. Some were employed as domestics; others operated laundries or other small businesses to service the large hotels in Pasadena. Another popular neighborhood, especially for Issei florists, was located just a few blocks south. By the 1920s, Japanese American residents had shifted toward northwest Pasadena, where there was also a significant African American population.

14. The Humane Society came in second, and the Pasadena Motorcycle Club came in third.

15. *Year Book and Directory* (Los Angeles: Rafu Shimpo, 1915), 12–13. See also *Ethnic History Research Project* (Pasadena, Calif.: City of Pasadena, 1995), 44–55.

16. *Ethnic History Research Project.* See also *Yearbook and Directory*, 1915.

17. *The Japanese Directory of Pasadena* (Pasadena, Calif.: Pasadena Japanese Community Center, 1956).

18. "Japanese Art Work Sought by Director of Movie Monument," *Pasadena Star-News*, June 18, 1927, 43.

19. "Japanese Liner Brings a Cargo of Precious Oriental Products," *San Francisco Call*, November 26, 1903, 12.

20. Chiyozo and Tsune may have had at least two more children who were either born in Japan or at least spent most of their lives in Japan.

21. Kendall Brown tells more about the Goto family on page 60 of this volume.

22. Brandow, "Biographical Sketch II," "Guide to the Japanese Gardens," 3.

23. For more on the Japanese bell, see page 98.

24. Richard Goto, telephone interview with the author, January 27, 2011.

25. Hertrich, *The Huntington Botanical Gardens*, 79–80.

26. Ibid, 80.

27. *Los Angeles Japanese Daily News, Year Book and Directory* (Los Angeles: Rafu Shimpo, 1939–40), 307, 309.

28. Richard Goto interview.

29. Yaeko Sakahara, telephone interview with the author, June 8, 2011. Del Mar Street was changed to Del Mar Boulevard in 1958.

30. For more on Seifu-an, see Robert Hori's essay in this volume.

31. Kawai, "Kawai Family Background," 4–5.

32. Photograph provided by the office of Kelly Sutherlin McLeod.

1. For more on Arabella Huntington's gardens at the Homestead, see page 51 of Kendall H. Brown's essay.

2. Kendall H. Brown discusses the early twentieth-century vogue for Japanese gardens on page 41.

3. For more on the elements of the Marsh Tea Garden, see Kendall H. Brown's essay, page 44.

4. Naomi Hirahara discusses Kawai's work in the Japanese Garden in her essay on page 96.

5. Kelly Sutherlin McLeod discusses the restoration of the Japanese House in her essay in this volume.

6. Robert Hori gives the history of the Seifu-an teahouse in his essay in this volume.

1. During construction, the project benefited from meticulous treatments to all wood elements by master carpenter Frank Clark of Mannigan Design, plus contributions by Toshiyuki Kawabata, Jamie Maddox and Ru Jensen of Electro Construction, Kevin McPherson and Rick Marion of Mesa Roofing Corporation, Durastrip, Scott Nelson of Naturalwalls, Alpine Plastering, and Yoshikawa Wright. The success of the project is largely attributable to the careful and patient supervision provided by Joe Hale, senior project manager, and Erin Duff Crowley, project engineer from ValleyCrest Construction—the project general contractor—assisted by Rogelio Ramirez, the Japanese House foreman.

2. Deciding to pursue a more "authentic" Japanese style instead would have meant choosing among the many regional and historical approaches to domestic Japanese architecture.

3. Kelly Sutherlin McLeod Architecture, Inc. (KSMA), served as project architect; as principal-in-charge Kelly was assisted by KSMA Project Manager Heather Donaghy Ballard, Chris Ward, and Adam Umber.

4. Catherine Smith of Griswold Conservation Associates assisted John Griswold with day-to-day, hands-on conservation work and directing the conservation crew. The project team also included David Cocke, SE, and Wayne Chang, SE, of the engineering firm Structural Focus; lighting specialists from Lighting Design Alliance; and mechanical, electrical, and plumbing engineers from Donald F. Dickerson Associates.

5. Atsuko Tanaka, Uchida Seizo, Nakatani Norihito, and Sarah Teasley, "The Reception and Understanding of Japanese Architecture in the United States: Three Concrete Examples," *Jūtaku sōgō kenkyū zaidan, kenkyū ronbunshū* (Collected Research Essays, Foundation for Consolidated Research on Housing) 33 (2006): 100–110. The other two buildings discussed are Shofuden, near Monticello, New York, and the house of art dealer Bunkio Matsuki in Salem, Massachusetts.

6. Atsuko Tanaka, e-mail to the author, July 25, 2011.

7. Tanaka et al., "The Reception and Understanding of Japanese Architecture in the United States," Section 4.3, Inquiry 4.3.1, "The Remodeling Situation and the Interior Formation," 107.

8. Frank Clark, e-mail to the author, October 1, 2011.

9. "The Secretary of the Interior's Standards for the Treatment of Historic Properties, with Guidelines for Preserving, Rehabilitating, Restoring, and Reconstructing Historic Buildings," National Park Service website, http://www.nps.gov/hps/tps/standguide. Restoration is the act or process of accurately depicting the form, features, and character of a property as it appeared at a particular period of time by means of the removal of features from other periods in its history and reconstruction of missing features from the restoration period. The limited and sensitive upgrading of mechanical, electrical, and plumbing systems and other code-required work to make properties functional is appropriate within a restoration project.

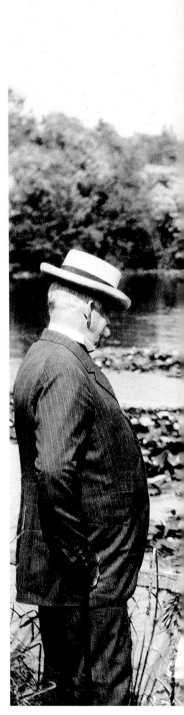

10. Tanaka et al., "The Reception and Understanding of Japanese Architecture in the United States," p. 2, Section 4.1.1, "Marsh Brothers and Japanese Gardens," 105–6.

11. The signature "William T. Crowell" was discovered on the underside of a decking board from the balcony; this suggests that Kawai may have been aided by a local American builder known to have been active in Pasadena and at the Huntington property. Or, perhaps Crowell's involvement was limited to the supply of building materials. For more on Kawai and his work in the Japanese Garden, see the essay by Naomi Hirahara in this volume.

12. Takeo Uesugi and Keiji Uesugi contributed to this account of the historic pond rehabilitation process.

13. William Hertrich to Henry E. Huntington, November 11, 1911, Box 1, William Hertrich Collection, Huntington Library,

14. There were also traces of a bright white coating consistent with a lime wash on a core taken from the lower part of the west wall. No other traces of the white lime wash were found in any of the other cores studied. Nor did we see it in the field anywhere; it might have been left from a local repair.

15. This decision was based on findings of the original materials and finishes, and in consultation with Nakamura and others who deemed it fitting with Japanese buildings of a similar style and period.

16. In black-and-white photos from the Marsh era, the exterior plaster of the house appears to be a consistent color that is lighter than the Huntington-era plaster.

17. *Sugi*, also known as Japanese cedar, is one of the most common types of wood used for traditional houses. Owing to the expense of *sugi*, the laminated wood used at the Japanese House may have been deliberately selected for its grain characteristics to simulate *sugi*.

Credits

Images are from the collection of the Huntington Library, Art Collections, and Botanical Gardens, with the exception of the following:

OTHER COLLECTIONS
Brooklyn Botanic Garden, 126.
Kendall H. Brown, 43.
Frank Clark, Mannigan Design, 142–43, 153 (both).
John Ellis, 148 (bottom), 152 (bottom), 158–59.
Griswold Conservation Associates, LLC, 146 (left), 157 (left, top and bottom).
Vergil Hettick, 190.
Kelly Sutherlin McLeod Architecture, Inc., 141, 147 (left), 148 (top), 149, 150 (top left), 152 (top), 156.
Sosei Matsumoto, 82.
Myoki-an, Kyoto © Benrido Photo Archives, 76.
Pasadena Japanese Cultural Institute, 100.
Archives, Pasadena Museum of History, 46, 140.
Pomona Progress Bulletin, August 13, 1955, 70.
Yaeko Sakahara, 88, 106, 107.
Tokugawa Art Museum, © Tokugawa Art Museum Image Archive, DNPartcom, 74.
Urasenke, Kyoto, 75 (bottom).

ILLUSTRATORS
Doug Davis, 77.
Marc P. Keane, 27, 35.
Lisa Pompelli, 202–3.

PHOTOGRAPHERS
Michelle Bailey, 58, 85, 127 (top), 147 (right), 150 (top right), 161 (bottom), 173 (top left), 174 (top), 180–81 (top center), 181 (top right), 188 (top left), 188 (center right), 188 (bottom), 189.
Martha Benedict, 4, 6, 12, 18–19, 20–21, 25, 62, 98, 108, 125 (both), 128 (top), 133, 144, 165, 175 (bottom), 176–77 (left), 187 (top right), 192–93, 196–97, 199 (bottom), 200–201.
Lisa Blackburn, 169, 174 (bottom), 175 (top), 177 (bottom), 178–79, 182–83, 186.
Kendall H. Brown, 26, 29, 30 (both), 31, 32, 34, 36.
James Folsom, 130, 166–67, 168.
Robert Hori, 129.
June Li, 32–33.
Andrew Mitchell, 68–69, 71, 78–79, 80–81, 90–91, 128 (bottom), 131 (all), 135, 146 (right), 150 (bottom), 155, 157 (right).
John Sullivan, jacket, 3, 15, 17, 23, 39, 65, 72–73, 75 (top, left and right), 79 (top and bottom), 83, 84, 86, 87, 93, 111, 124, 127 (center and bottom), 138, 139, 154 (both), 163, 171, 173 (top right), 173 (bottom), 177 (top right), 180 (top left), 185, 187 (top left), 187 (bottom), 188 (center left), 191.

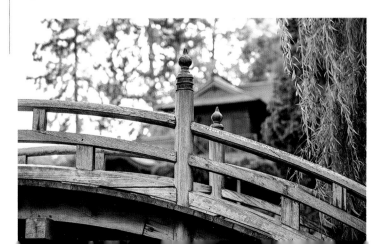

Contributors

T. June Li joined the Huntington in 2004 to establish the historical and cultural context for the Chinese garden, the first phase of which opened in 2008. Previously, she had been associate curator of Chinese and Korean art at the Los Angeles County Museum of Art. At the Huntington as curator of Liu Fang Yuan, Li founded a series of educational and music programs that explore the many facets of Chinese garden culture, including its relationship to that of Japan and other East Asian countries.

Kendall H. Brown is Professor of Asian Art History in the School of Art at California State University, Long Beach. He specializes in Japanese art of the early twentieth century, modern woodblock prints, and Japanese gardens. His book *Quiet Beauty: The Japanese Gardens of North America* was published by Tuttle in 2013.

James Folsom is the Marge and Sherm Telleen/Marion and Earle Jorgensen Director of the Huntington's Botanical Gardens.

Vergil Hettick is curator of the Earl Burns Miller Japanese Garden at California State University, Long Beach.

Naomi Hirahara is a social historian and Edgar Award–winning mystery writer. A former editor of the *Rafu Shimpo* newspaper, she has written several nonfiction books about the Japanese American experience and California horticultural history. For more information, visit her website, http://www.naomihirahara.com.

Robert Hori is the cultural curator of the Huntington's Japanese Garden. He is a certified instructor of the Urasenke School of Tea and an independent curator of traditional and contemporary performing and visual arts from Japan.

Kelly Sutherlin McLeod, FAIA, is the preservation architect who led the restoration of the Japanese House at the Huntington. Previous projects for her firm, Kelly Sutherlin McLeod Architecture, Inc., have included the conservation of Greene & Greene's Gamble House in Pasadena. For more information, visit her website, http://www.ksmarchitecture.com.

Suggestions for Further Reading

Berthier, François. *Reading Zen in the Rocks: The Japanese Dry Landscape Garden.* Chicago: University of Chicago Press, 1997.

Brown, Kendall H. *Japanese-Style Gardens of the Pacific West Coast.* New York: Rizzoli, 1999.
———. *Quiet Beauty: The Japanese Gardens of North America.* North Clarendon, Vt.: Tuttle, 2013.

Castile, Rand. *The Way of Tea.* New York: Weatherhill, 1971.

Conan, Michel, ed. *Sacred Gardens and Landscapes: Ritual and Agency.* Washington, D.C.: Dumbarton Oaks, 2007.

Conder, Josiah. *Landscape Gardening in Japan.* London: Kelly and Walsh, 1893; Tokyo: Kodansha, 2002.

Earle, Joe. *Infinite Spaces: The Art and Wisdom of the Japanese Garden, Based on the Sakuteki by Tachibana no Toshitsuna.* Boston: Tuttle, 2000.

Fujioka, Ryoichi. *Tea Ceremony Utensils.* New York: Weatherhill/Shibundo, 1973.

Goto, Seiko. *The Japanese Garden: Gateway to the Human Spirit.* New York: Peter Lang, 2003.

Guth, Christine M. E. *Art, Tea, and Industry: Masuda Takashi and the Mitsui Circle.* Princeton, N.J.: Princeton University Press, 1993.

Hertrich, William. *The Huntington Botanical Gardens, 1905–1949: Personal Recollections of William Hertrich.* San Marino, Calif.: Huntington Library, 1949.

Hirahara, Naomi. *Green Makers: Japanese American Gardeners in Southern California.* Los Angeles: Southern California Gardeners' Federation, 2000.
———. *A Scent of Flowers: The History of the Southern California Flower Market, 1912–2004.* Los Angeles and Pasadena, Calif.: Southern California Flower Market and Midori Books, 2004.

Hirota, Dennis, comp. and ed. *Wind in the Pines: Classic Writings of the Way of Tea as a Buddhist Path.* Fremont, Calif.: Asian Humanities Press, 1995.

Isozaki, Arata, Tadao Ando, and Terunobu Fujimori. *The Contemporary Tea House: Japan's Top Architects Redefine a Tradition.* Trans. Glenn Rich. Tokyo and New York: Kodansha, 2007.

Keane, Marc Peter. *Japanese Garden Design.* Rutland, Vt.: Tuttle, 1996.
———. *The Japanese Tea Garden.* Berkeley, Calif.: Stone Bridge Press, 2009.

Kuck, Loraine E. *The World of the Japanese Garden: From Chinese Origins to Modern Landscape Art.* New York: Walker/Weatherhill, 1968.

Kuitert, Wybe. *Themes in the History of Japanese Garden Art.* Honolulu: University of Hawai'i Press, 2002.

Lancaster, Clay. *The Japanese Influence in America.* 2nd ed. New York: Abbeville, 1983.

Okakura, Kakuzo. *The Book of Tea.* New York: Fox Duffield, 1906.

Ozawa, Yuichi. *Story of Shofuso: A Cultural Bridge between Japan and the United States.* Philadelphia: Friends of the Japanese House and Garden, 2010.

Plutschow, Herbert. *The Grand Tea Master: A Biography of Hounsai Soshitsu Sen XV.* Turnbull, Conn.: Weatherhill, 2001.

Sasaki, Sanmi. *Chado: The Way of Tea—A Japanese Tea Master's Almanac.* Trans. Shaun McCabe and Iwasaki Satoko. Boston: Tuttle, 2002.

Sen Soshitsu XV. *Tea Life, Tea Mind.* New York: Weatherhill, 1979.
———. *The Japanese Way of Tea: From Its Origins in China to Sen Rikyu.* Trans. V. Dixon Morris. Honolulu: University of Hawai'i Press, 1998.
———. *The Spirit of Tea.* Turnbull, Conn.: Weatherhill, 2003.
———, ed. *Chanoyu: The Urasenke Tradition of Tea.* Trans. Alfred Birnbaum. New York: Weatherhill, 1988.

Takei, Jiro, and Marc P. Keane. *Sakuteiki, Visions of the Japanese Garden: A Modern Translation of Japan's Gardening Classic.* Boston: Tuttle, 2001.

Tanaka, Sen'o. *The Tea Ceremony.* New York: Harmony Books, 1977.

Tani, Akira. *What Is Chanoyu?* Kyoto: Tankosha, 2008.

Varley, Paul, and Isao Kumakura, eds. *Tea in Japan: Essays on the History of Chanoyu.* Honolulu: University of Hawai'i Press, 1989.

Yamada, Shoji. *Shots in the Dark: Japan, Zen, and the West.* Trans. Earl Hartman. Chicago: University of Chicago Press, 2009.

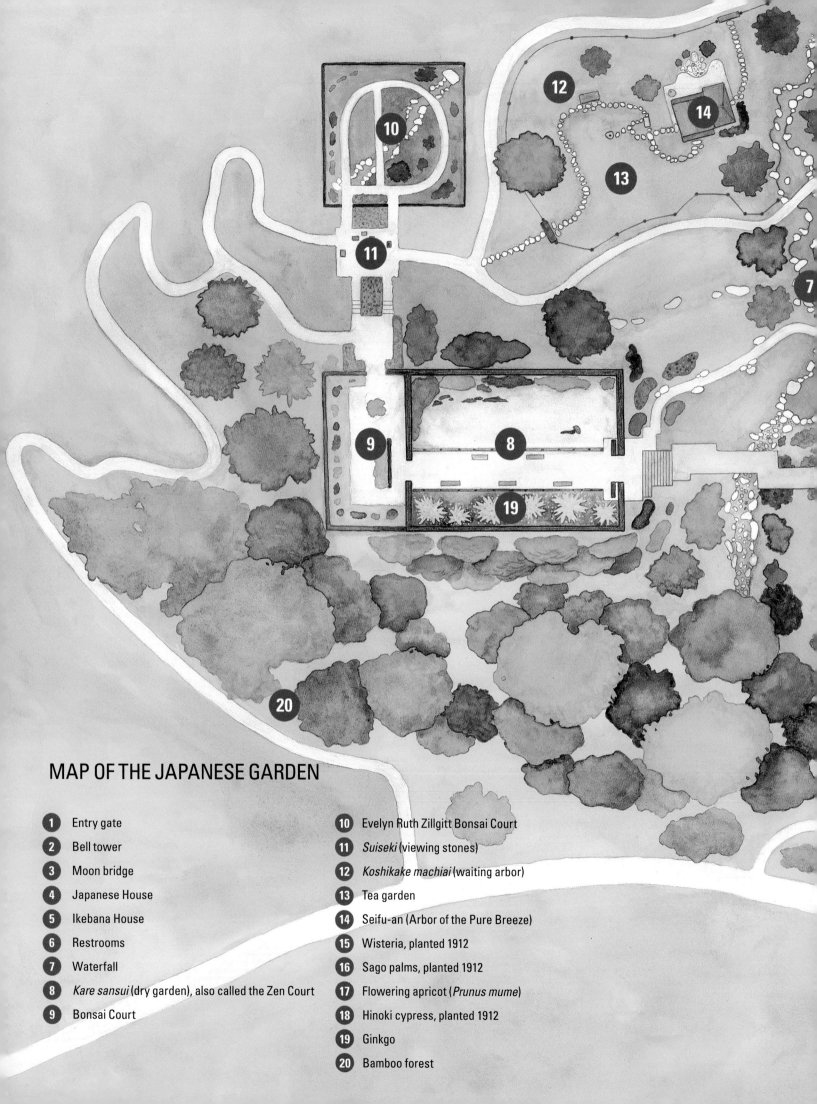

MAP OF THE JAPANESE GARDEN

1 Entry gate
2 Bell tower
3 Moon bridge
4 Japanese House
5 Ikebana House
6 Restrooms
7 Waterfall
8 *Kare sansui* (dry garden), also called the Zen Court
9 Bonsai Court

10 Evelyn Ruth Zillgitt Bonsai Court
11 *Suiseki* (viewing stones)
12 *Koshikake machiai* (waiting arbor)
13 Tea garden
14 Seifu-an (Arbor of the Pure Breeze)
15 Wisteria, planted 1912
16 Sago palms, planted 1912
17 Flowering apricot (*Prunus mume*)
18 Hinoki cypress, planted 1912
19 Ginkgo
20 Bamboo forest

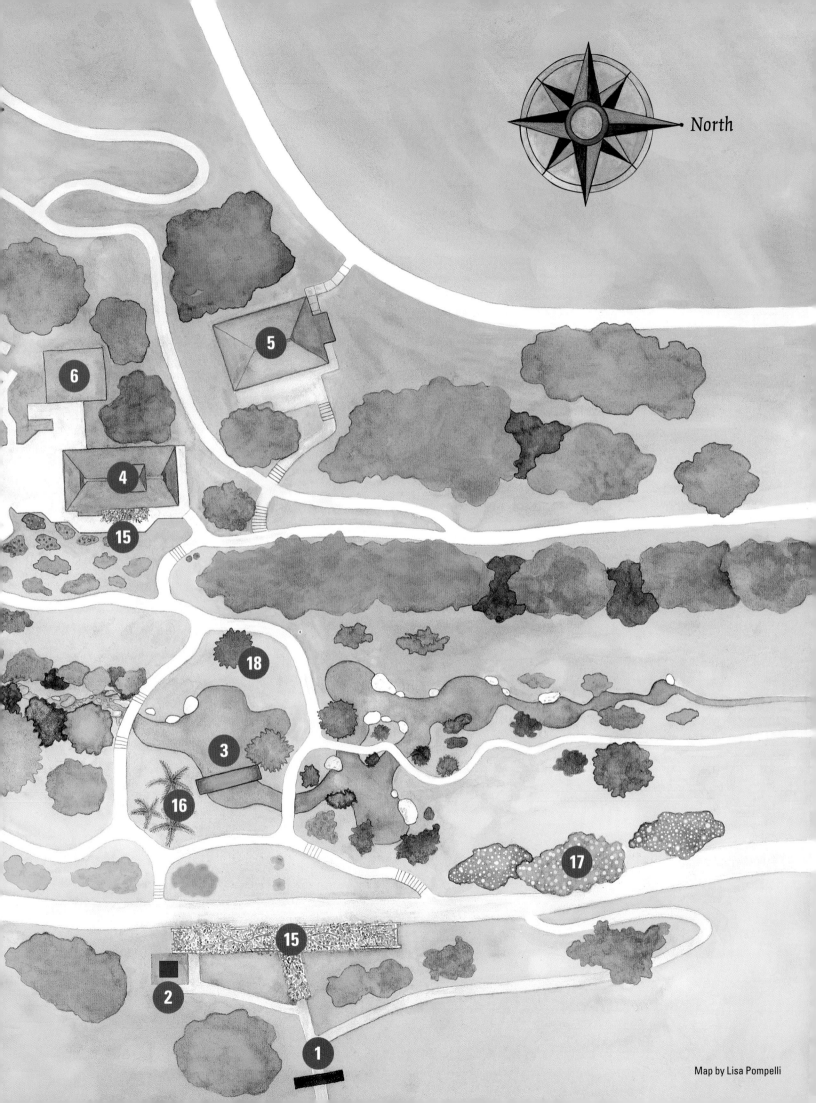

North

Map by Lisa Pompelli

Index

205

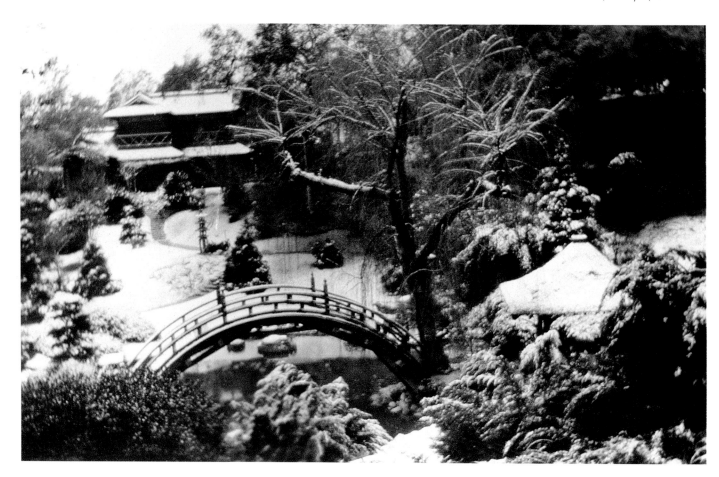

208

EDITING AND INDEXING: Jean Patterson
PHOTO EDITING: Michelle Bailey
DESIGN: Amy McFarland, Clean{Slate}Design
PRINCIPAL PHOTOGRAPHY: John Sullivan
COLOR MANAGEMENT AND PREPRESS: Charles Allen Imaging Experts
Printed in South Korea

LIBRARY OF CONGRESS CATALOGING-IN-PUBLICATION DATA

One hundred years in the Huntington's Japanese garden : harmony with
nature / edited by T. June Li.
 pages cm
 Includes bibliographical references and index.
 ISBN 978-0-87328-256-7 (alkaline paper)
1. Gardens, Japanese—California—San Marino—History. 2. Gardens,
Japanese—California—San Marino—Design—History. 3. Huntington
Botanical Gardens—History. I. Li, T. June.
 SB458.O54 2013
 712.09794'93—dc23

 2012044319